P9-DGJ-191

Once there was a way...

Once there was a way...

# Photographs of the Beatles by Harry Benson

## Harry N. Abrams, Inc. Publishers

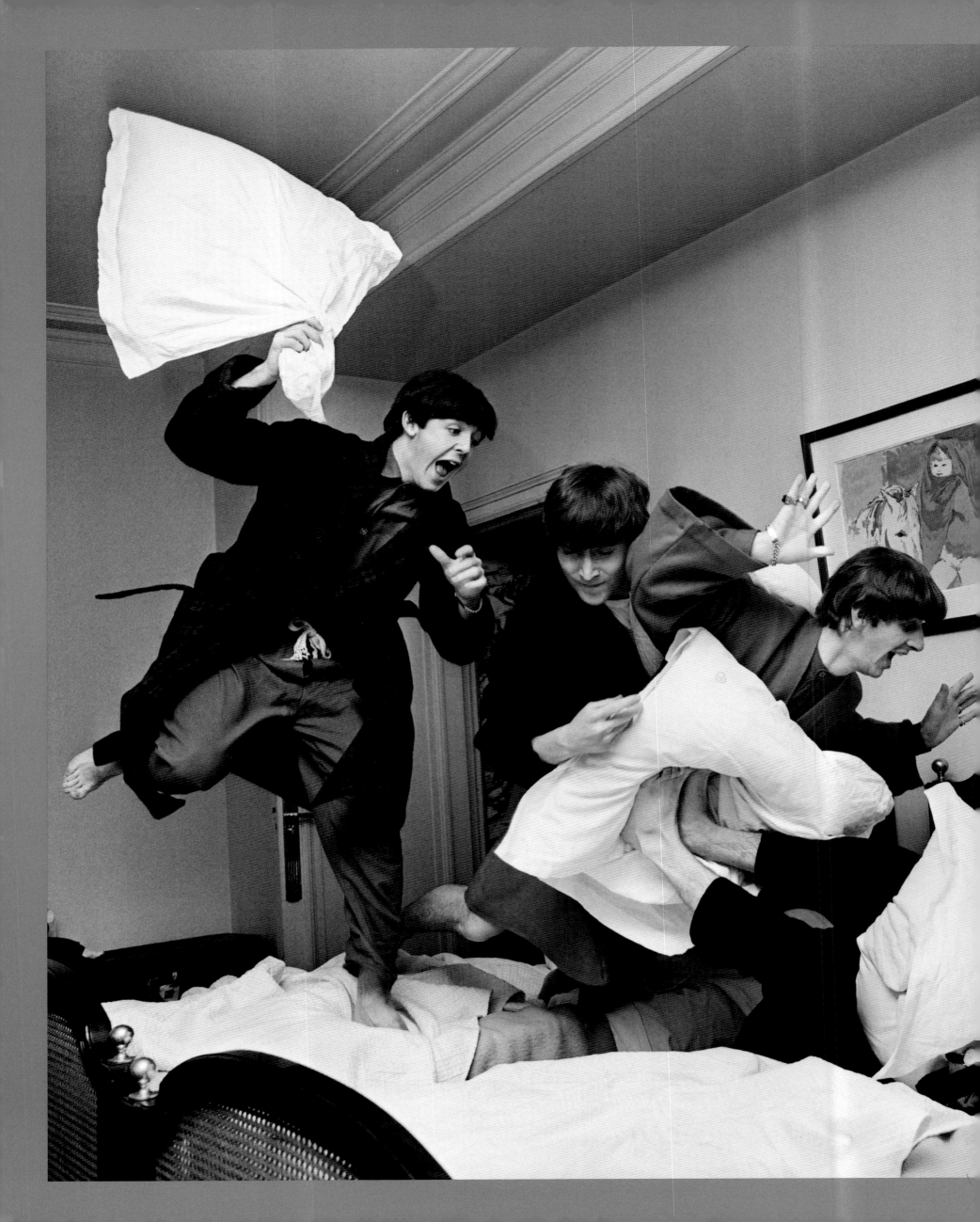

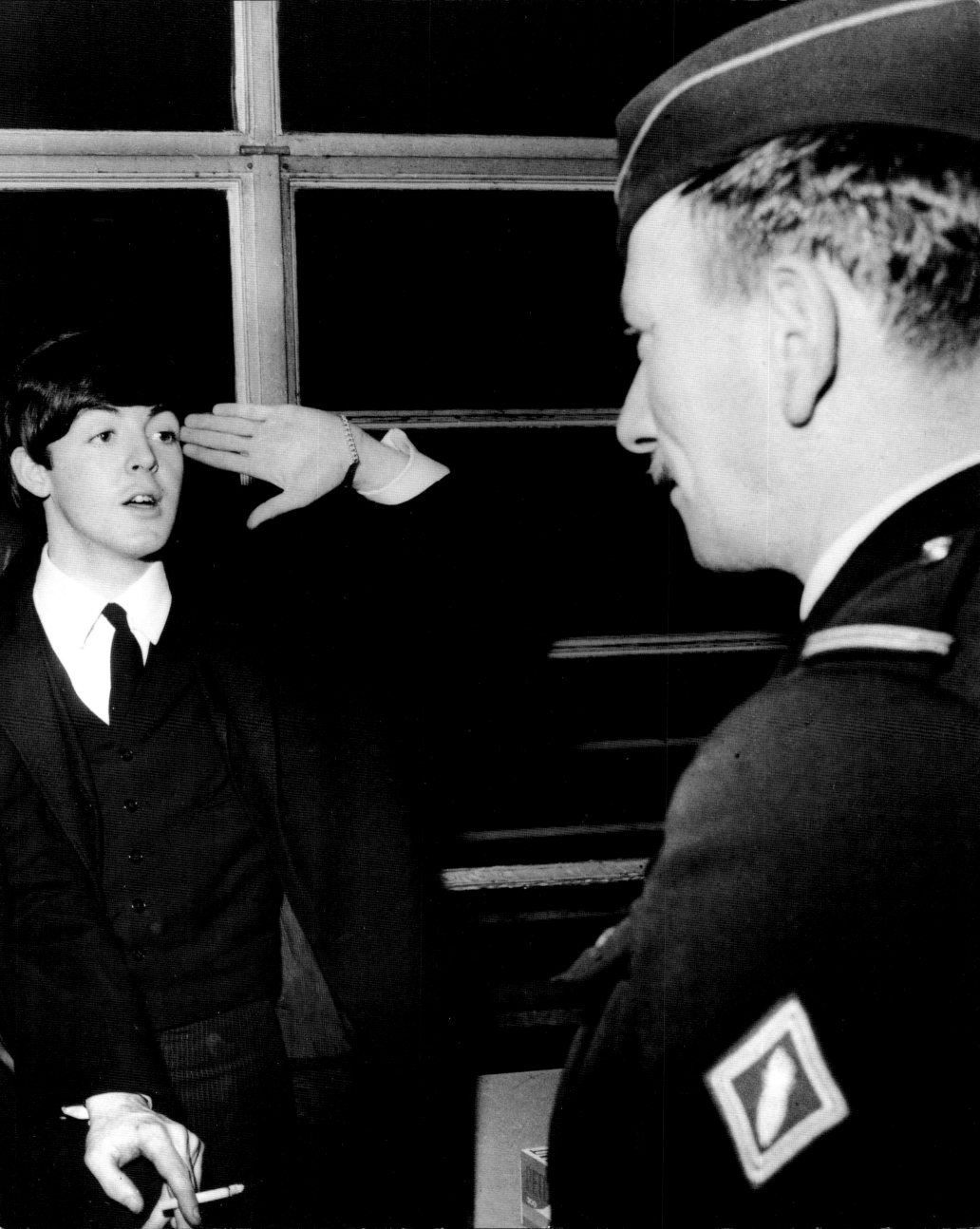

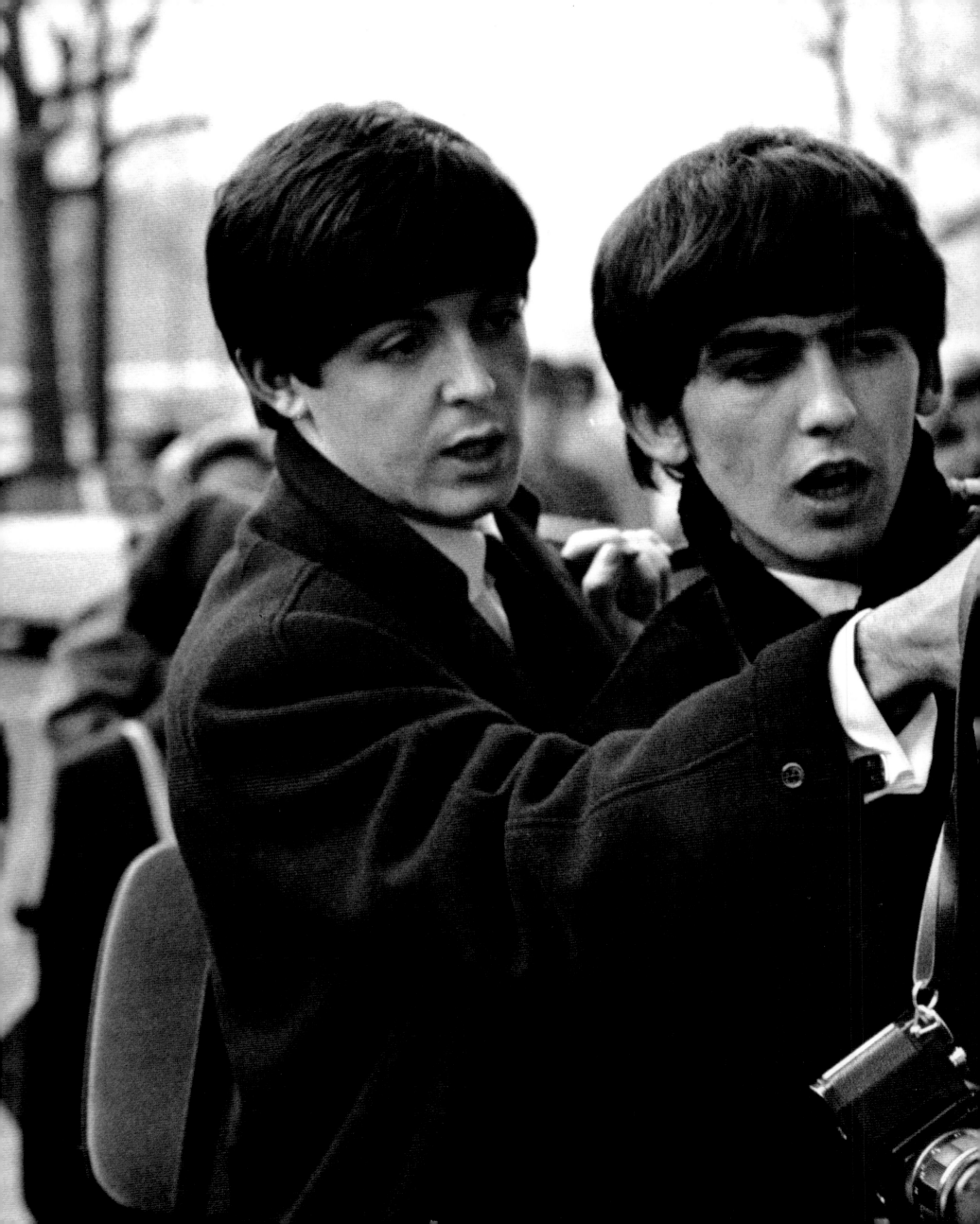

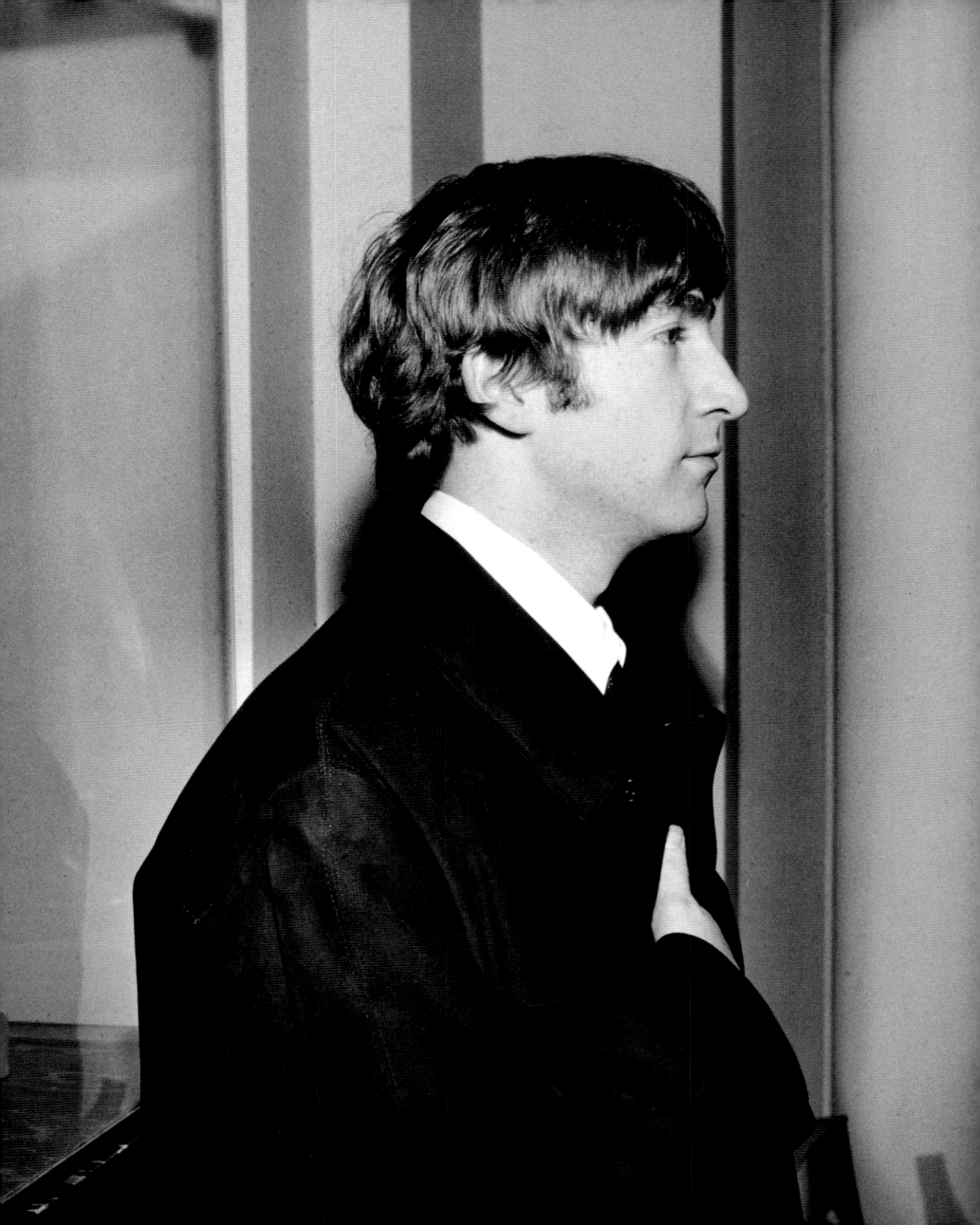

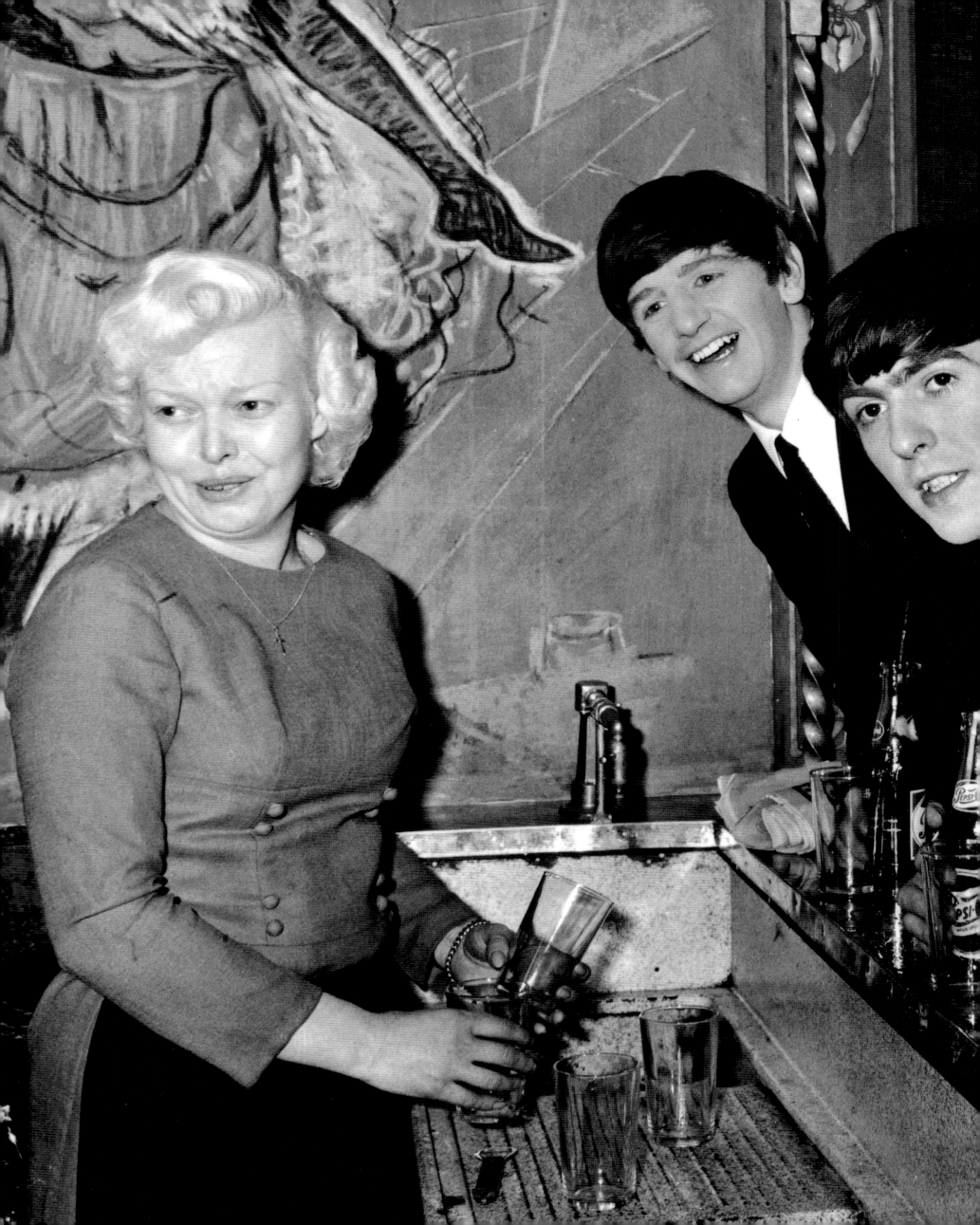

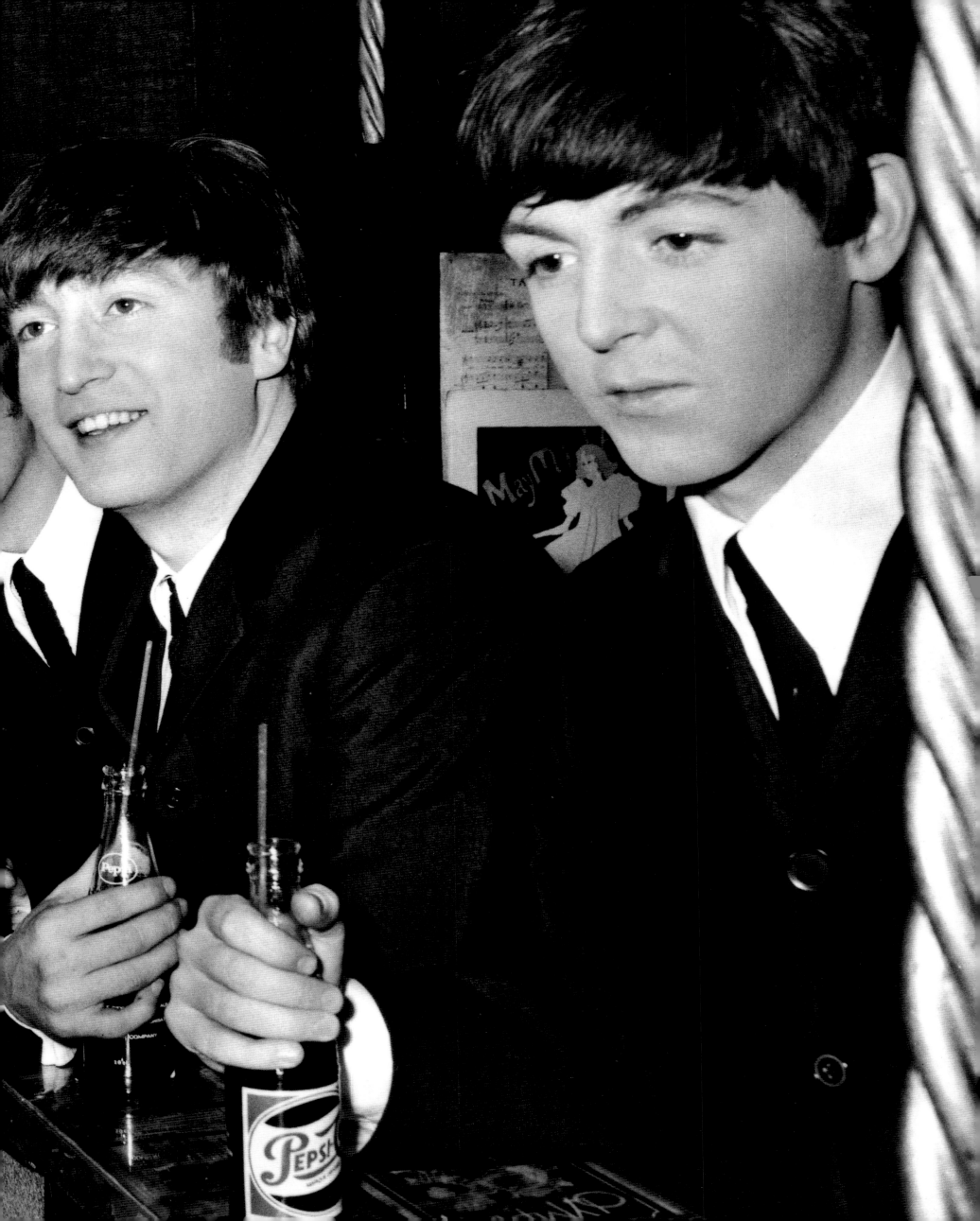

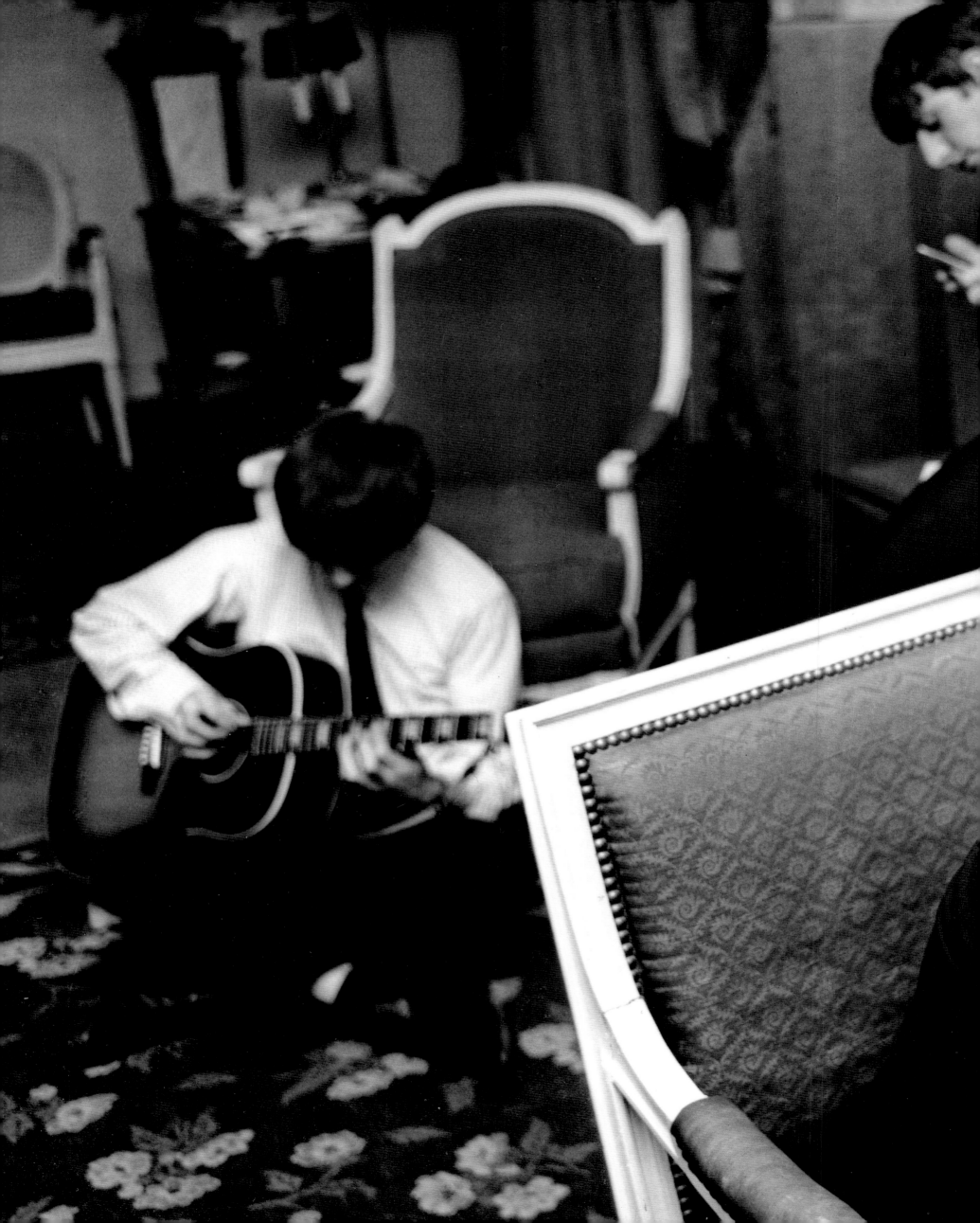

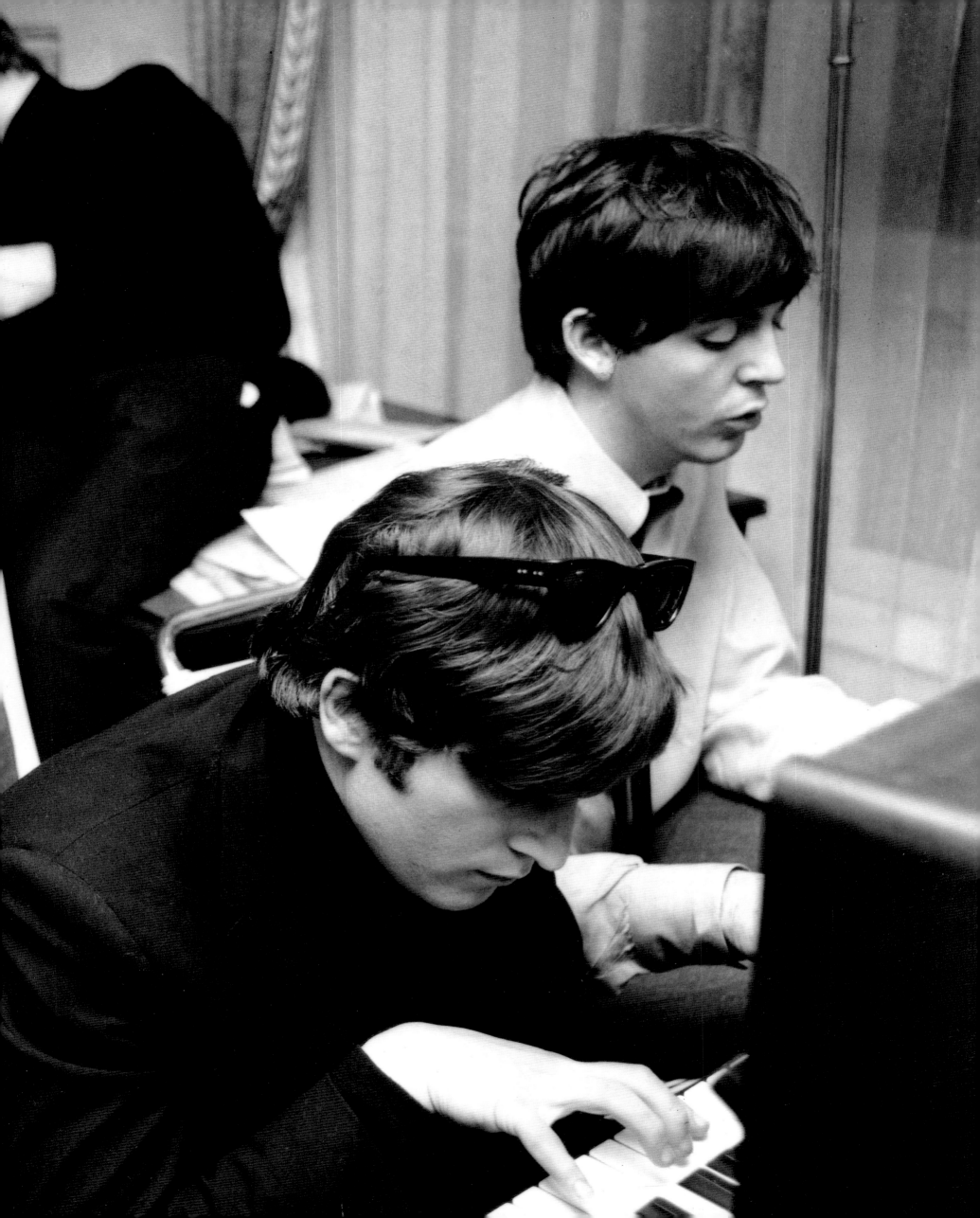

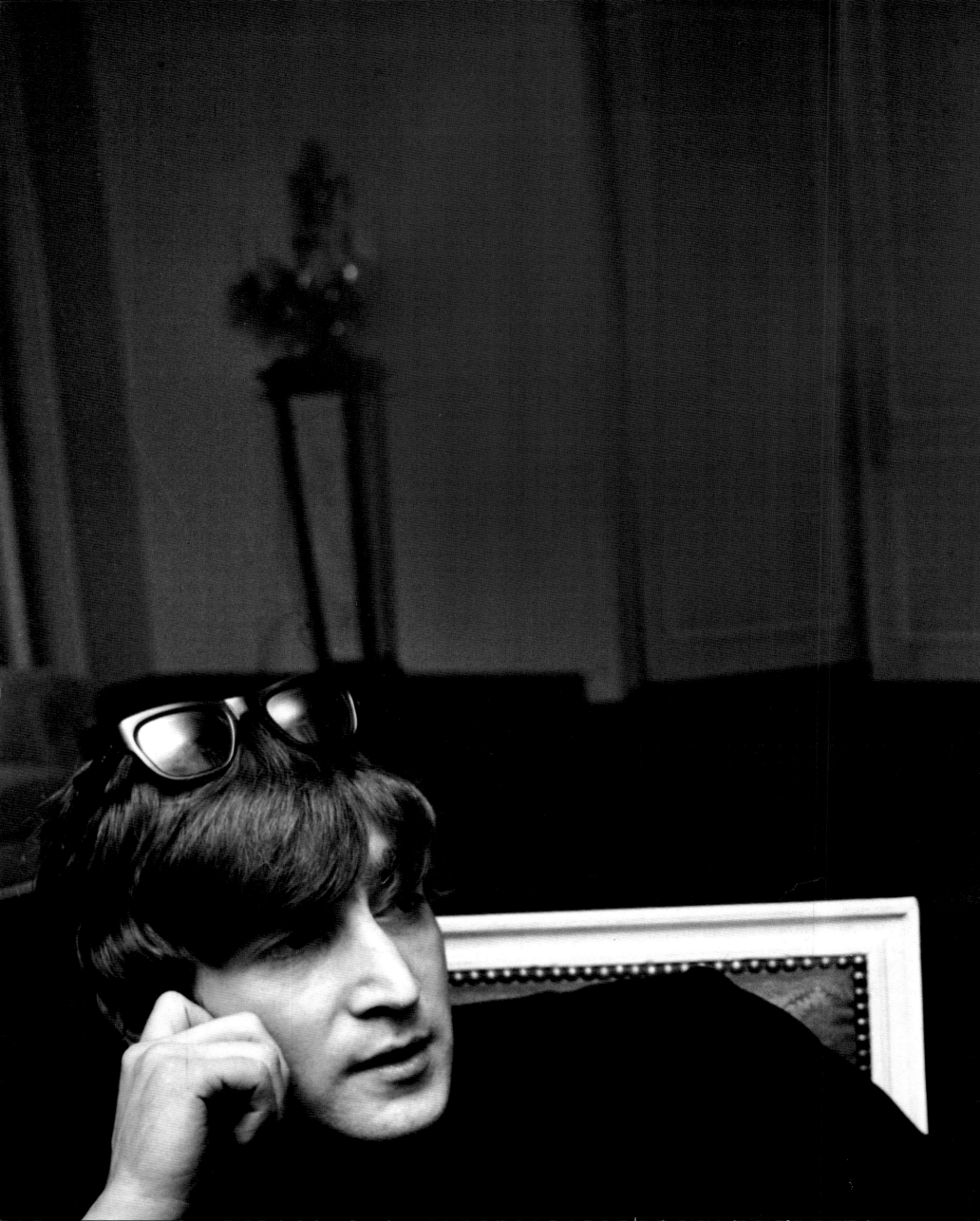

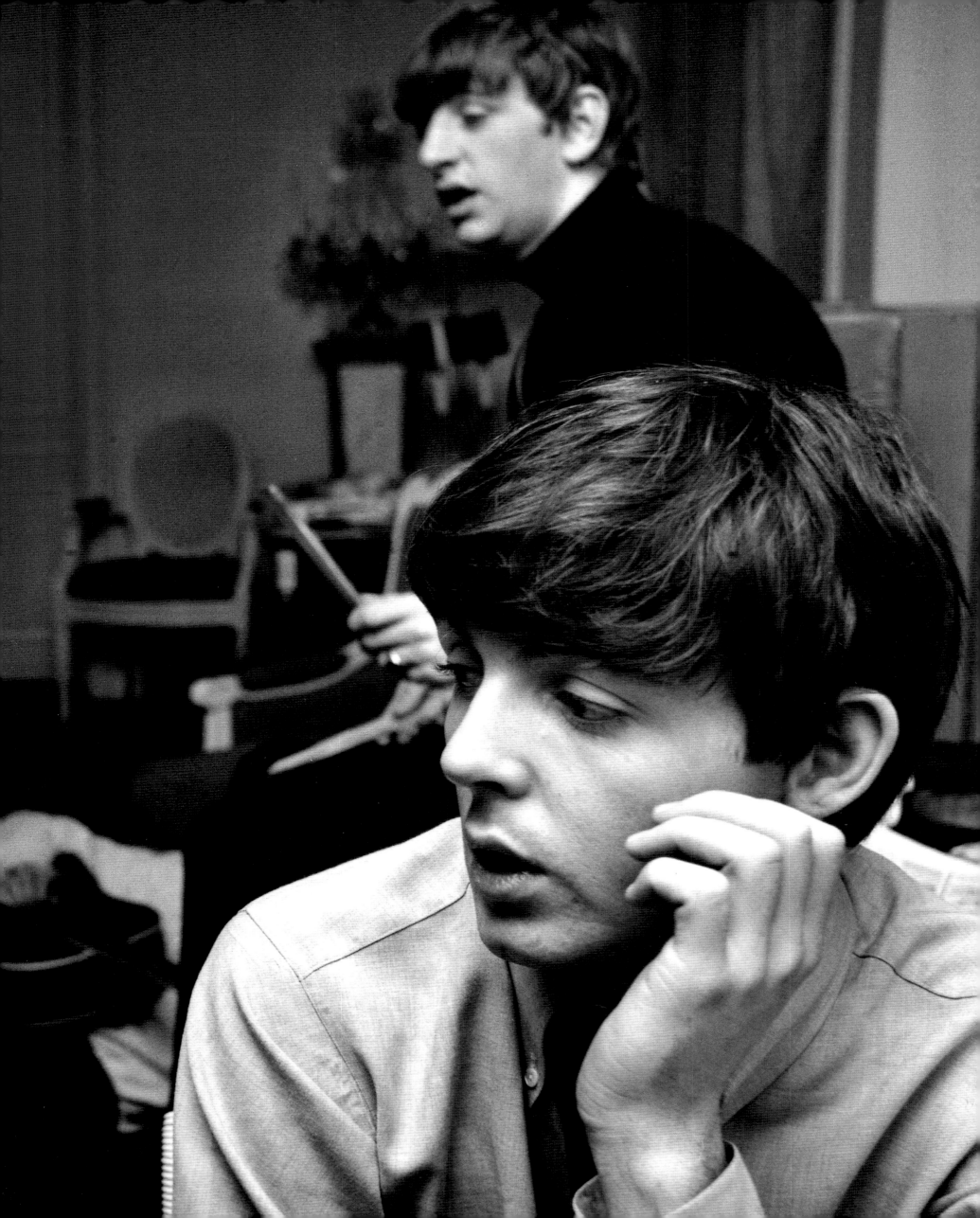

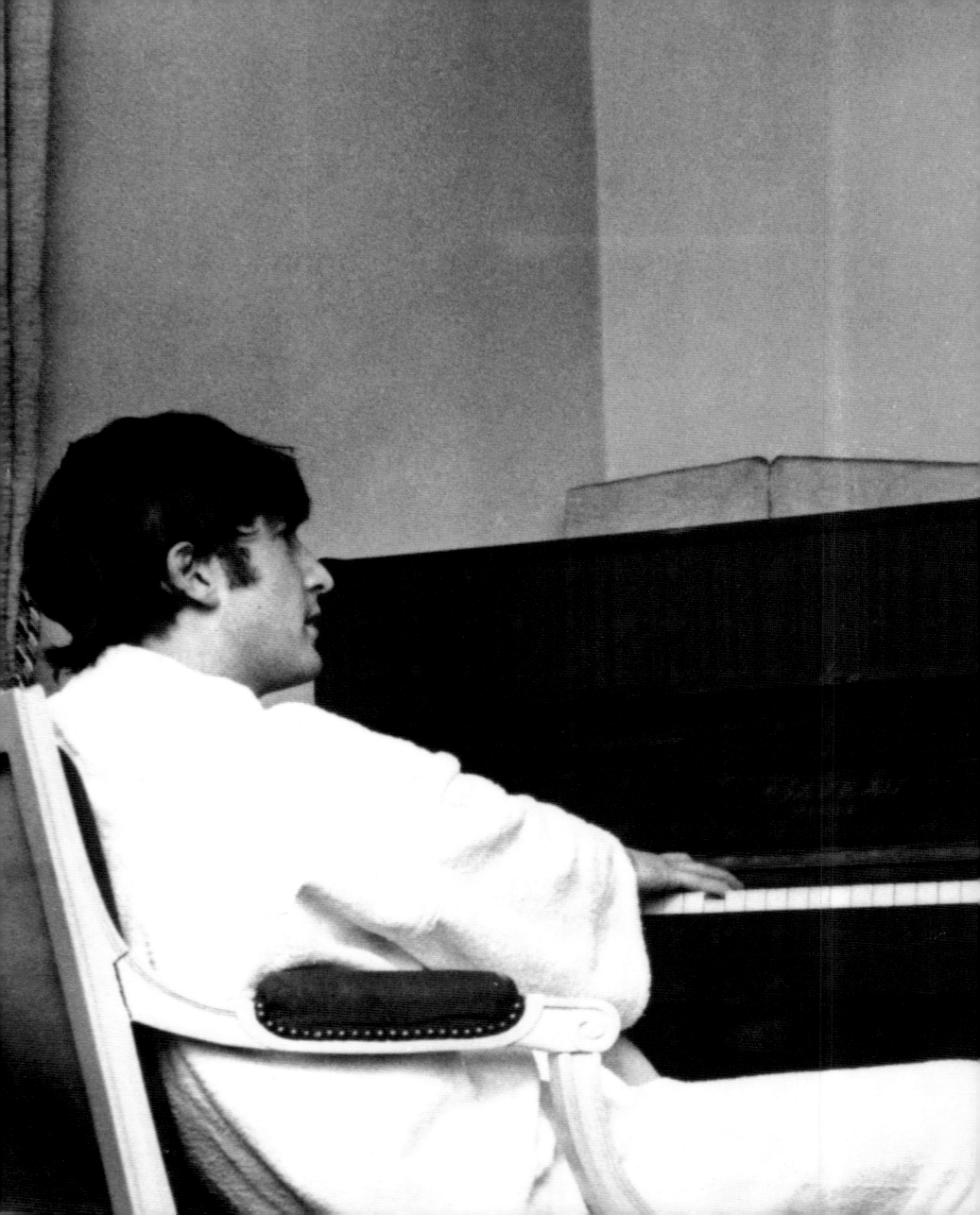

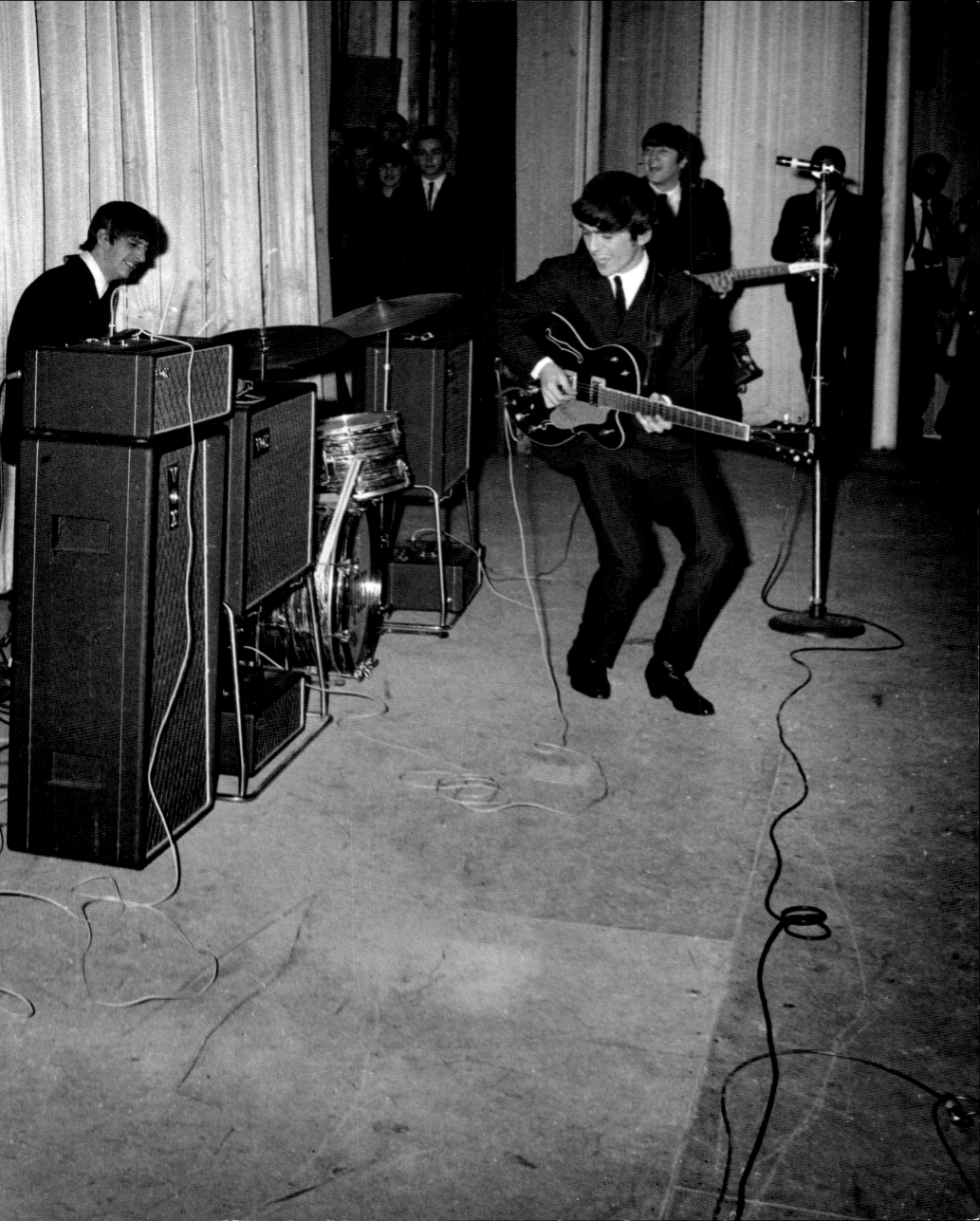

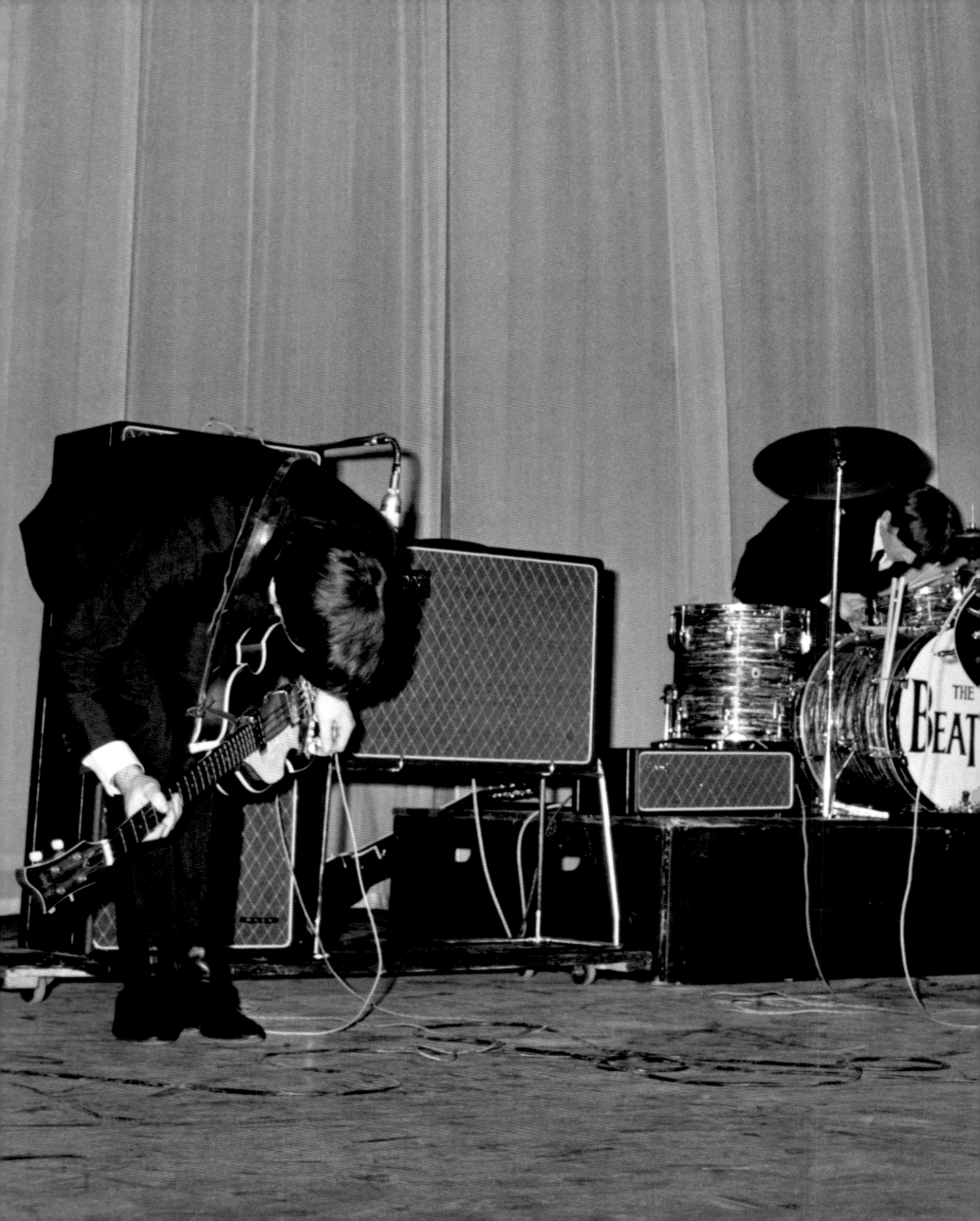

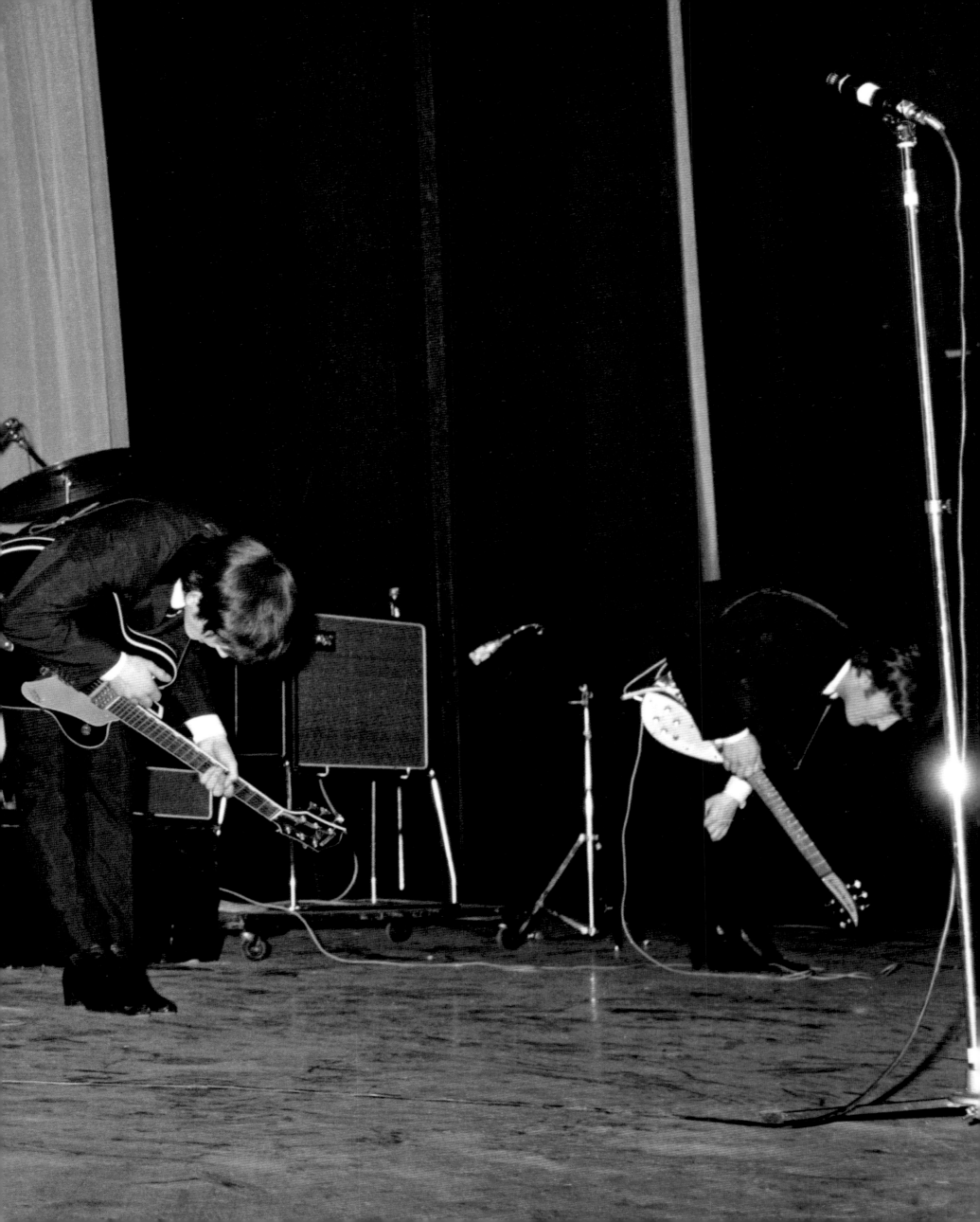

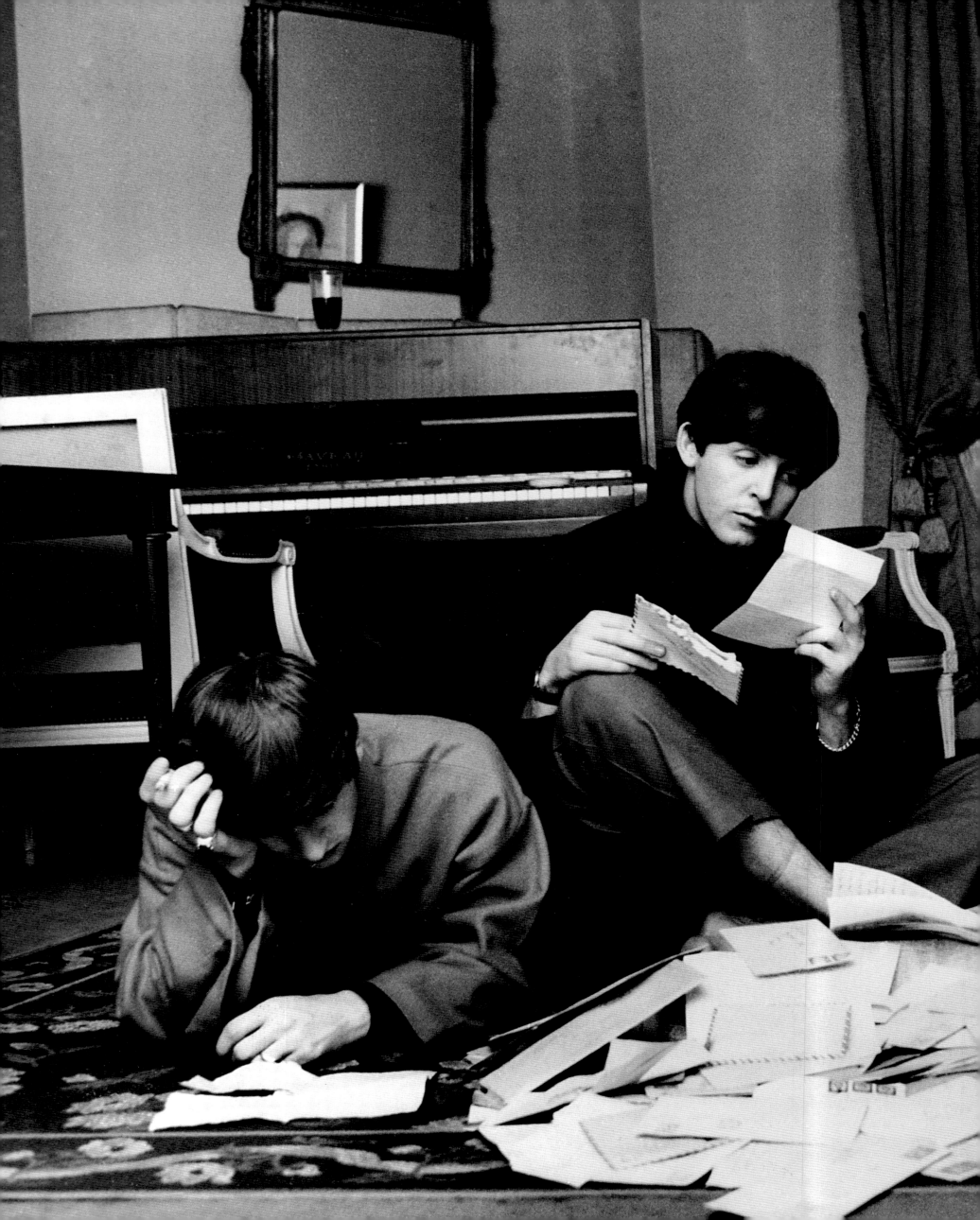

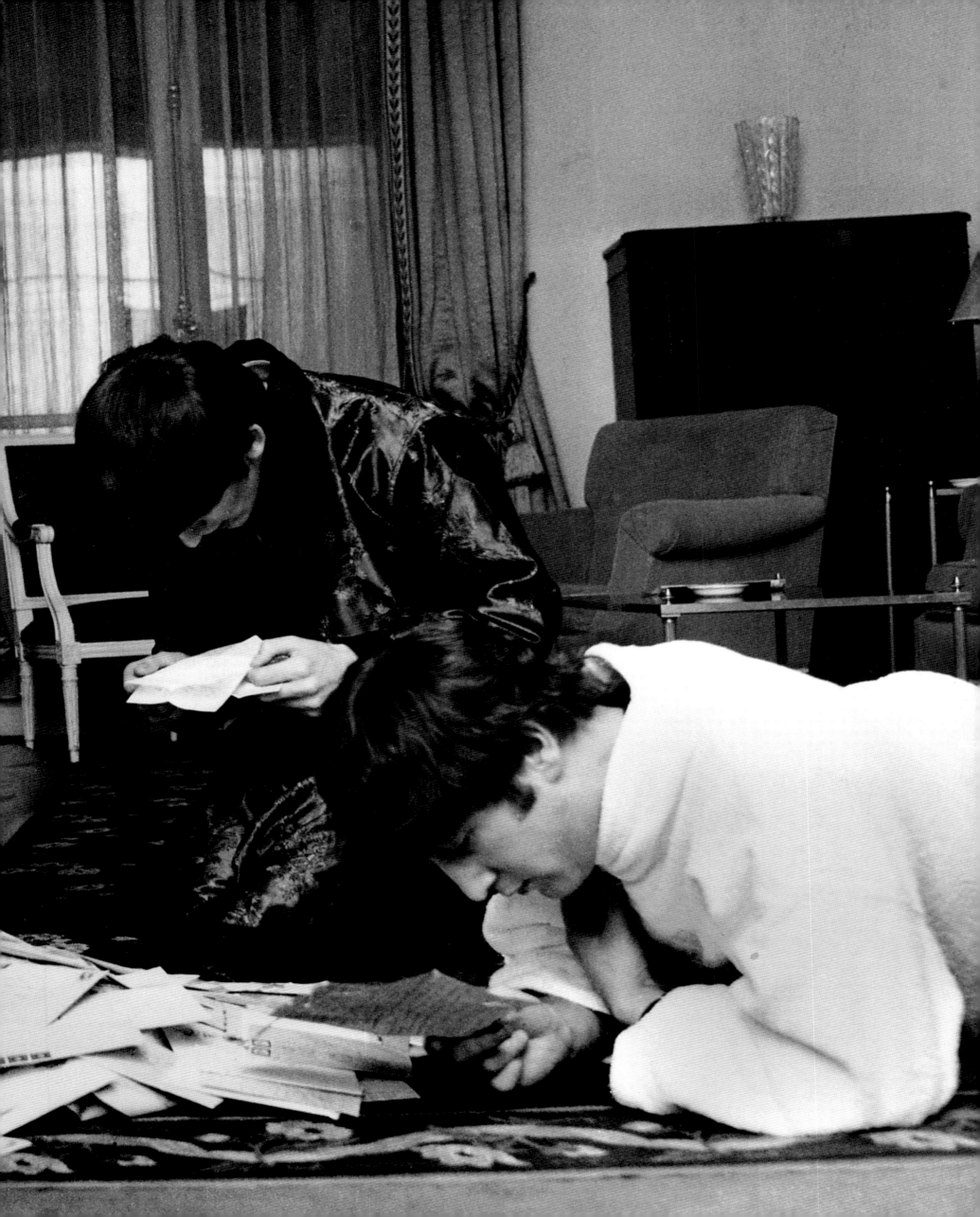

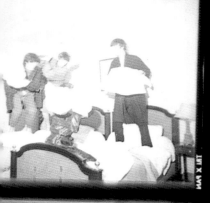
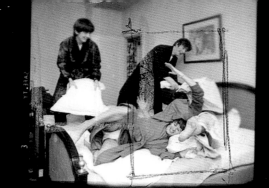
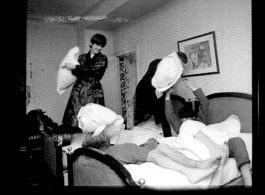
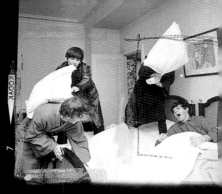
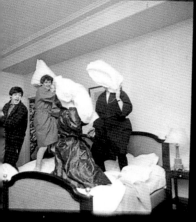
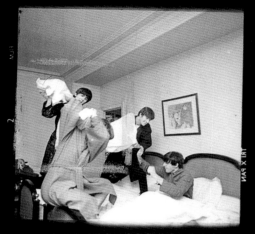
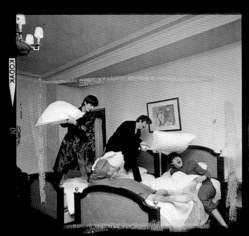
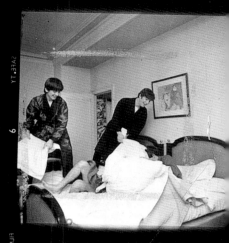
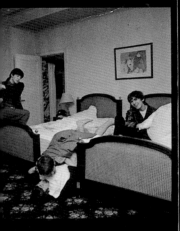
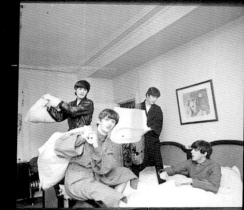
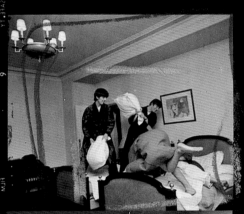
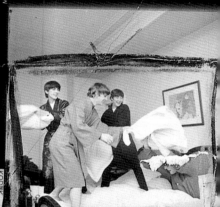
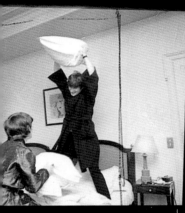
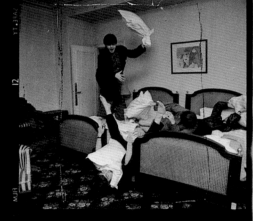
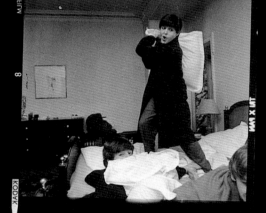
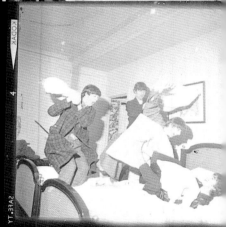
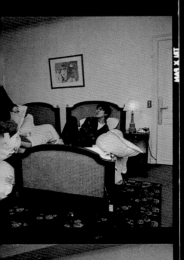
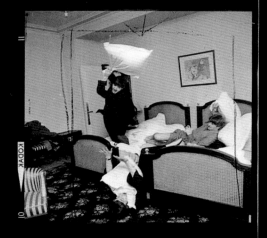
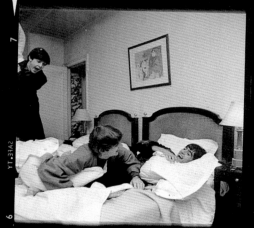

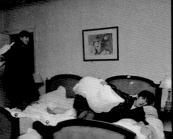
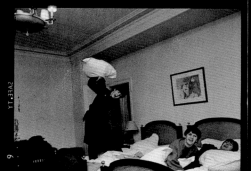
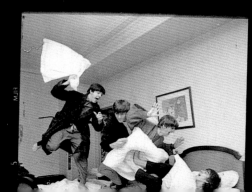
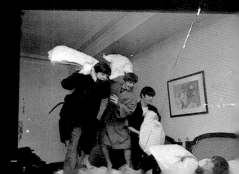

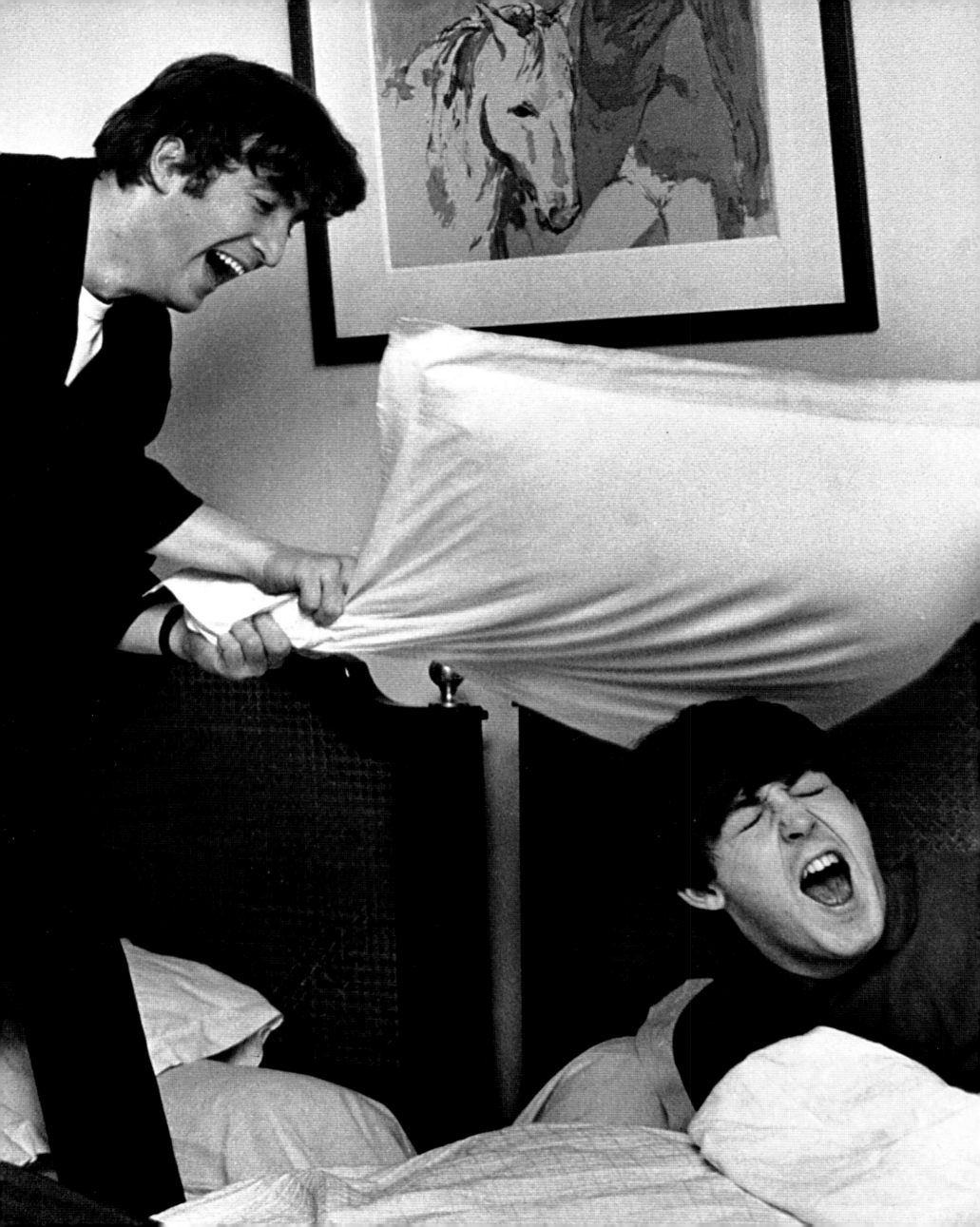

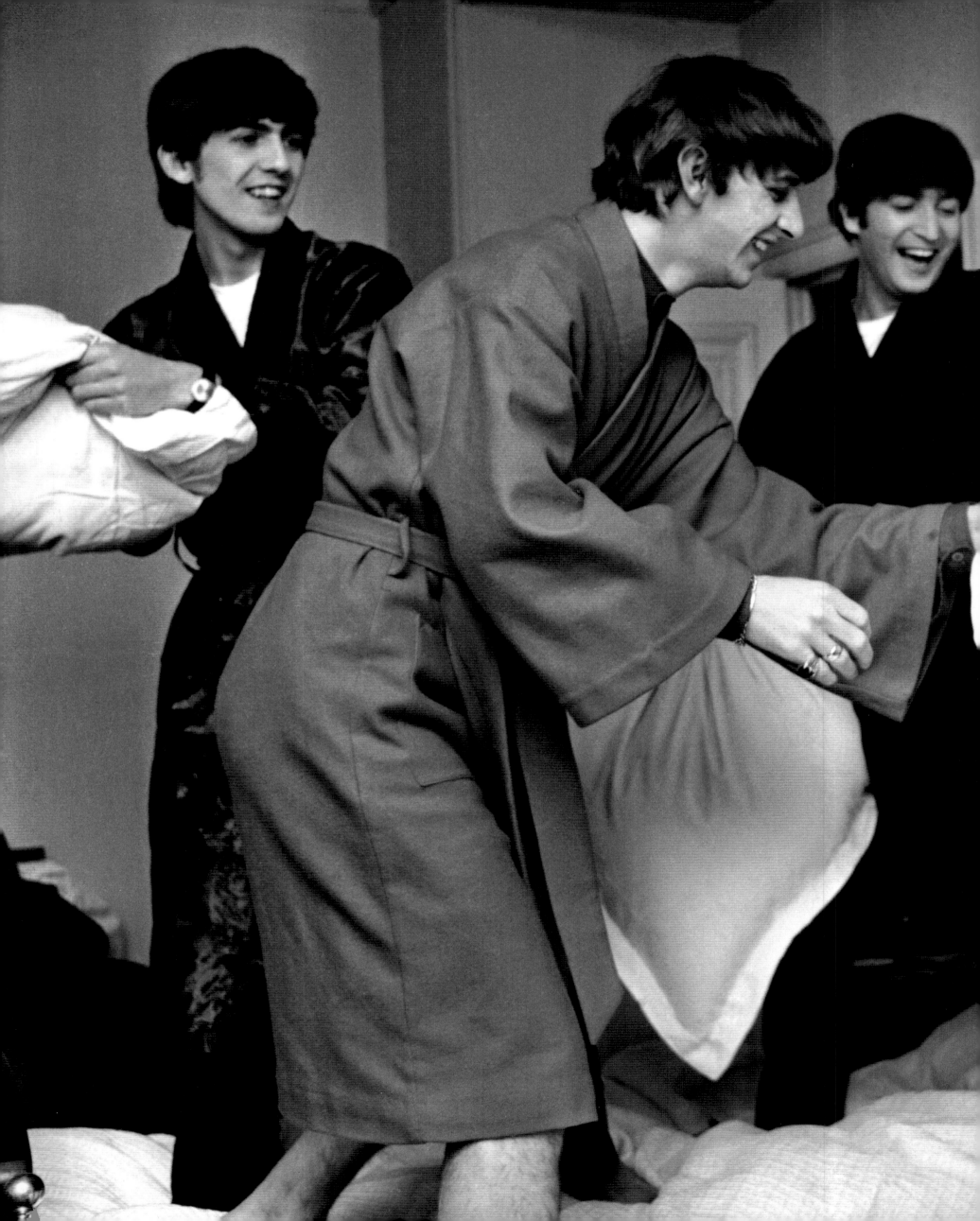

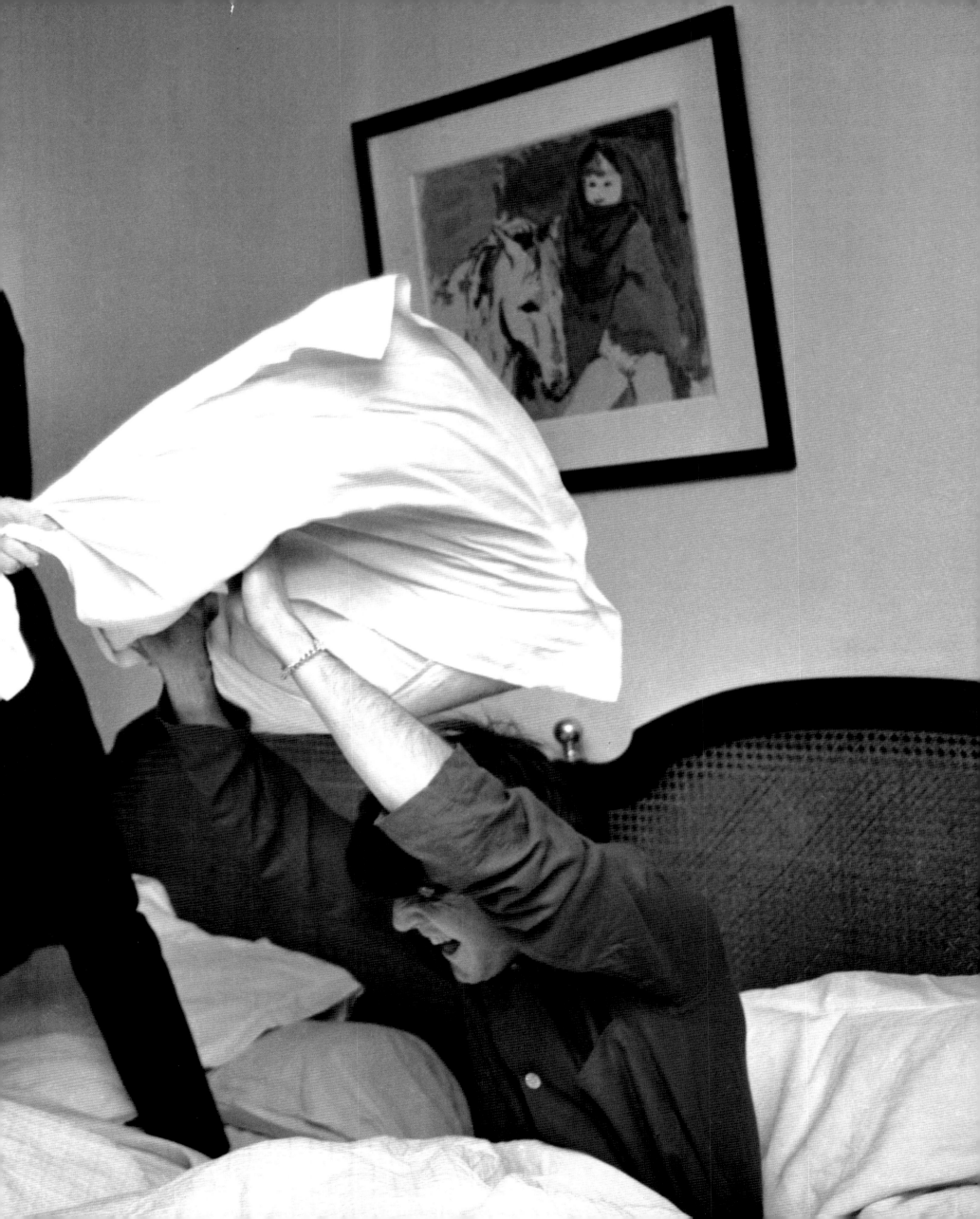

New York
1964

The Beatles' appearances on the Ed Sullivan Show had been arranged by Brian in the fall of 1963, but the excitement surrounding their trip exploded after "I Want to Hold Your Hand" topped the American charts. Pan Am Flight 101 from Heathrow, London, to Idlewild, New York, was the first journey to America for John and his rarely seen wife Cynthia, Paul, Ringo, and many in the Beatles entourage (George had previously been to St. Louis to see his sister). Surprisingly, given that I was already a well-traveled photojournalist, it was my first visit as well. I had always dreamed of making it in America, and my father, who had made a go of it during the Depression and returned disappointed to Glasgow, would say to me, "All distant fields look green." Years later, after I had moved to New York, I once said to him on a visit home, "You know, dad, they are green." ☙ Certainly the gray tarmac at Idlewild on the afternoon of February 7, 1964, looked to us like the greenest field in creation. I was behind the four Beatles when we disembarked and I had asked them to wave up at me for a picture. They almost forgot, but Ringo remembered and made them turn around. The crowds of screaming girls holding welcoming signs—some with the word *Beatles* misspelled—had been held back behind police barriers, so there was no hysteria on the ground. I didn't bother to develop the film. I threw it in a bag in my closet and found it again about fifteen years ago. I'm glad I did, as it was an historic day. ☙ Brian was very concerned about the New York press, out in force to greet us. After all, a few months before no one in America had been interested in the Beatles and now, with the success of "I Want to Hold Your Hand," everyone wanted to talk to them. Capital Records worked with Epstein's people to orchestrate the greeting at the airport, and he wanted the Beatles to live up to the expectations and anticipation. They did not disappoint him. They were sensational. They could think on their feet and answered reporters' questions with quick-witted one-liners. If one was stuck for an answer, another would chime in and make everyone laugh. Asked why they thought they were so popular, Paul fumbled with "We don't know, really," and John rescued him, saying, "If we knew, we'd form another group and be managers." Ringo scored a big laugh when the group was asked what they thought about Beethoven. "Great. Especially his poems." They were having a good time with their newfound success. Brian was relieved, especially for his drummer, not long with the band, as he confided to me over a coffee that night: "I was very worried about Ringo not being able to fit in, but he's doing just fine." ☙ New York's Plaza Hotel was under tight security so the fans could not get past the guards at the elevators. One girl sneaked up and got into George's bedroom. She was quite attractive, too. I was in the room at the time, along with a few other people, when she was carried out. I was moving into a room on their floor when I too almost got thrown out by one of the hotel staff, but George saved me, saying, "You can't take him away, he's with us." ☙ Beatlemania was much more powerful in New York than it had been in Paris. The swarms of fans had been waiting a long time in the cold outside the Plaza Hotel when we rushed to the limousine on the way to the Ed Sullivan Theater two days later. The five of us were crammed into the back—the limos were not as large then as they are now. Girls rushed up screaming and touching the windows. ☙ I believe the fact that there were four of them helped the Beatles deal with their growing fame. You'd think one might be envious, but I wouldn't have wished their life on anyone. Aside from furtive outings after dark, they were virtual prisoners inside the hotel. To try to keep from being bored they ordered room service all the time. Food, liquor, soft drinks. They later remarked that they had seen America from looking out of hotel and car windows. At least Epstein, who doted on them, made sure that they had the best suites in the best hotels, with fresh flowers and fruit in the sitting rooms. ☙ The Americans seemed both delighted and disturbed by the Beatles' long hair, and merchandisers capitalized on the obsession by producing hundreds of thousands of Beatles wigs. Ed Sullivan got one from someone in the audience and put it on his head while warming up the crowd before the show began. It was estimated that over seventy-three million people saw the Beatles that Sunday night, performing on a set cleverly constructed of arrows that pointed in their direction. When they began to sing, girls in the audience started to scream, and the rest of us could hardly hear. After the show there was still the nervous tension from being on stage. Back in the hotel they crashed in Brian's protective presence, trying to unwind, away from the loud confusion of the screaming fans. ☙

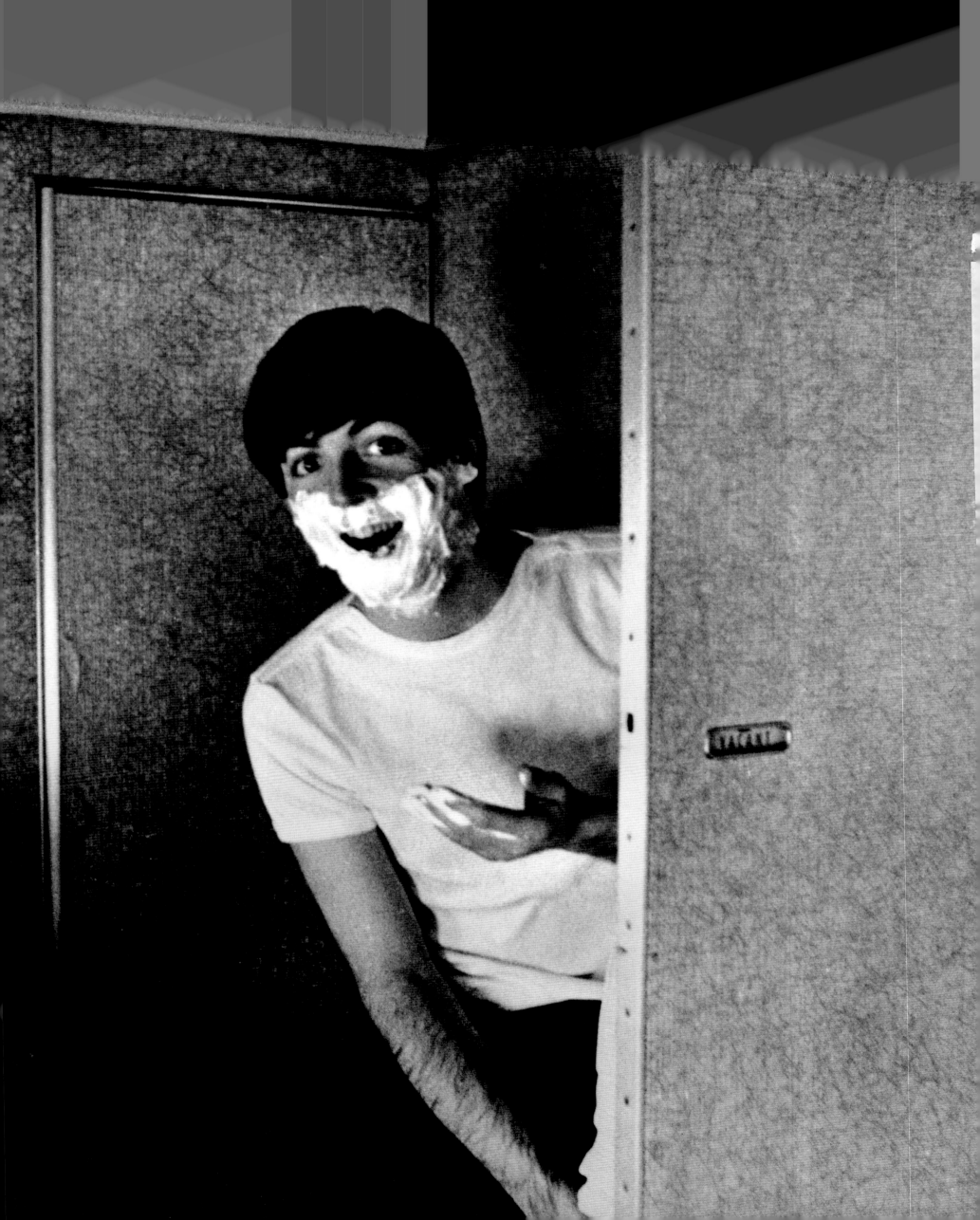

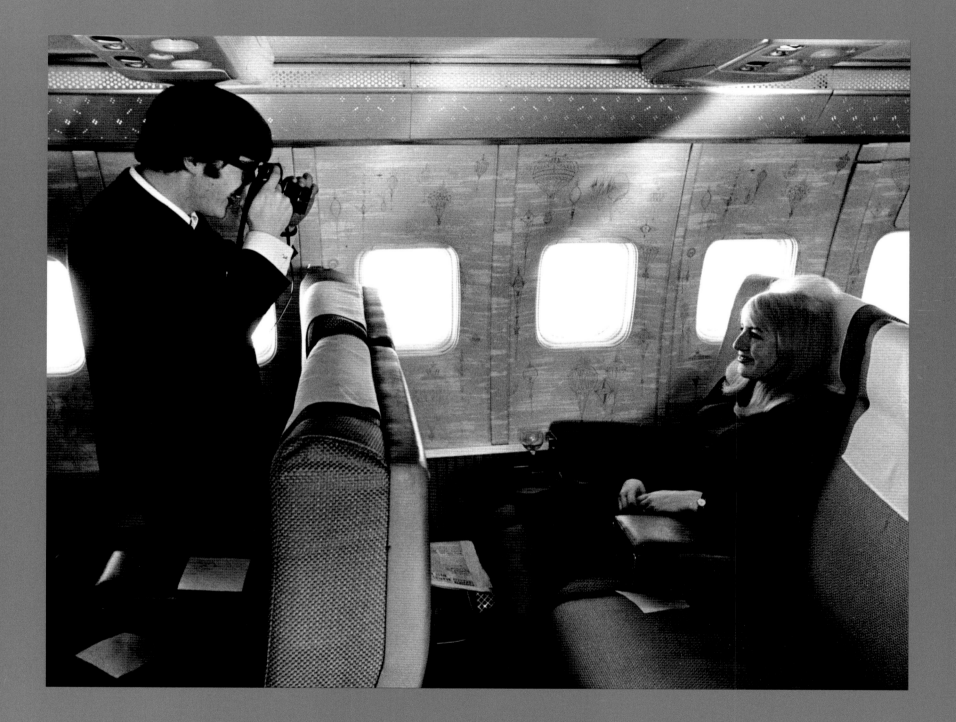

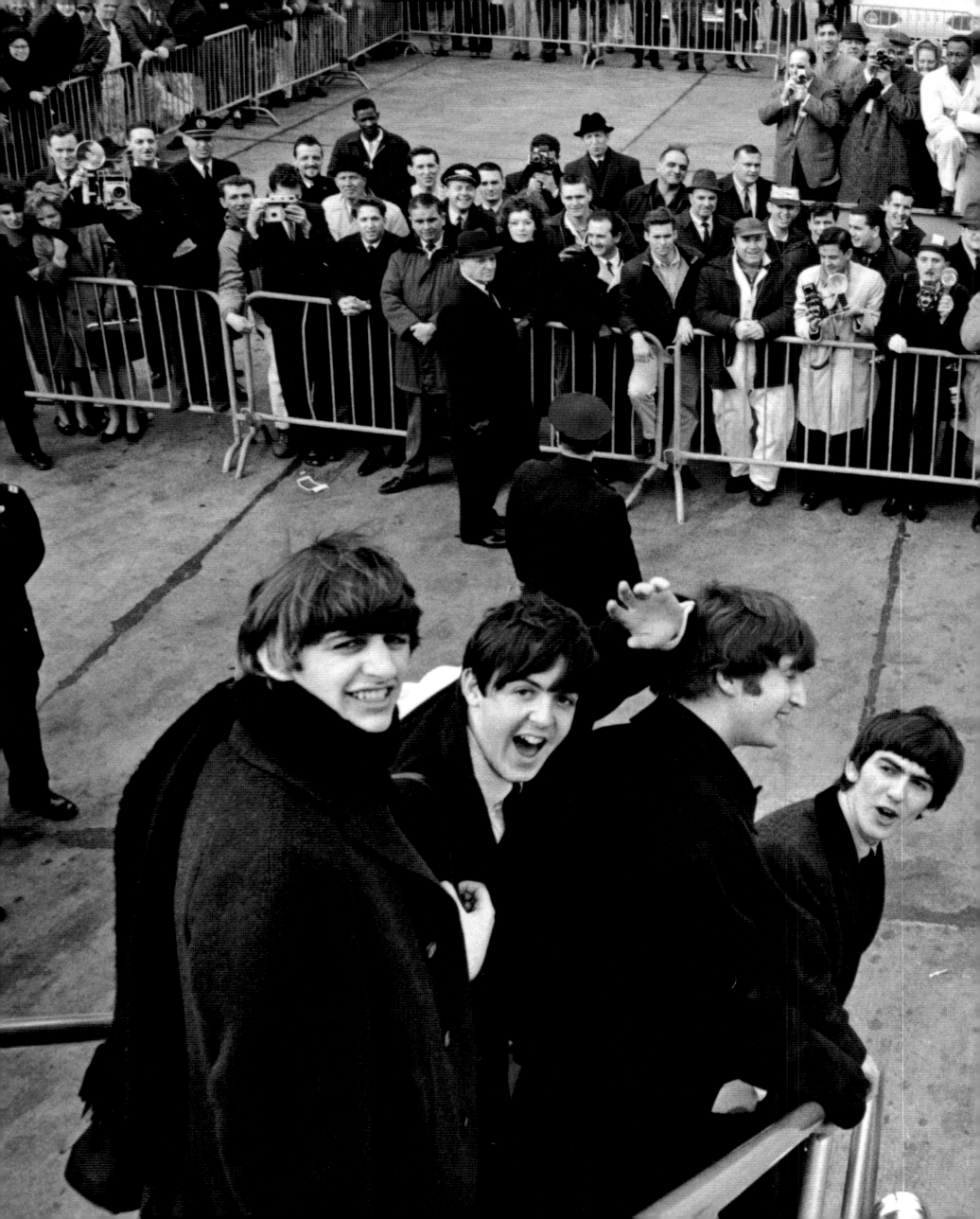

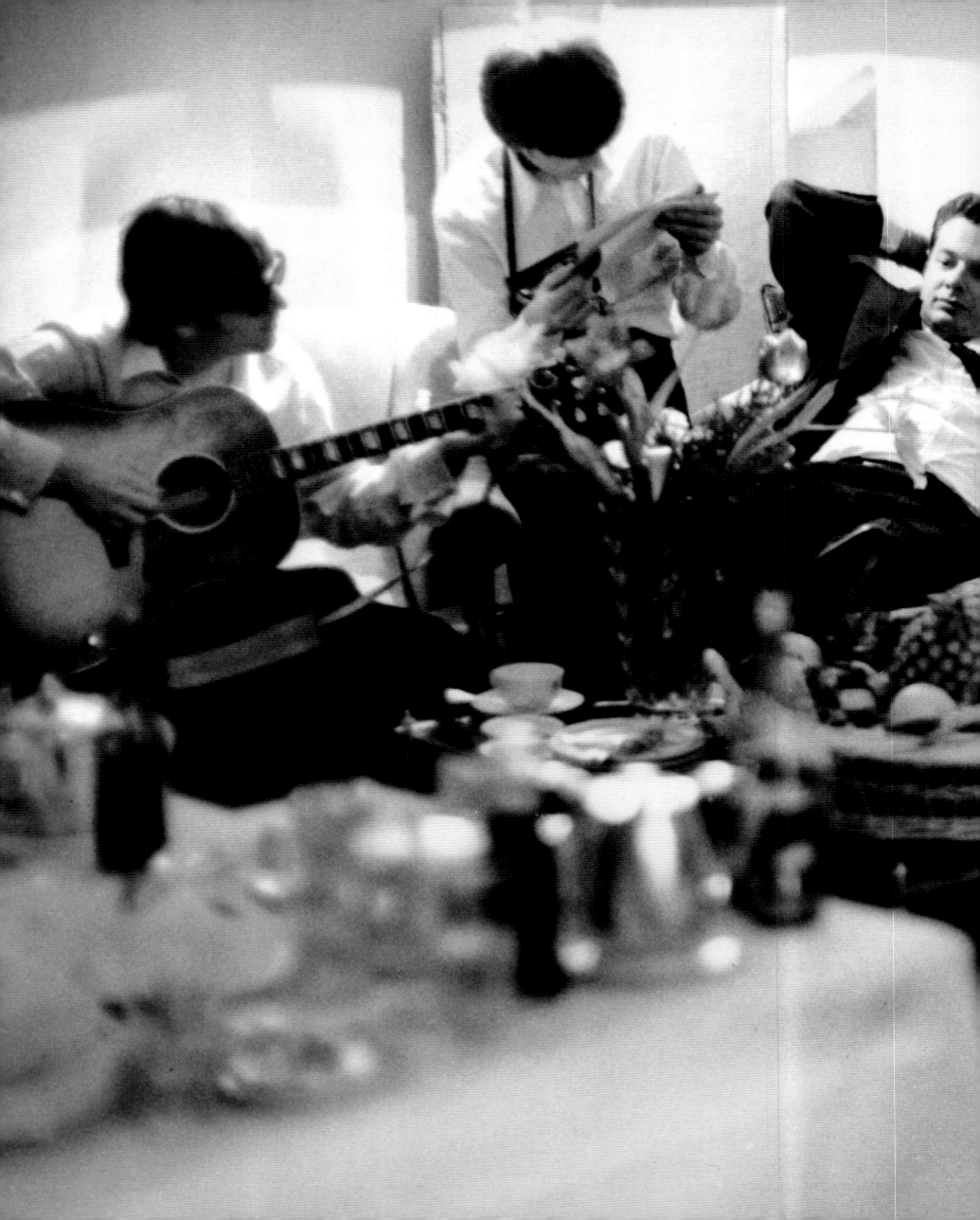

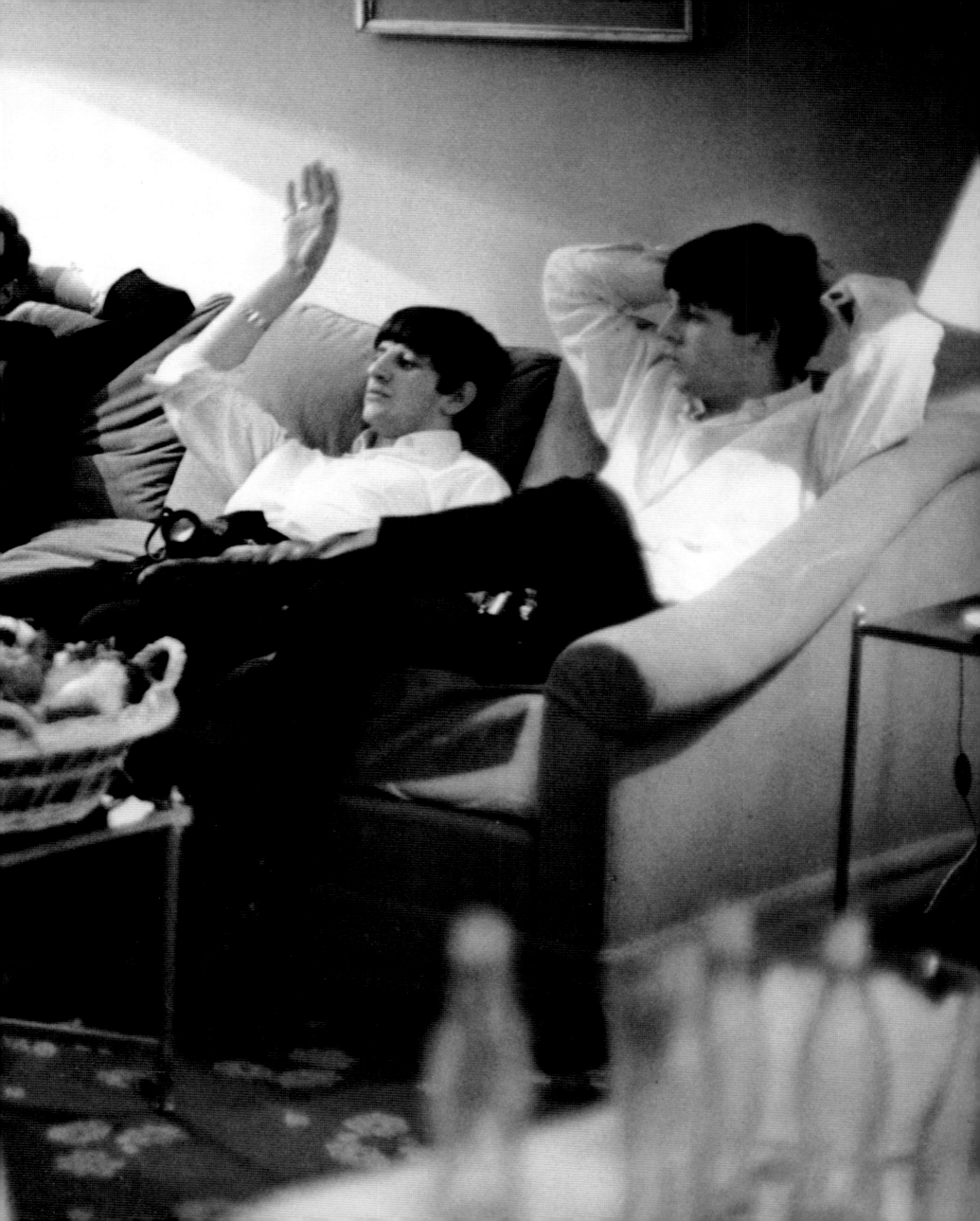

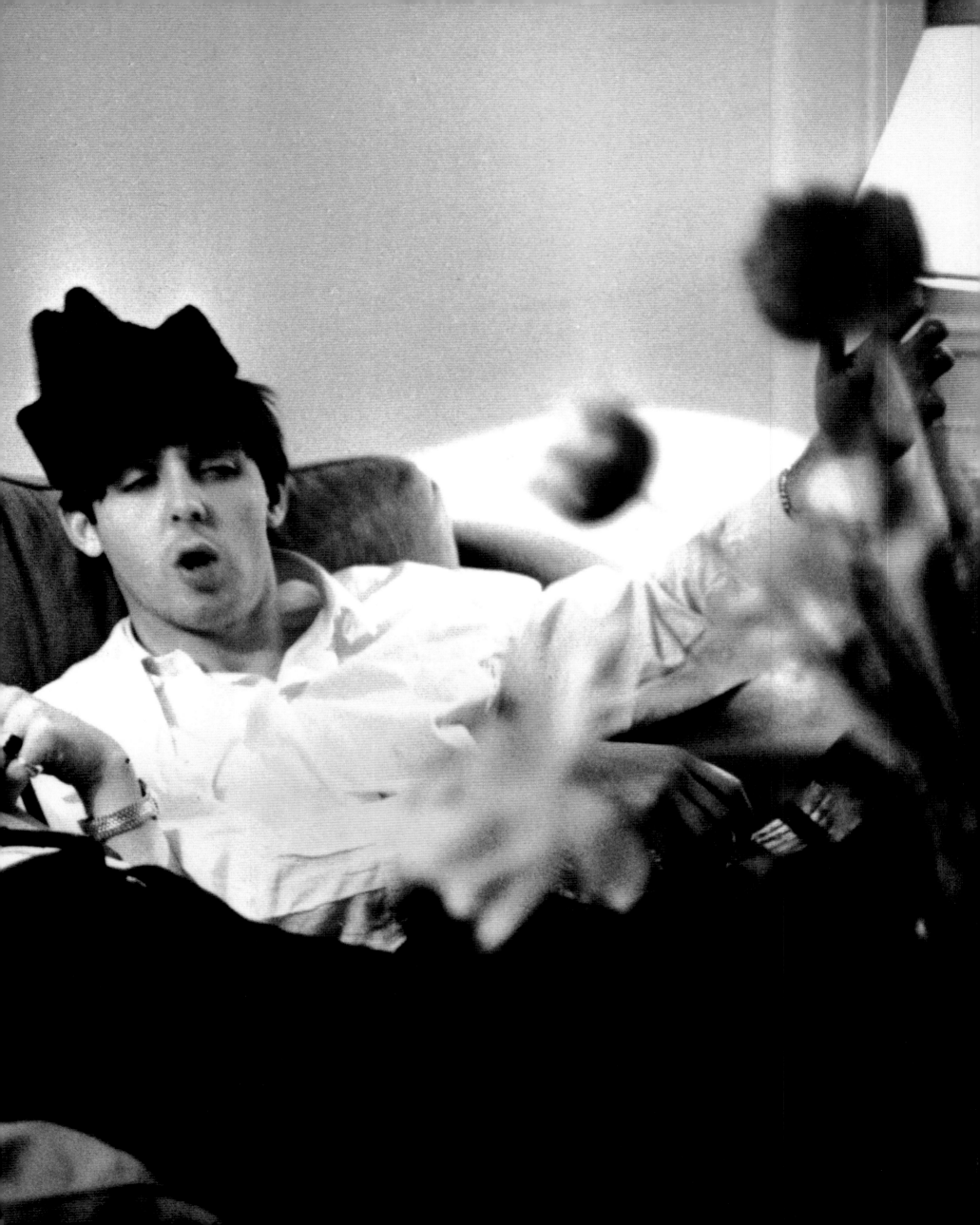

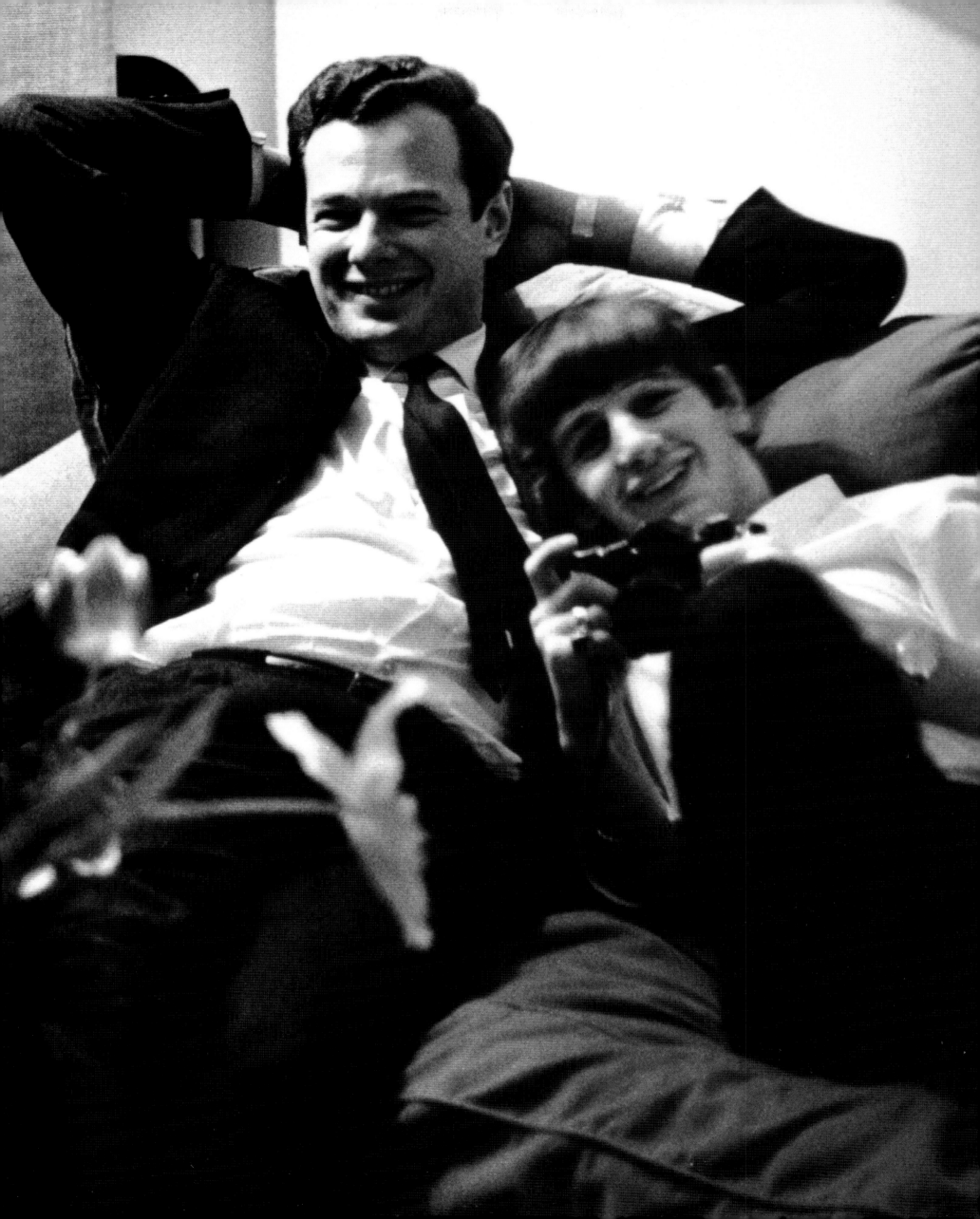

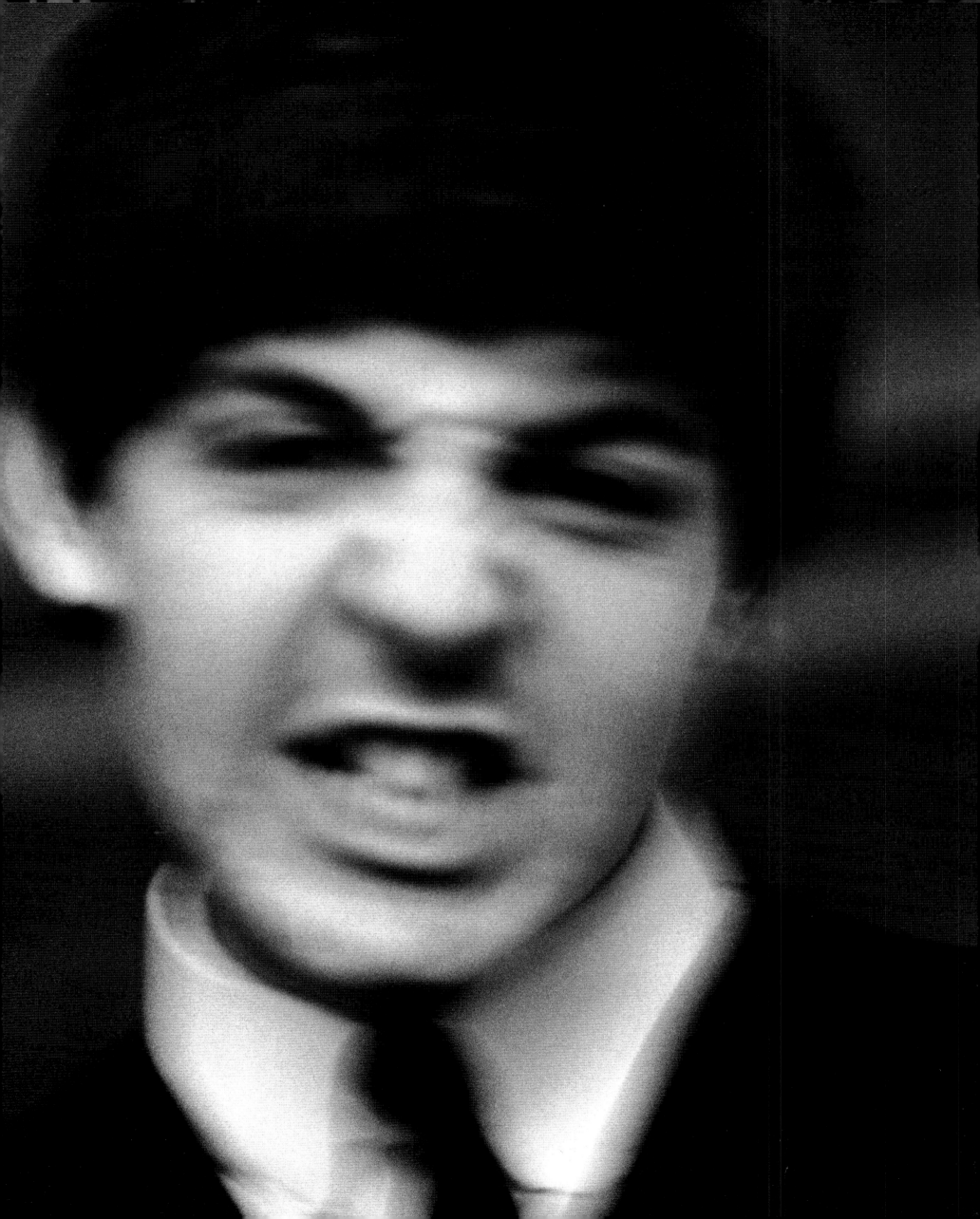

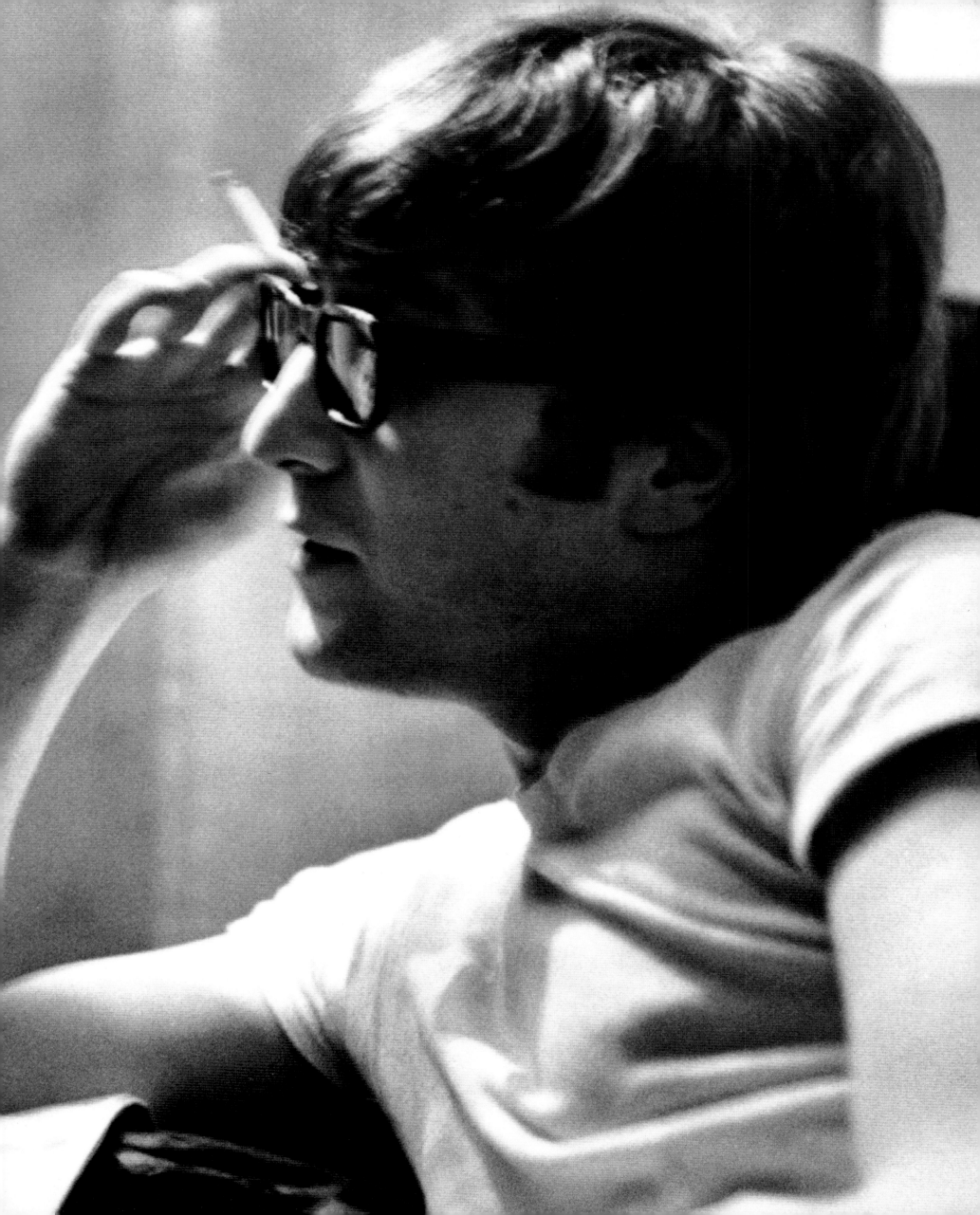

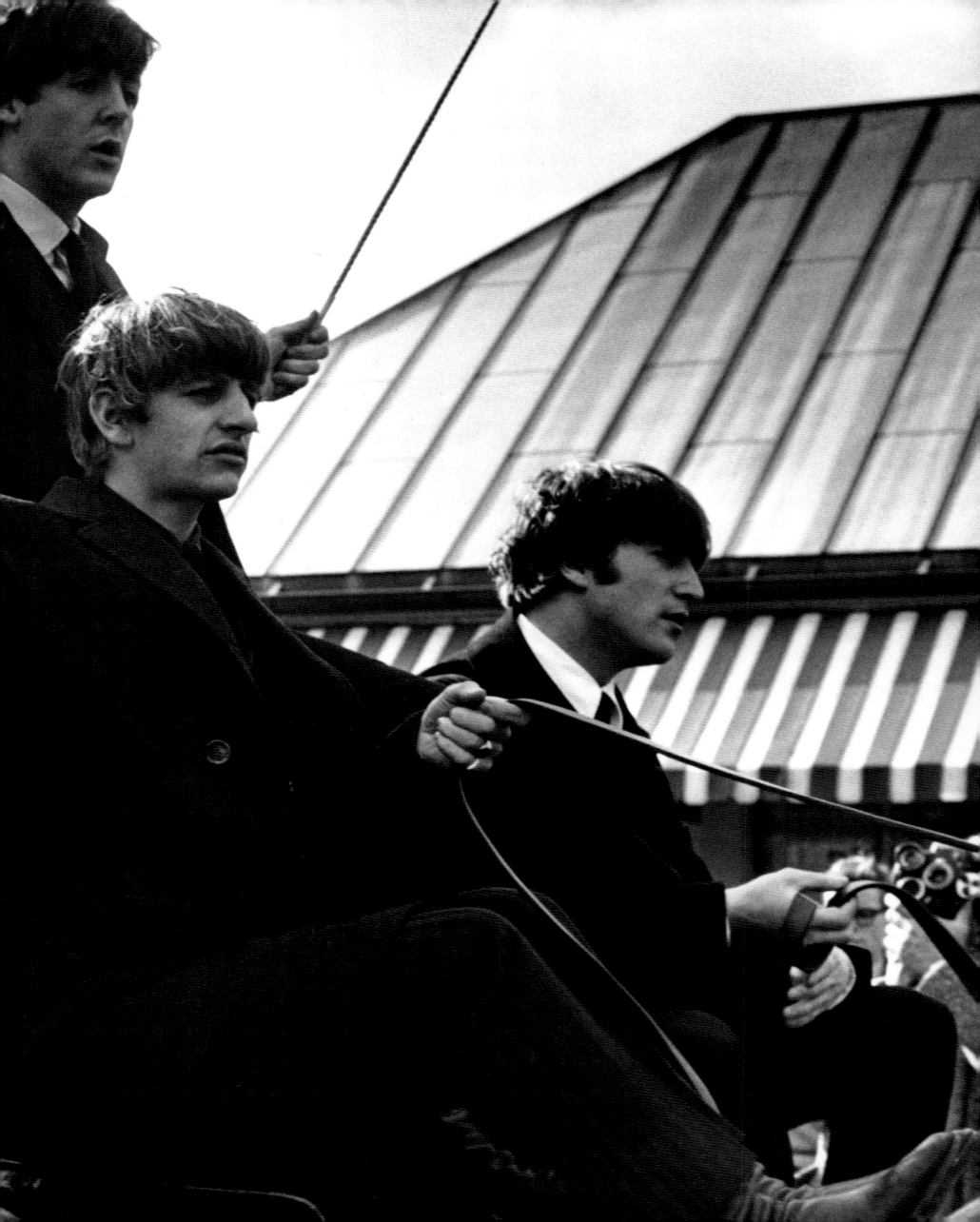

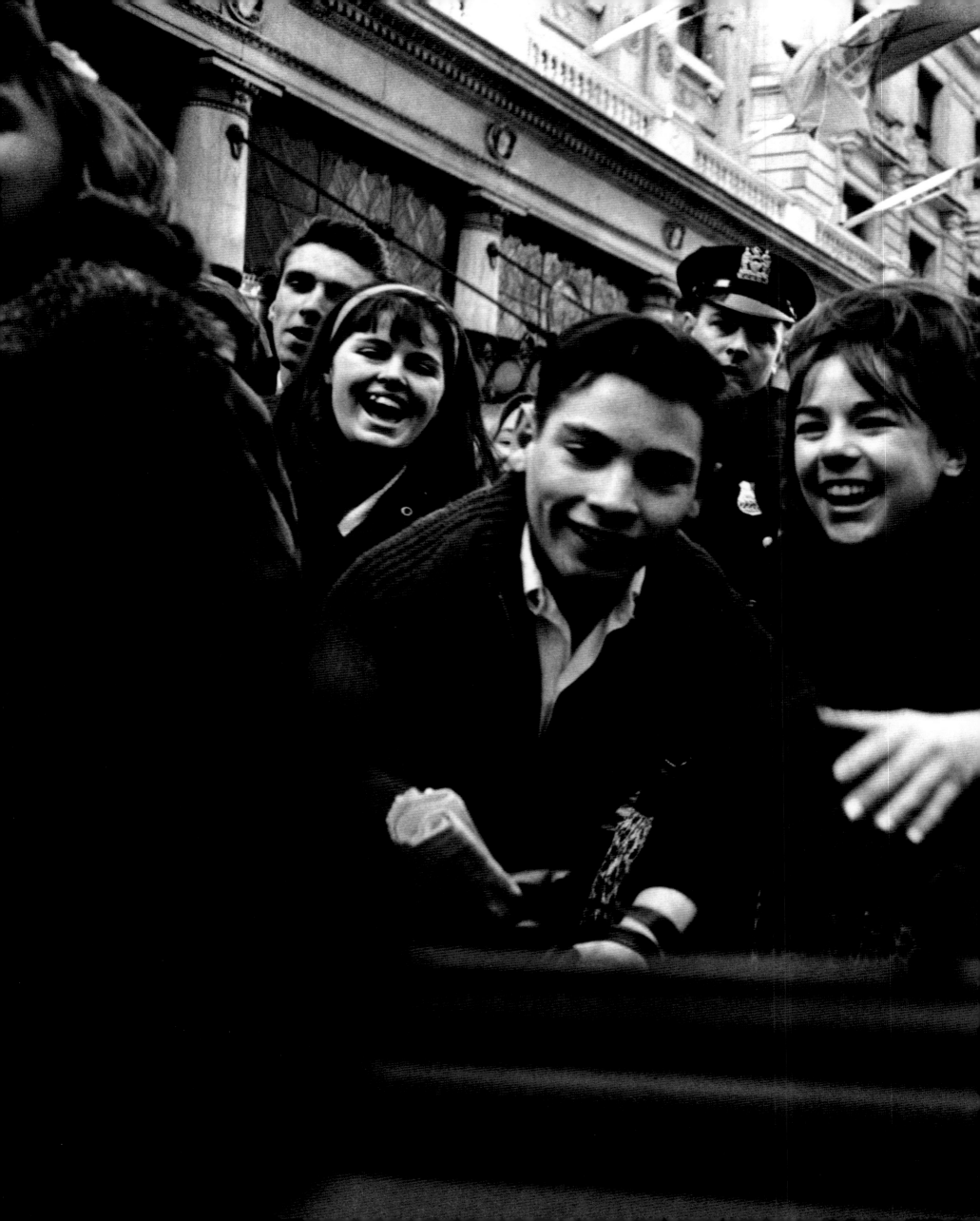

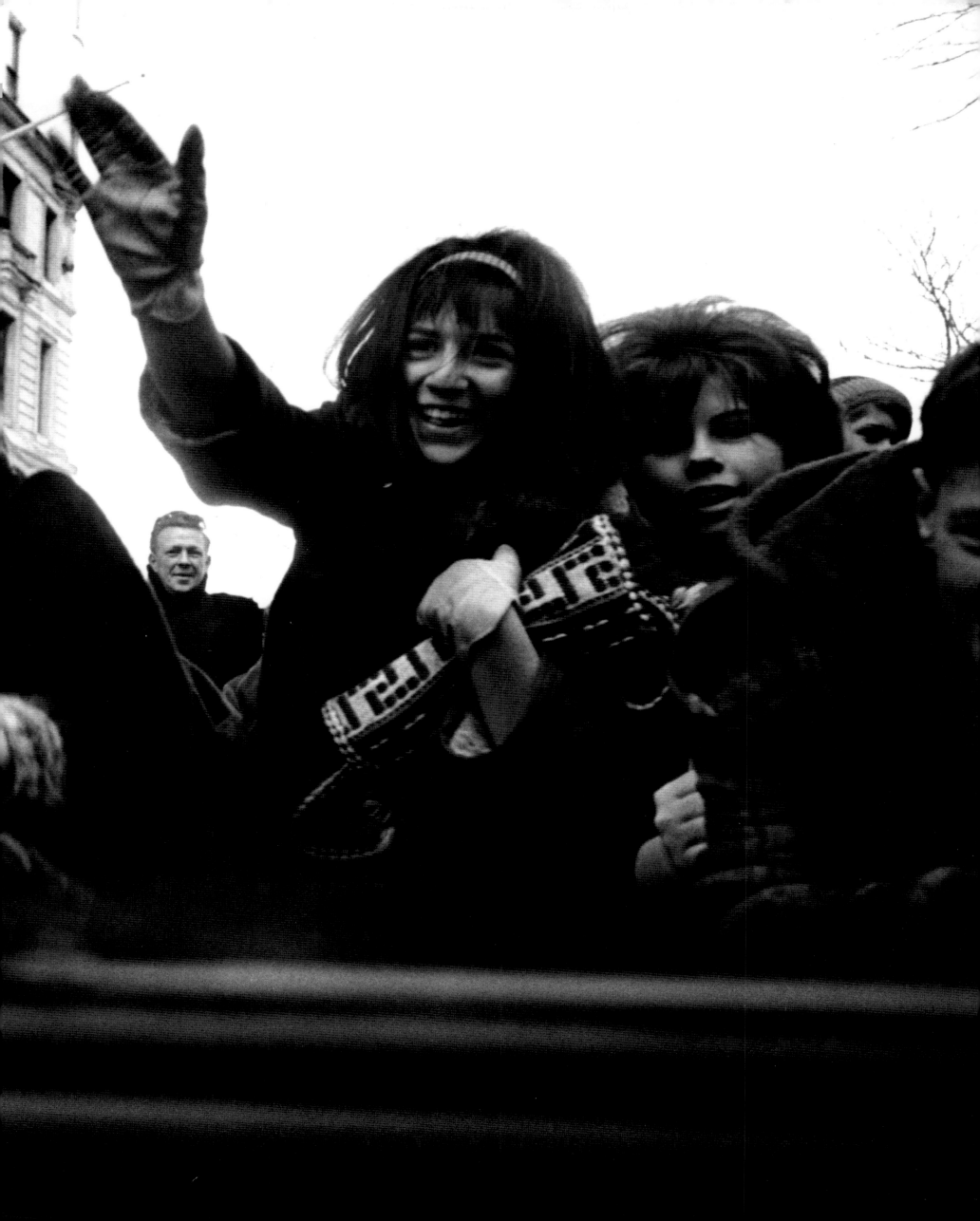

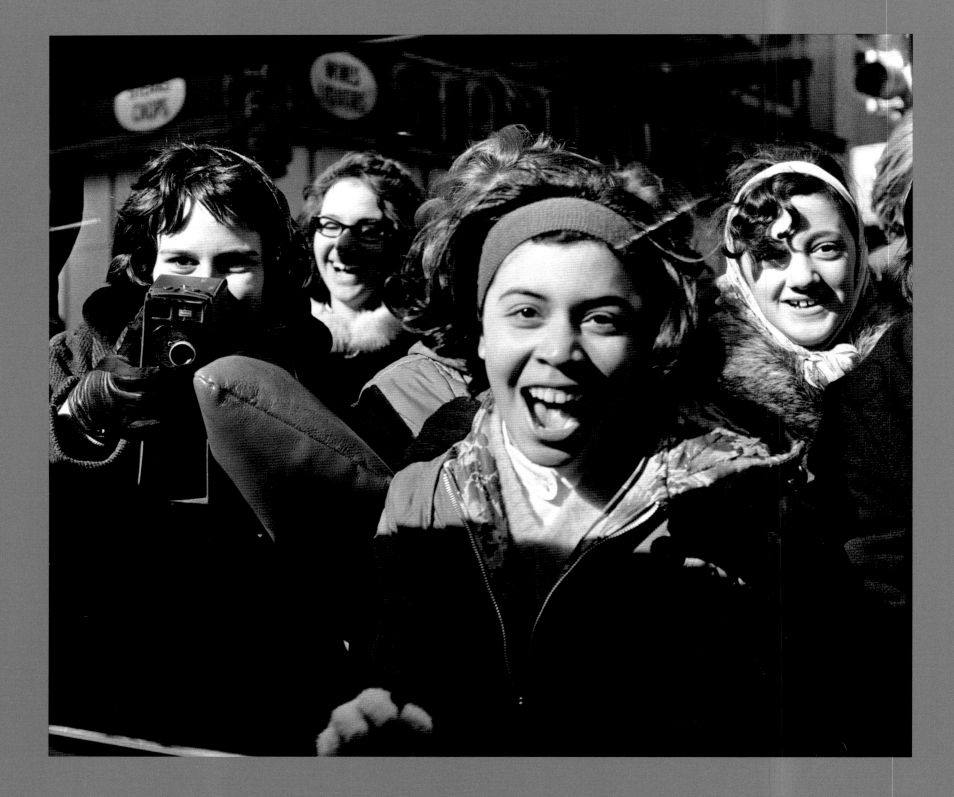

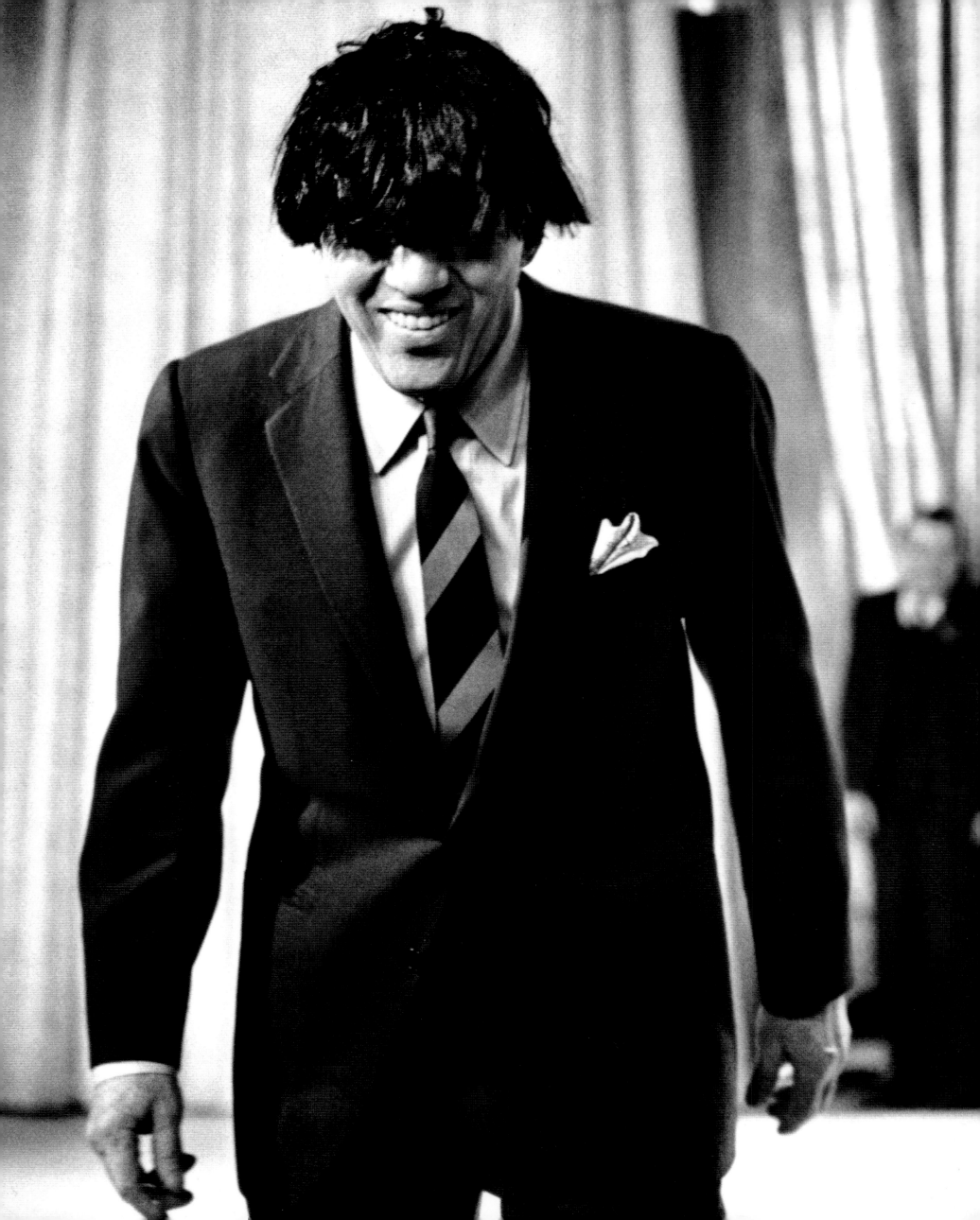

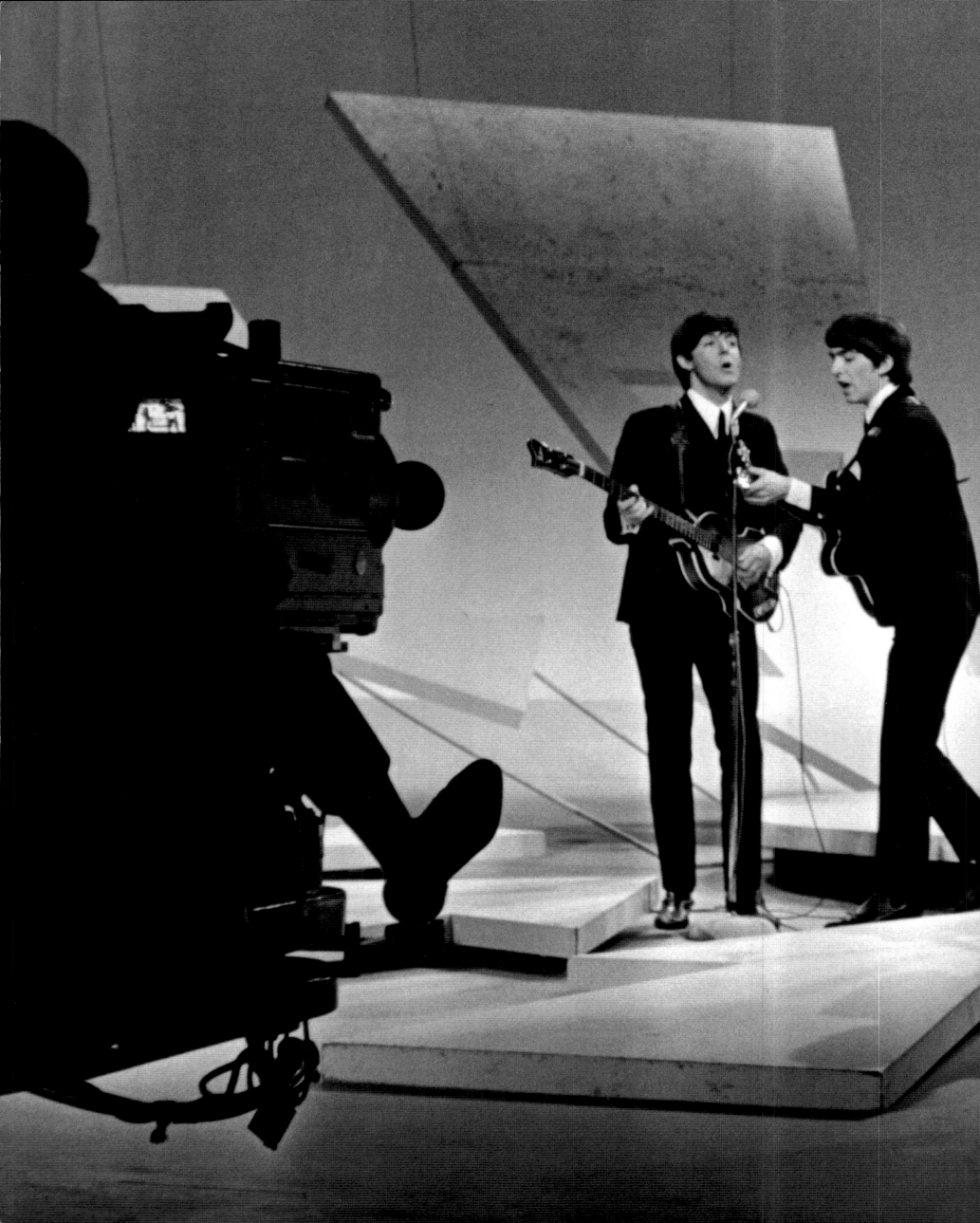

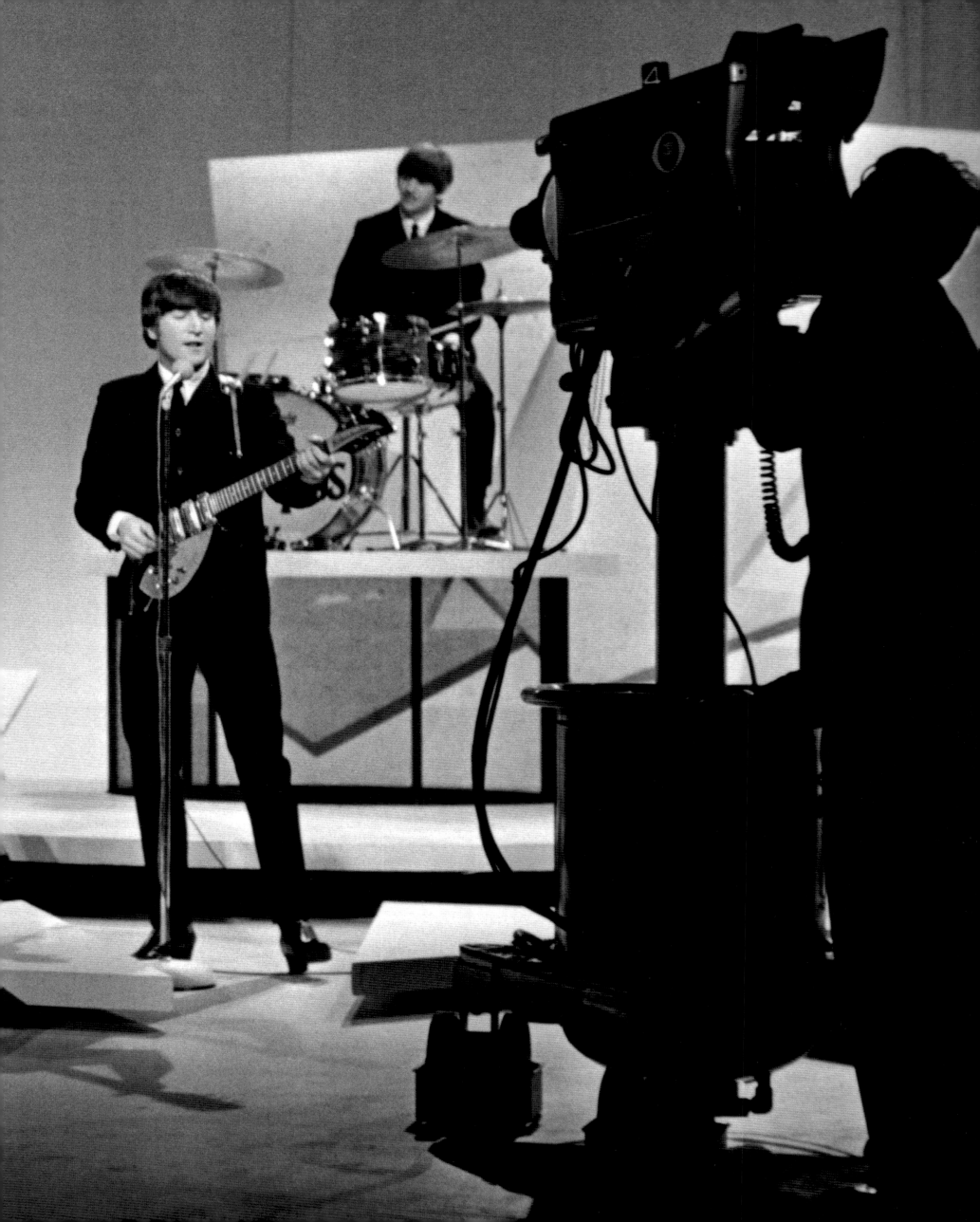

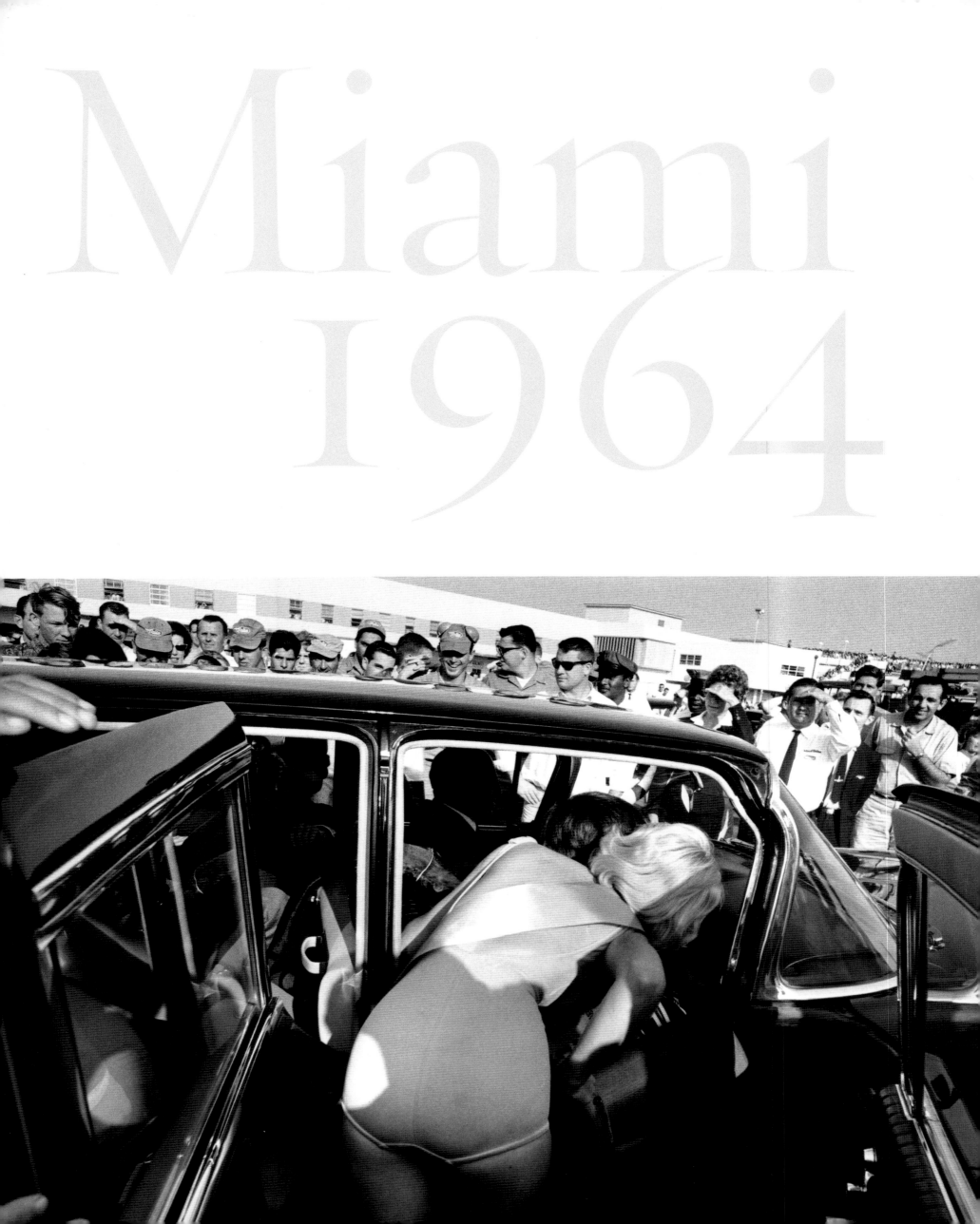

The Beatles' schedule was hectic after their first Ed Sullivan Show appearance. In a blizzard, we took a train to Washington, D.C. for a performance at the Washington Coliseum and a party at the British Embassy at which some people were rude (there was an uproar and the British ambassador later called the Beatles to apologize for his guests' behavior). Then back to New York for a concert at Carnegie Hall, before flying to Miami on February 13 for their second appearance on the Ed Sullivan Show. ❧ At the Miami airport, four local beauty-pageant winners in swimsuits met the Beatles and followed them through the terminal, smothering them with kisses, until the cops stepped in and freed them as the girls tried to climb into their limos. The crowds were calm and giggly and very polite. We settled into the Deauville Hotel, and someone sent over matching terrycloth jackets and swimsuits, which the Beatles wore for their romp on the beach. We were all overwhelmed by the sunshine, the palm trees, and the beautiful blue-green water. We thought we had arrived in paradise. ❧ At rehearsals in the hotel's Mau Mau Club, the Beatles were very polite and deferential toward Sullivan, hardly the wisecracking bunch already familiar from their press conferences. They would say things like, "Is this where you want us to stand, Mr. Sullivan?" They knew when to grovel. I can still hear Sullivan in his distinctive voice introducing them as, "Those nice young men from Liverpool." Almost seventy-five million viewers watched the live broadcast from the hotel on February 16. ❧ It was my idea to put them together with Cassius Clay. While we were cooped up in the hotel, I had plenty of time to watch TV, and there was Clay, shouting and spouting off poems, preparing for his title fight in Miami with the heavyweight boxing champion of the world, Sonny Liston. Here was some-one the Beatles should meet. When I suggested this to the Beatles, John, who also must have been watching the pre-fight coverage, said he didn't want to meet the challenger who was going to lose the fight. The Beatles wanted to meet the champ, Sonny Liston. I knew I could get them into Clay's gym and I had a journalist's intuition that Clay would make a far better story, but I gamely went to Liston's gym and introduced myself to Willie Reddish, one of his seconds, who told me I'd better ask Sonny himself about that. While wrapping his hands with bandages, Liston didn't even look up at me as he said he didn't want to meet those "bums." There was no point in trying to change his mind. ❧ The Beatles were expecting to see Liston on February 18, when I took them to the gym where Clay was working out. The boxer was ready for them. He completely controlled the occasion. He ordered them around the ring, shouting, "Lie down. Stand up. Who's the most beautiful?" He called Paul the pretty one, but said, "You're not as pretty as me." In the car on the way back to the hotel, John turned to me and said, "That man made a fool of us and it's your fault, Benson." They stayed mad at me for a month. ❧ It didn't matter to me. I had lots of other assignments coming up. While the Beatles headed back to England, I went off to Jamaica to photograph Ian Fleming, the author of the James Bond novels, at his home Goldeneye. I was back in Miami on February 25 to cover the Clay-Liston fight. When Liston failed to come out of his corner in the seventh round, there was a new heavyweight champion, who christened himself Muhammad Ali that very night. A few months younger than Ringo and John, and a few months older than Paul and George, Ali was destined to become one of a handful of individuals of their generation who could reasonably claim an equal share of fame and accomplishment. ❧

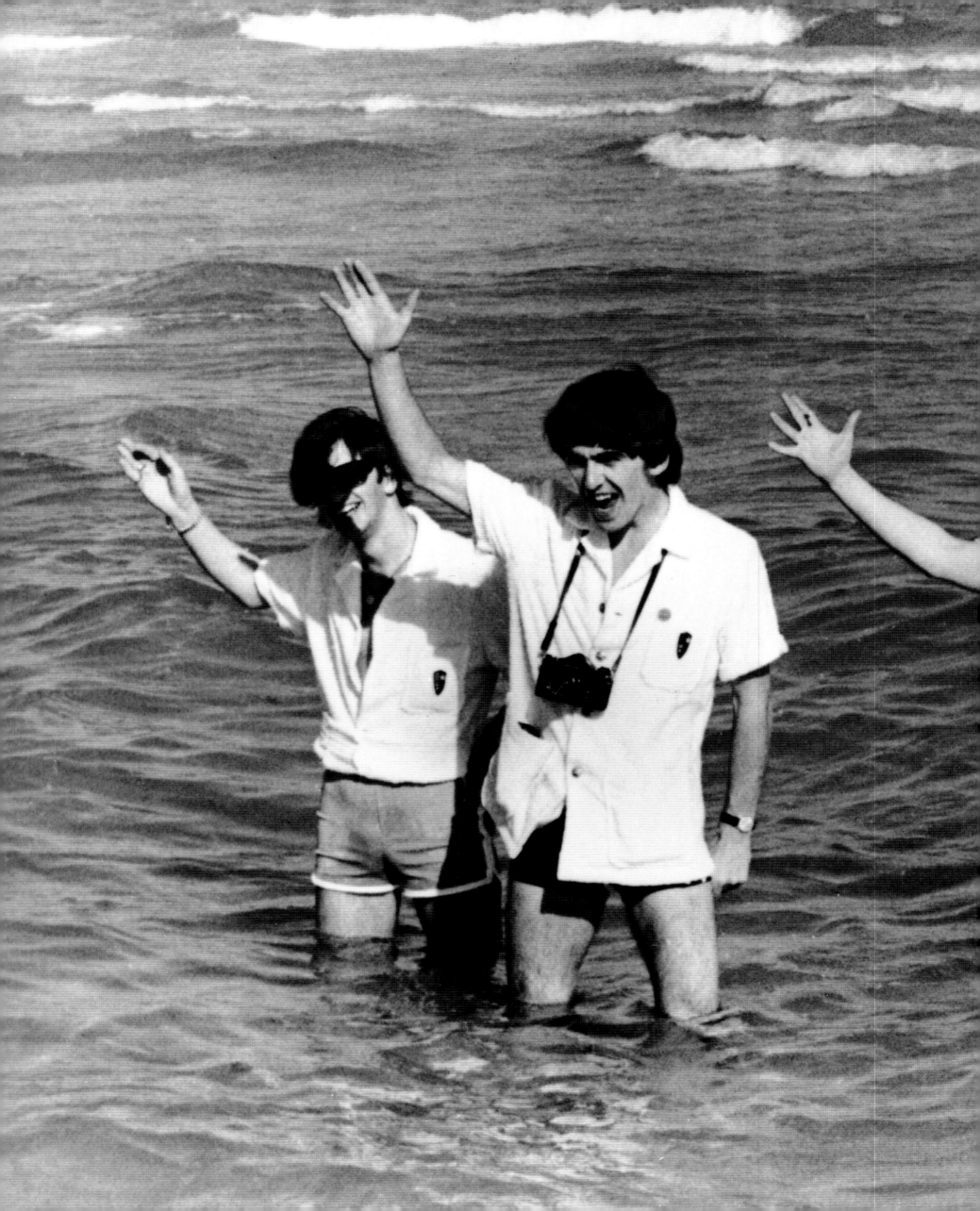

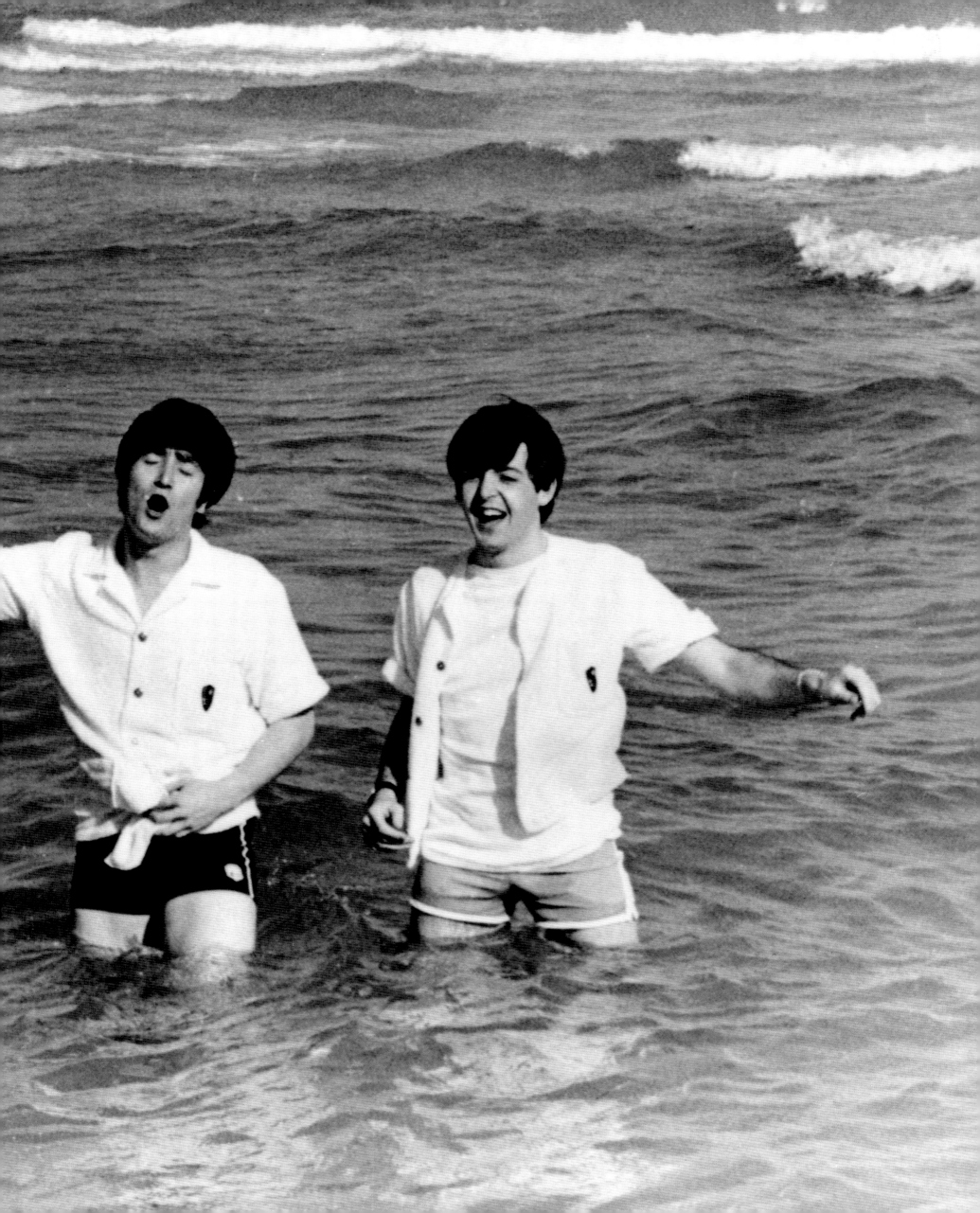

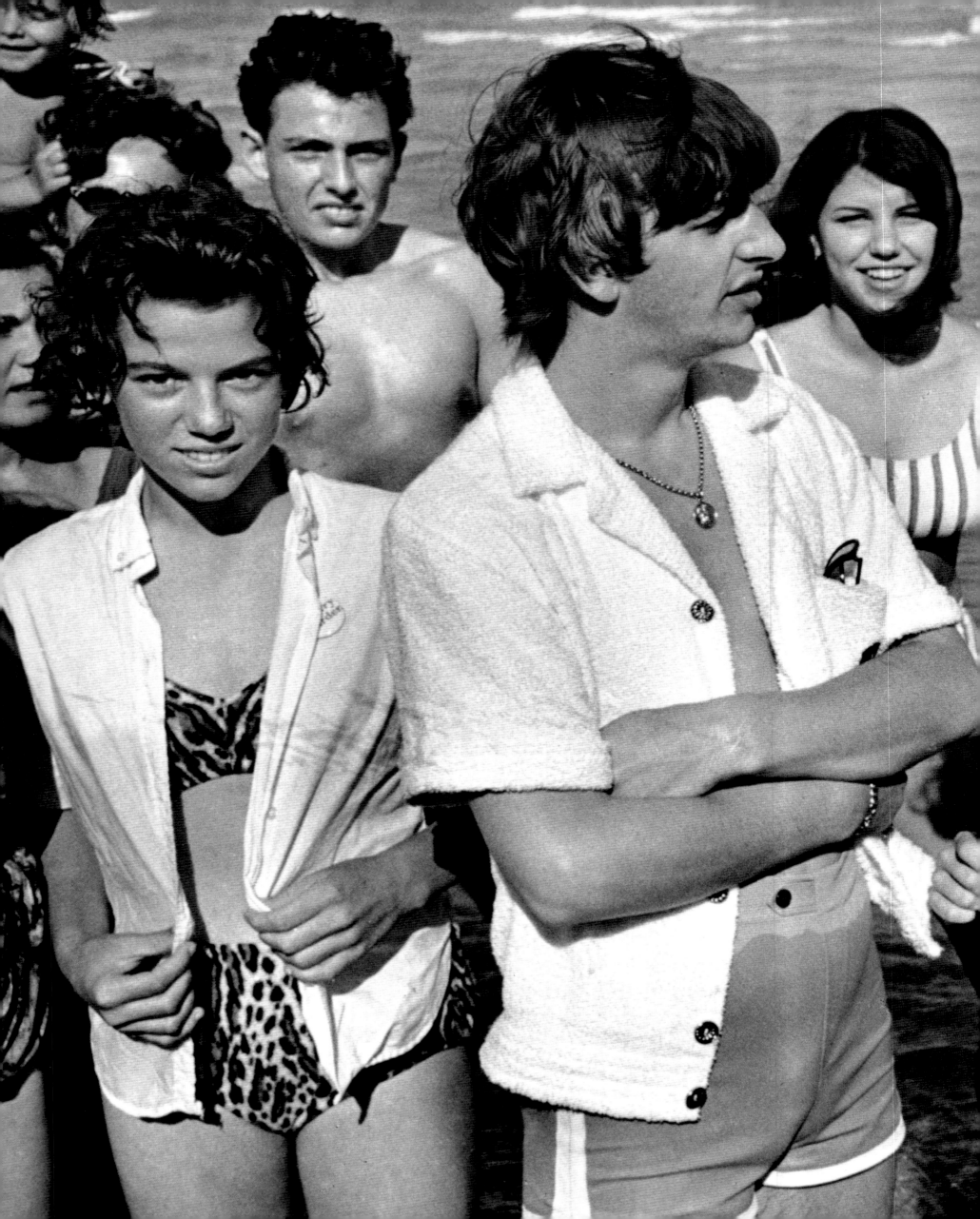

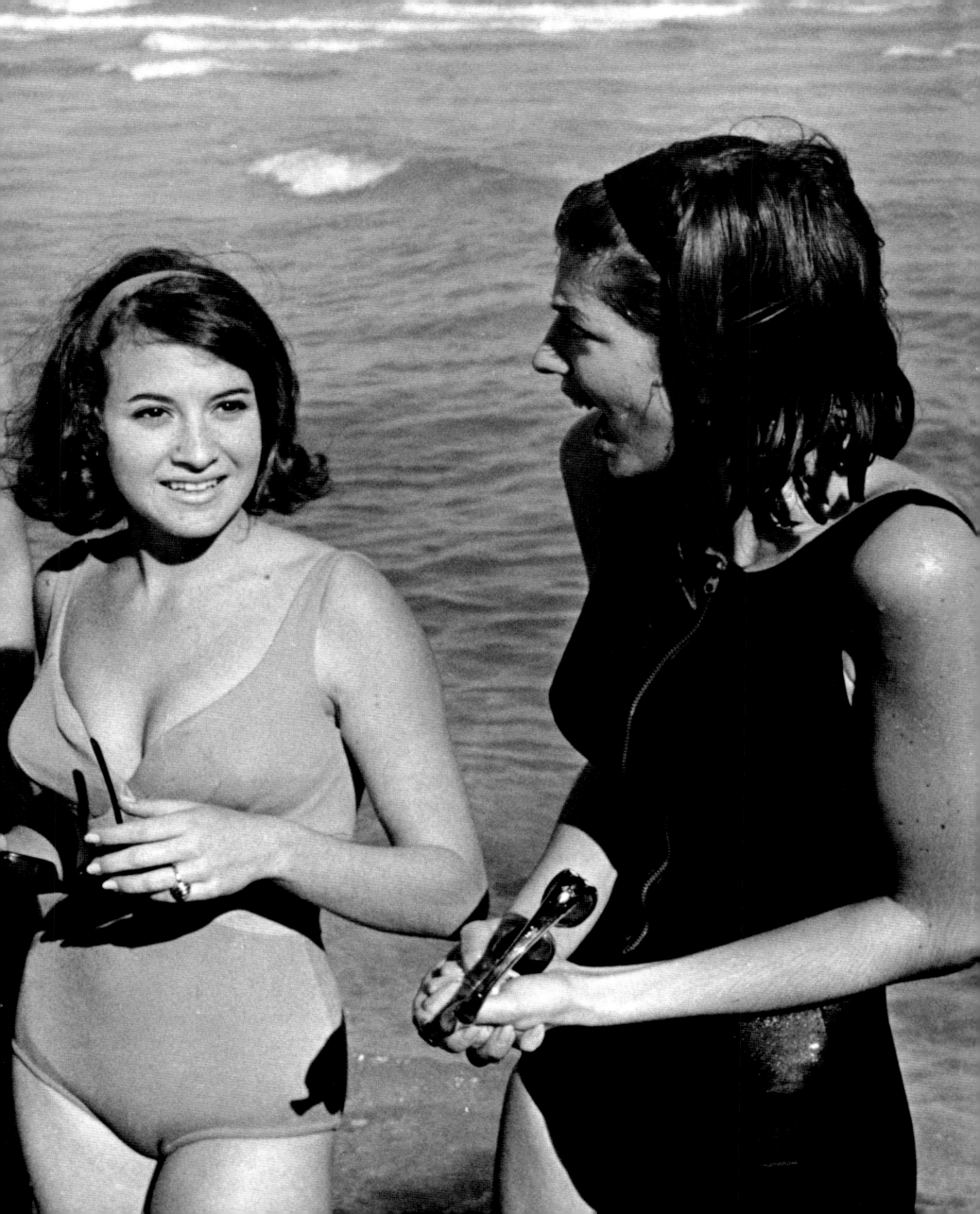

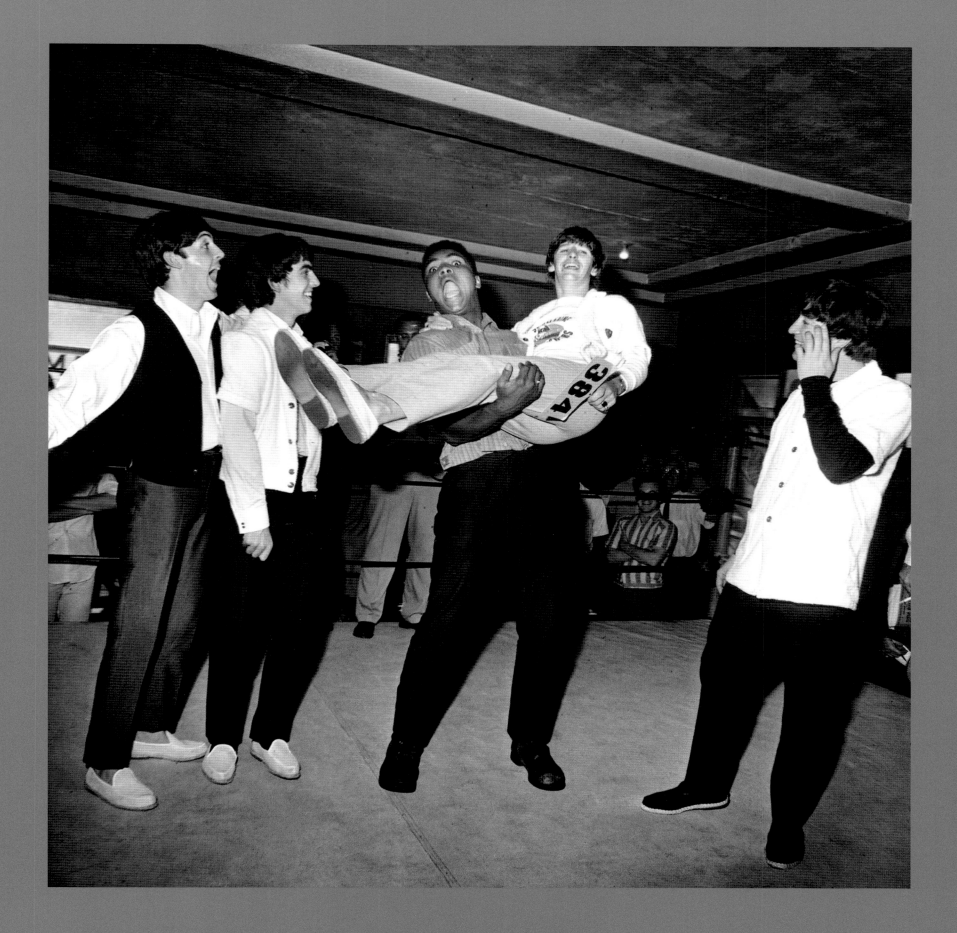

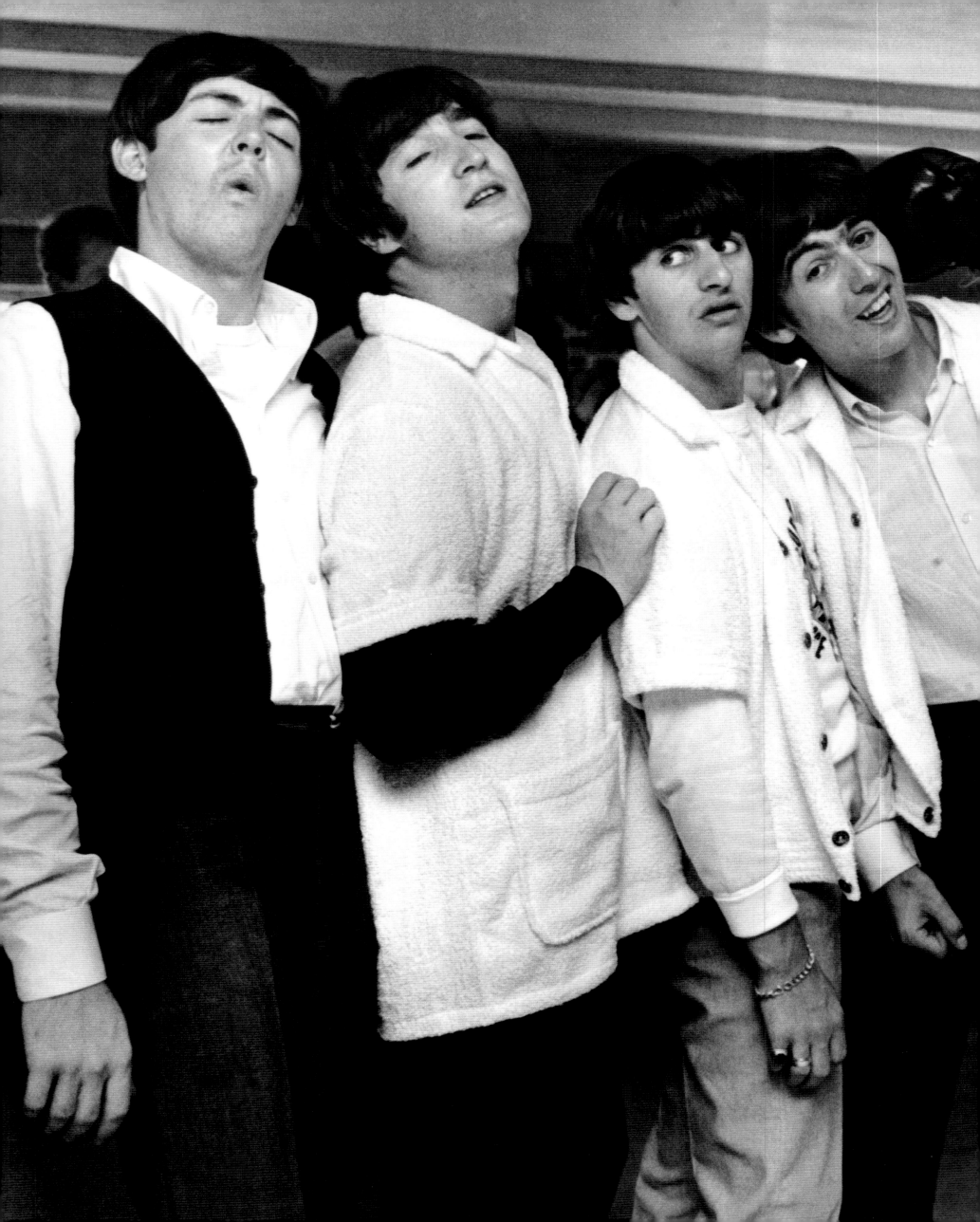

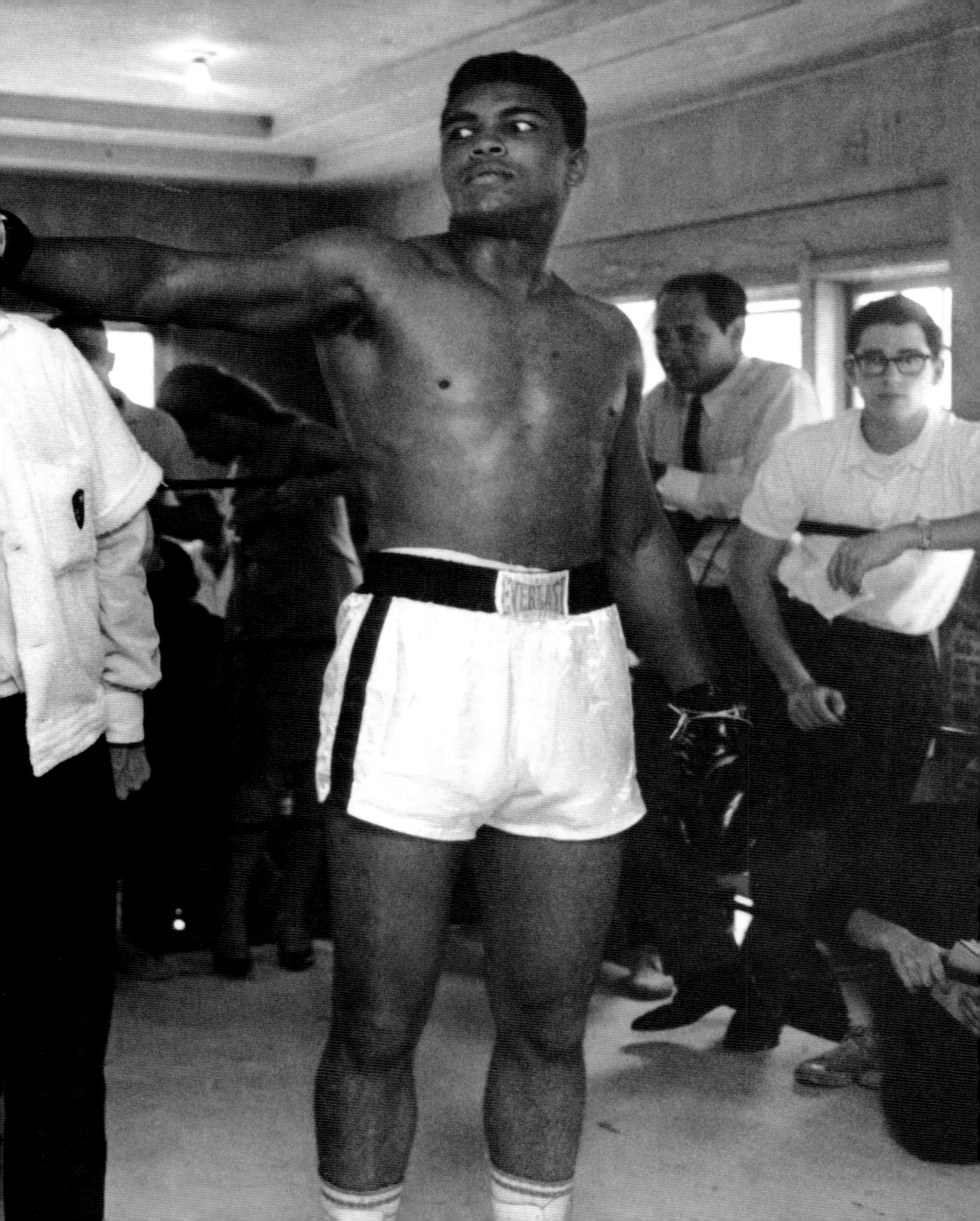

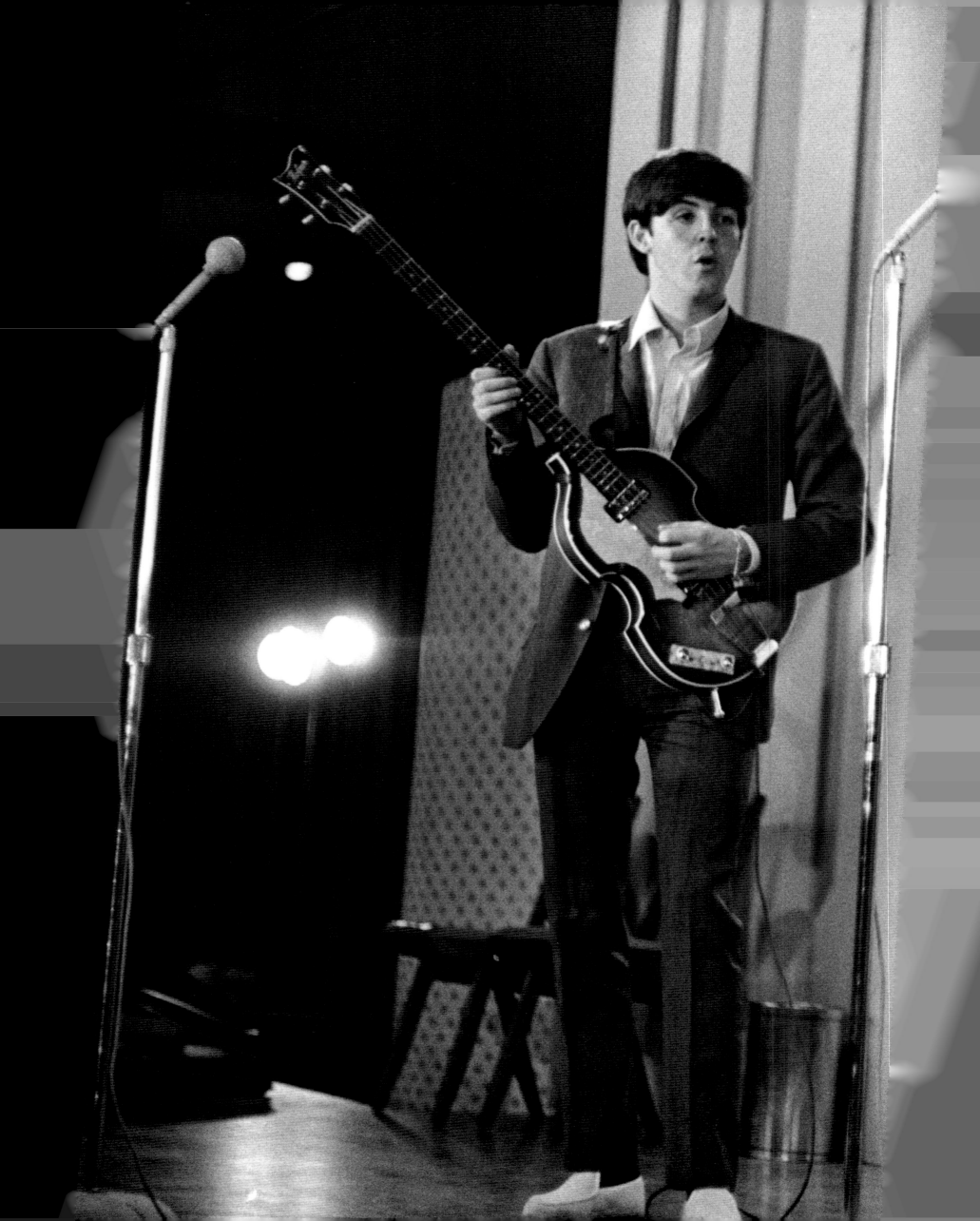

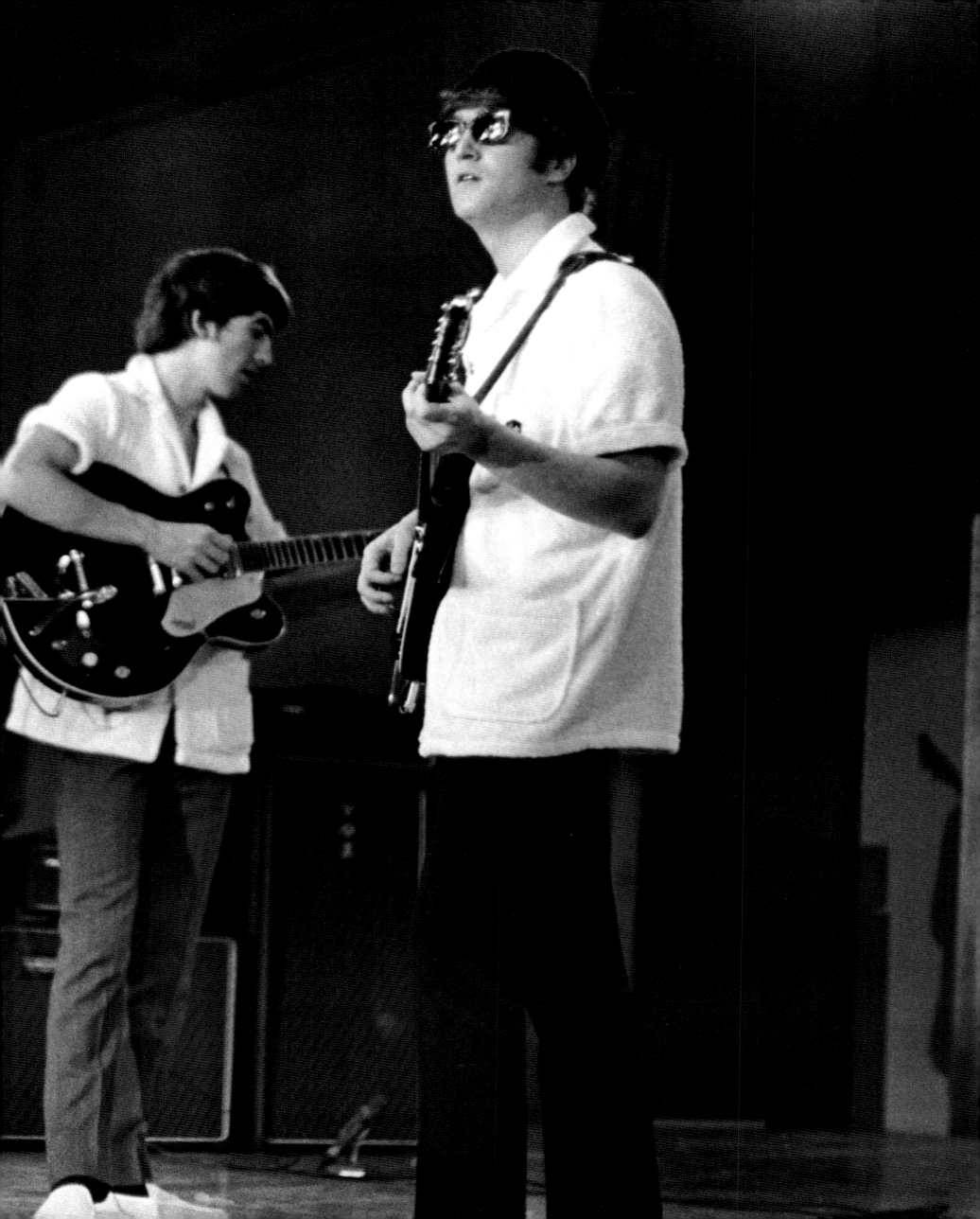

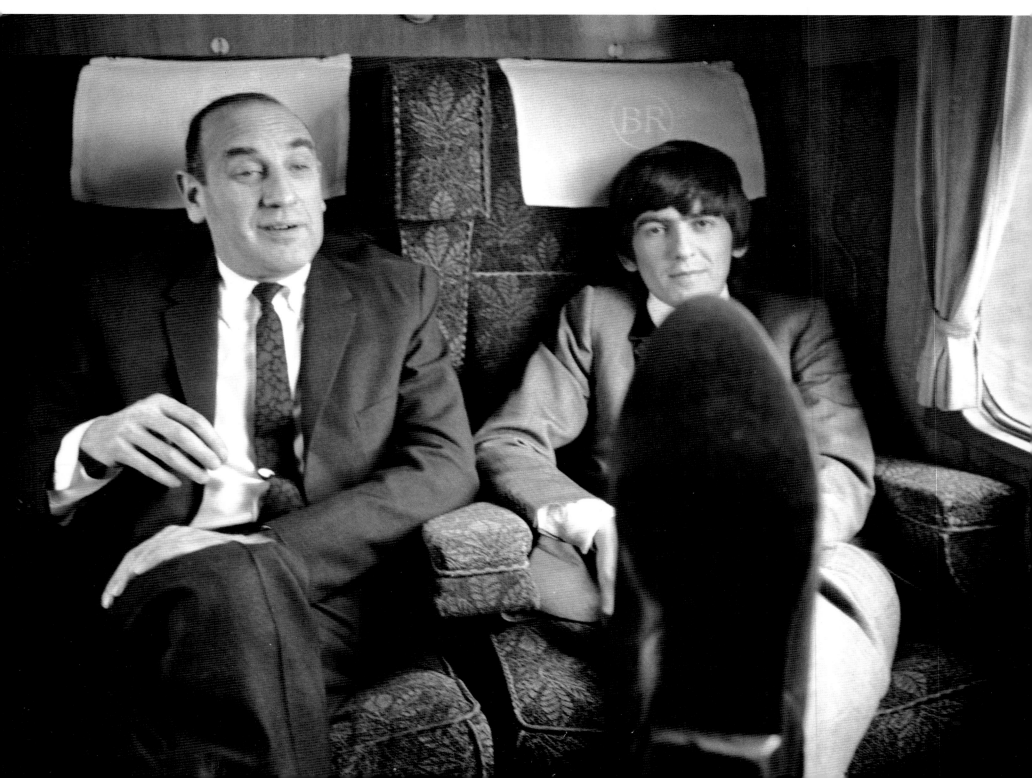

When I got back to London from Miami, less than six weeks had passed since we'd all gone off to Paris, but the course of my life was changed forever. It wasn't the Beatles that did it, so much as America itself. I loved every minute of my time there, and I desperately wanted to return. I could also sense that the American press photographers, by and large an honorable and polite bunch, could be outmaneuvered by a wily Fleet Street photographer who gave equal priority to getting a story and blocking a competitor's access to it. The prize: publication in the most widely read magazines in the free world. ☾ Meanwhile, everyone I knew wanted to know what the Beatles were like. It would be a small exaggeration to say that all England had nothing else on its mind until we unexpectedly won the World Cup in soccer two years later. When I was commissioned to shoot the filming of their first movie, *A Hard Day's Night*, a few days on the set were enough for me—there were too many people and too much hysteria wherever they went. There was no let-up and no place for them to hide. Everywhere they went people were grabbing at them, sticking pens in their faces to get autographs. Reporters were elbowing each other to get to the front to ask questions. George said to me, "The only time I ever get any peace is when I'm locked in the bathroom." ☾ Under the circumstances, that *A Hard Day's Night* got made at all was a major accomplishment. That it was actually a good film was downright amazing. The filmmakers took the sensible course of sticking rather close to the kind of experiences that the Beatles were having in the real world (the working title was *Beatlemania*) and letting each Beatle be himself. They were careful to film in locations near London where crowds could be controlled, so the Beatles could be brought onto the sets for short takes without a lot of preparation. Filming started on March 2 and wrapped on April 24—seven and a half weeks, when the Beatles were also recording songs for the film, making promotional appearances, and performing. They had written most of the songs in intense sessions in their hotel room during their stay in Paris, one of which I had photographed. ☾ The first scenes to be filmed took place on a train, and the press was allowed in to cover the launch. Every day for about a week, the cast and crew got on a train at Paddington Station in London, and traveled out to the West Country and then back to London, with the Beatles disembarking along the way to dodge waiting fans. Comic actor Wilfred Bramble, playing Paul's granddad, mugs in one photo, while the director, Richard Lester, who honed his skills doing innovative comedy shows for TV, can be seen sitting with George. He tried to catch the group off guard to make the film as realistic as possible. The movie had its debut on July 6 and was an instant smash hit. Incredibly, it had only been five months since the cable announcing they were number one in America had reached them in Paris. ☾

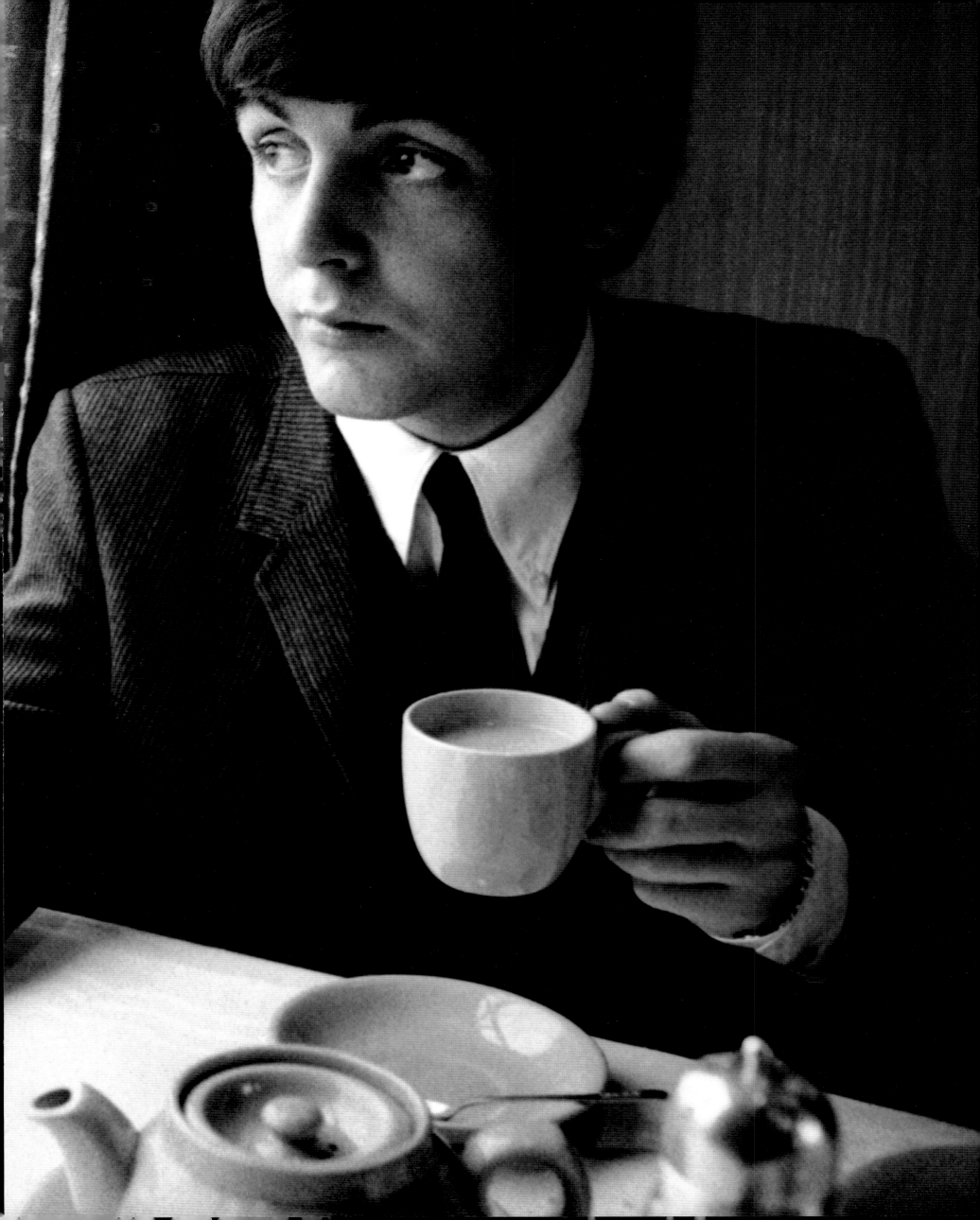

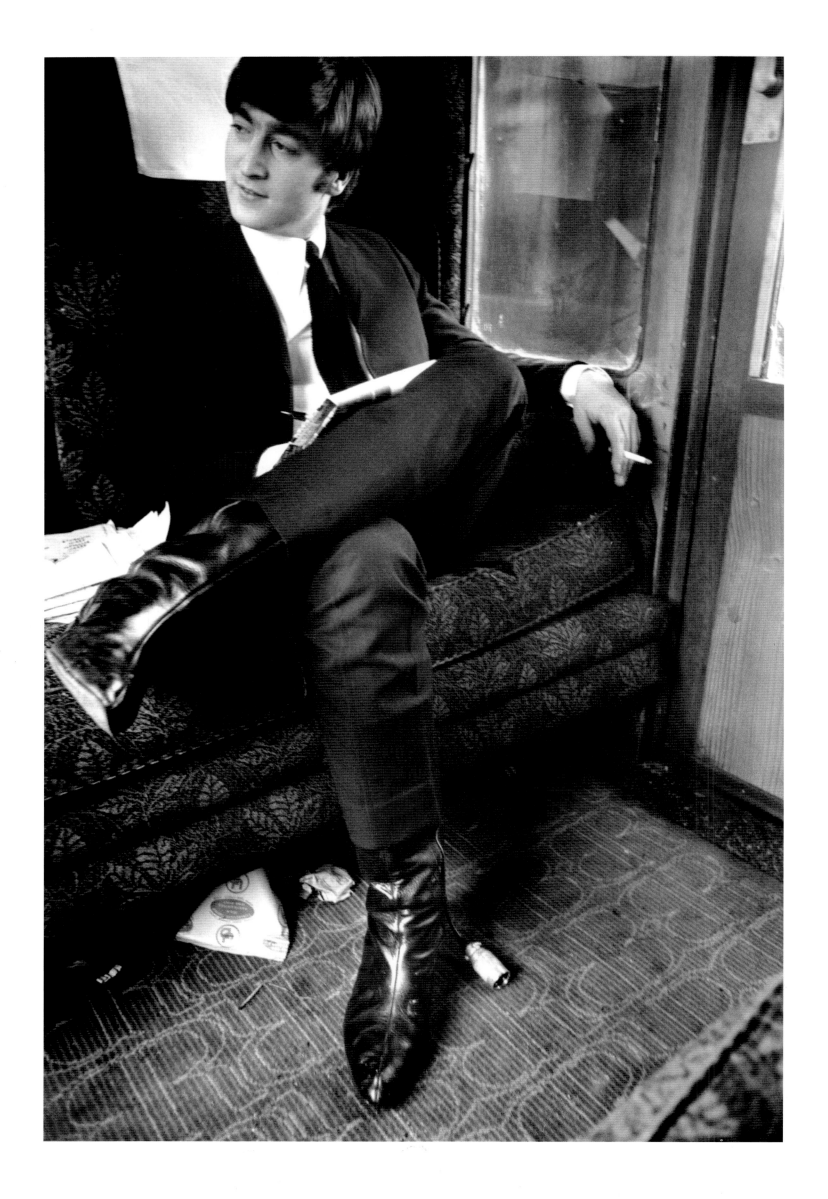

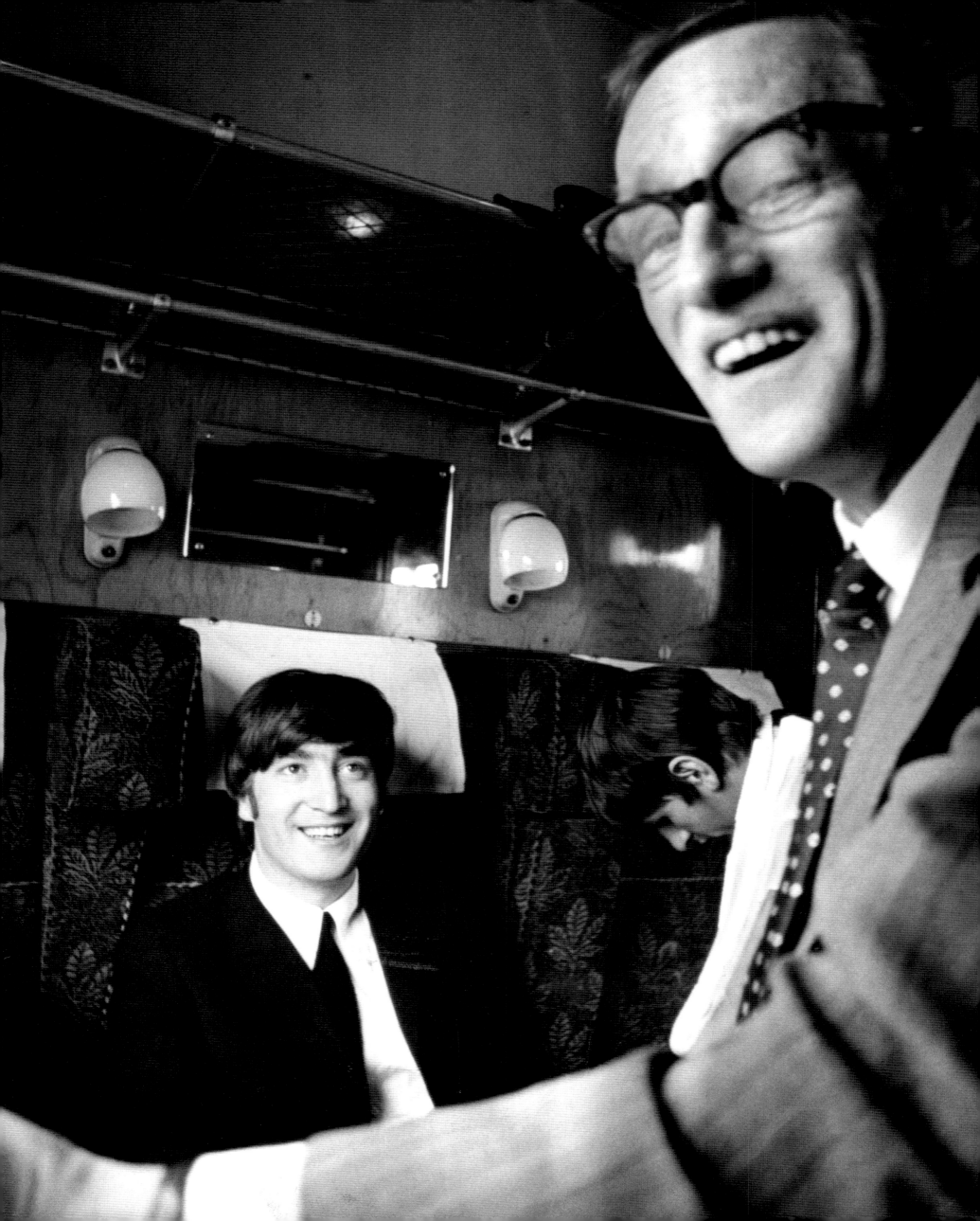

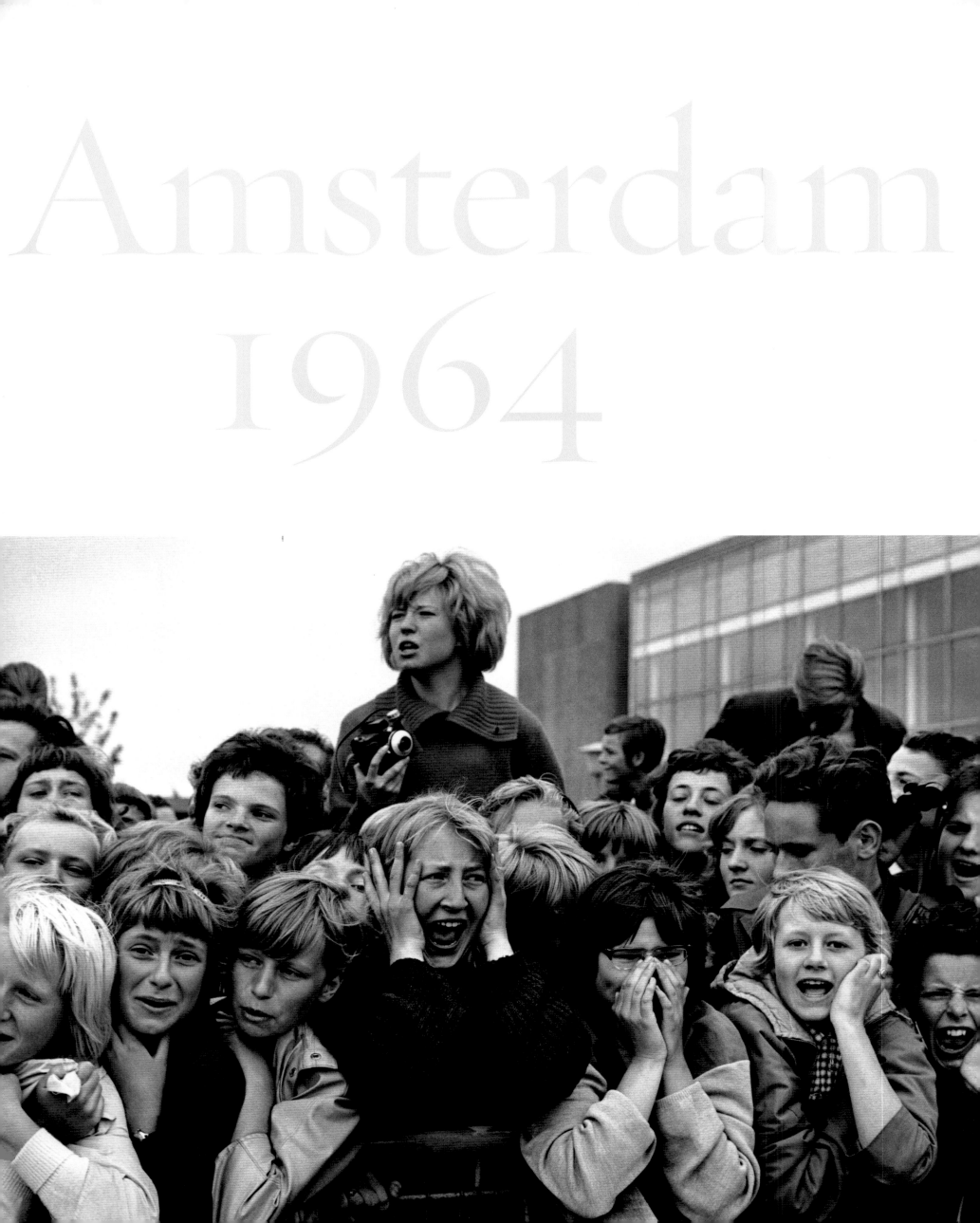

Amsterdam
1964

With no time off and Beatlemania escalating, the Beatles now had to leave on a world tour beginning on June 4 with a concert in Copenhagen. Ringo collapsed with tonsillitis on June 3. There were so many calls in London about Ringo's health, the telephone company had to install extra switchboards. It didn't surprise me that one of them was ill. On top of their heavy schedule, they would stay out all night every night when in London, presiding like royalty at the Ad Lib Club in Soho or some other trendy spot. ☾ Although the Beatles wanted to cancel, they couldn't, and so they got a replacement drummer to fill in until Ringo was healthy—Jimmy Nicol, a session musician from London. This seemed like it might be newsworthy, and I went along on the first leg, to Copenhagen and Amsterdam. The photographs that follow were taken in Amsterdam. Nicol was a pleasant person and a good drummer who was going to make the most of his two weeks as a member of the most famous group in the world. He signed autographs and gave interviews. Who could blame him? He was having a grand time. John was pleasant to him, Paul was ambivalent, and George did not bother to hide the fact that he felt Nicol was an intruder. He believed they should have waited for Ringo to get well. ☾ Before their first appearance in Amsterdam, a live TV show on June 5, the Beatles went for a canal ride, sightseeing and greeting their fans. Kids jammed the bridges to get a glimpse, threw things at their boat, and jumped into the water. Police had to pull them out. That evening, the Dutch television producers talked the group into letting members of the audience sit on the stage while they performed, insisting that it would be safe. What the four didn't know was the producers of the show had arranged to have the fans rush the stage at the end of the performance. Things got out of hand and chaos ensued. It was clear to me that the Beatles knew they were entering a stage where the smallest wrong decision could cause physical harm to themselves and others. You grow up fast in a situation like that. ☾ This was the end of my first tour of duty with the Beatles. Jimmy Nicol's last performance as a Beatle was in Adelaide, Australia, on June 13, and he quickly returned to private life with one great story to tell his grandchildren. Ringo came out of hospital on June 11, and joined his band mates in Melbourne. By the end of the year, there was surely nothing that they could have wished for that they didn't have (except, perhaps, peace of mind), and I got what I wanted—a guarantee of ongoing assignments in America. Before long, I found myself living in New York City in a furnished apartment on East 63rd Street that had previously been occupied by Rock Hudson, and diving head first into Lyndon Johnson's Great Society, which was beginning to come apart at the seams. ☾

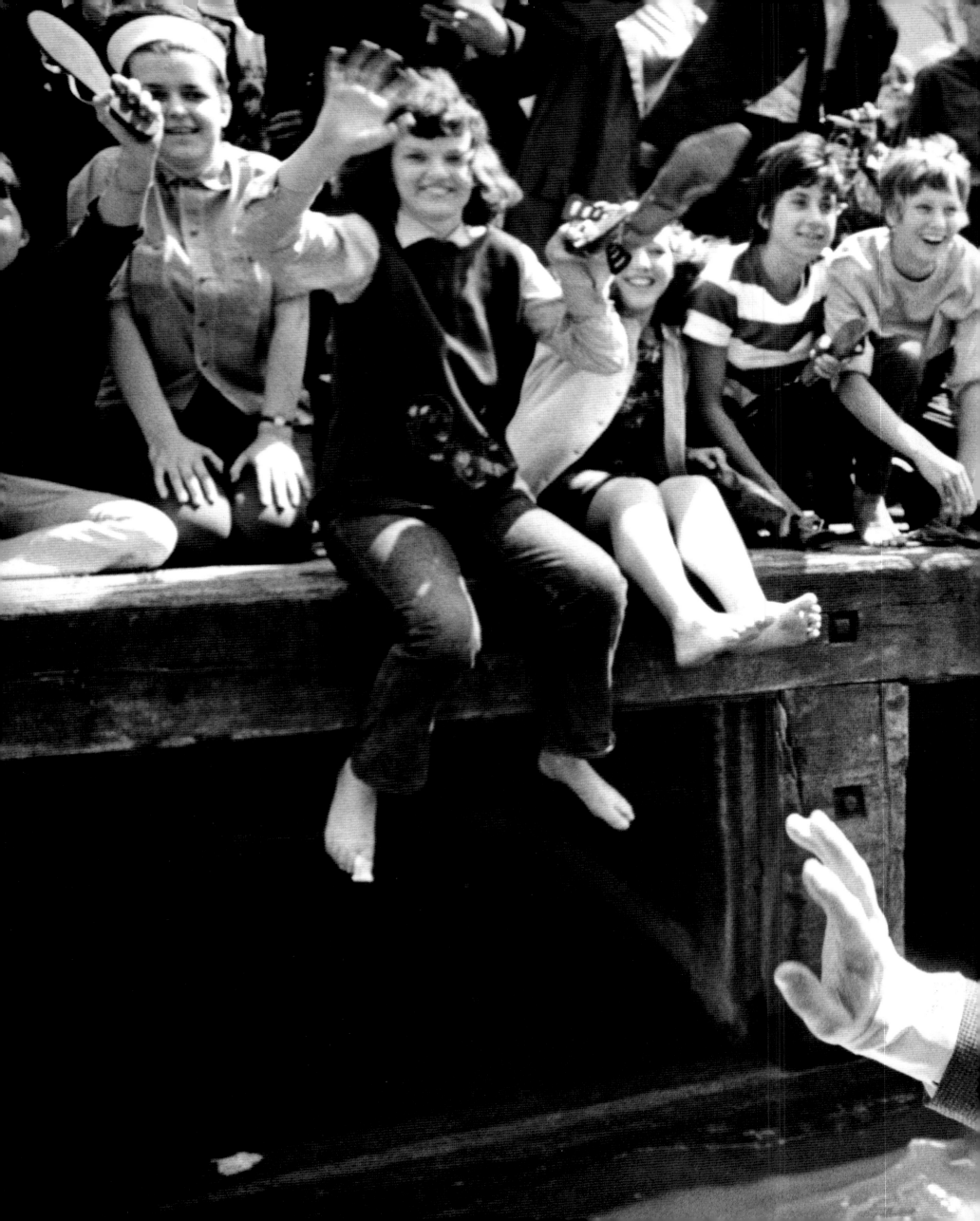

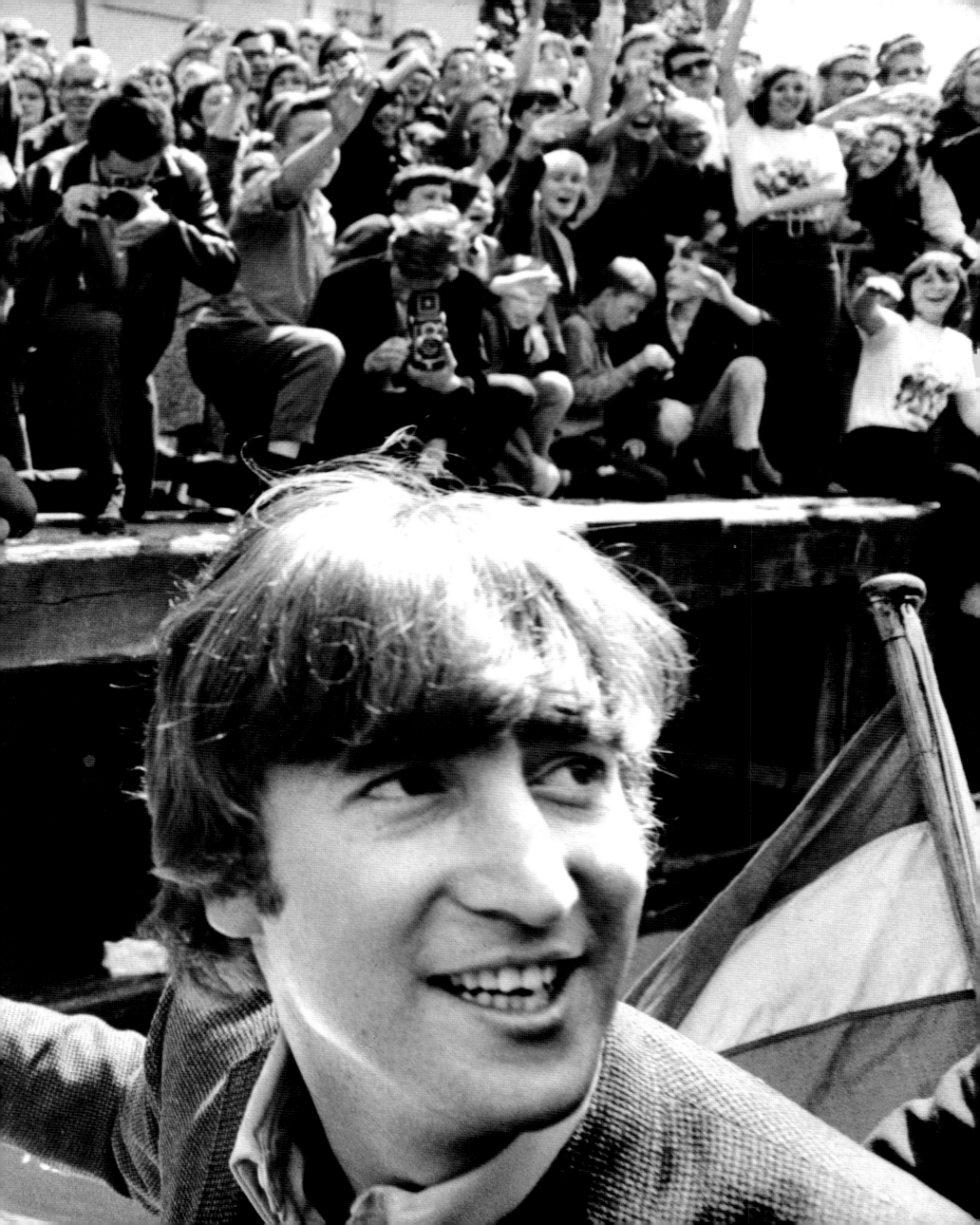

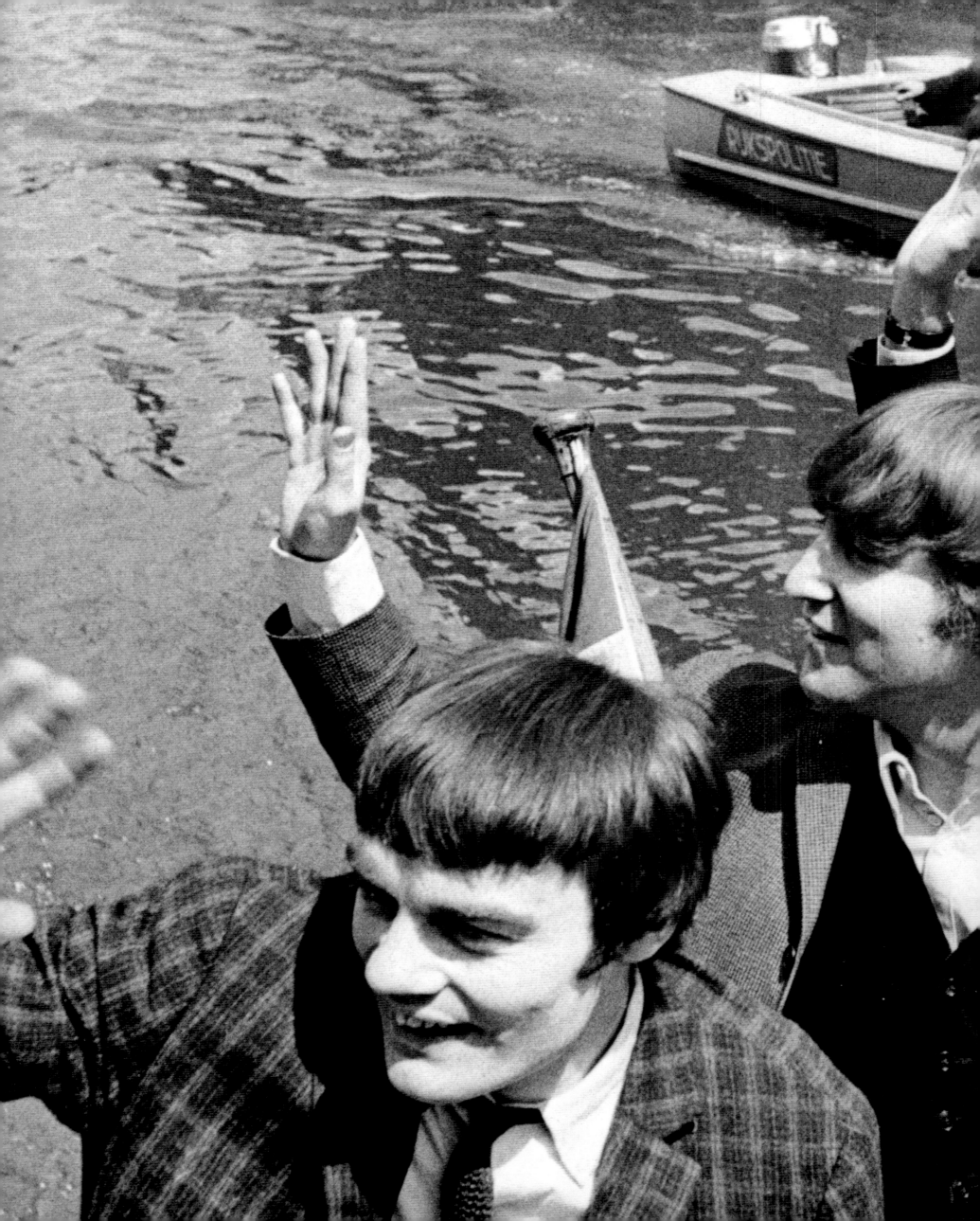

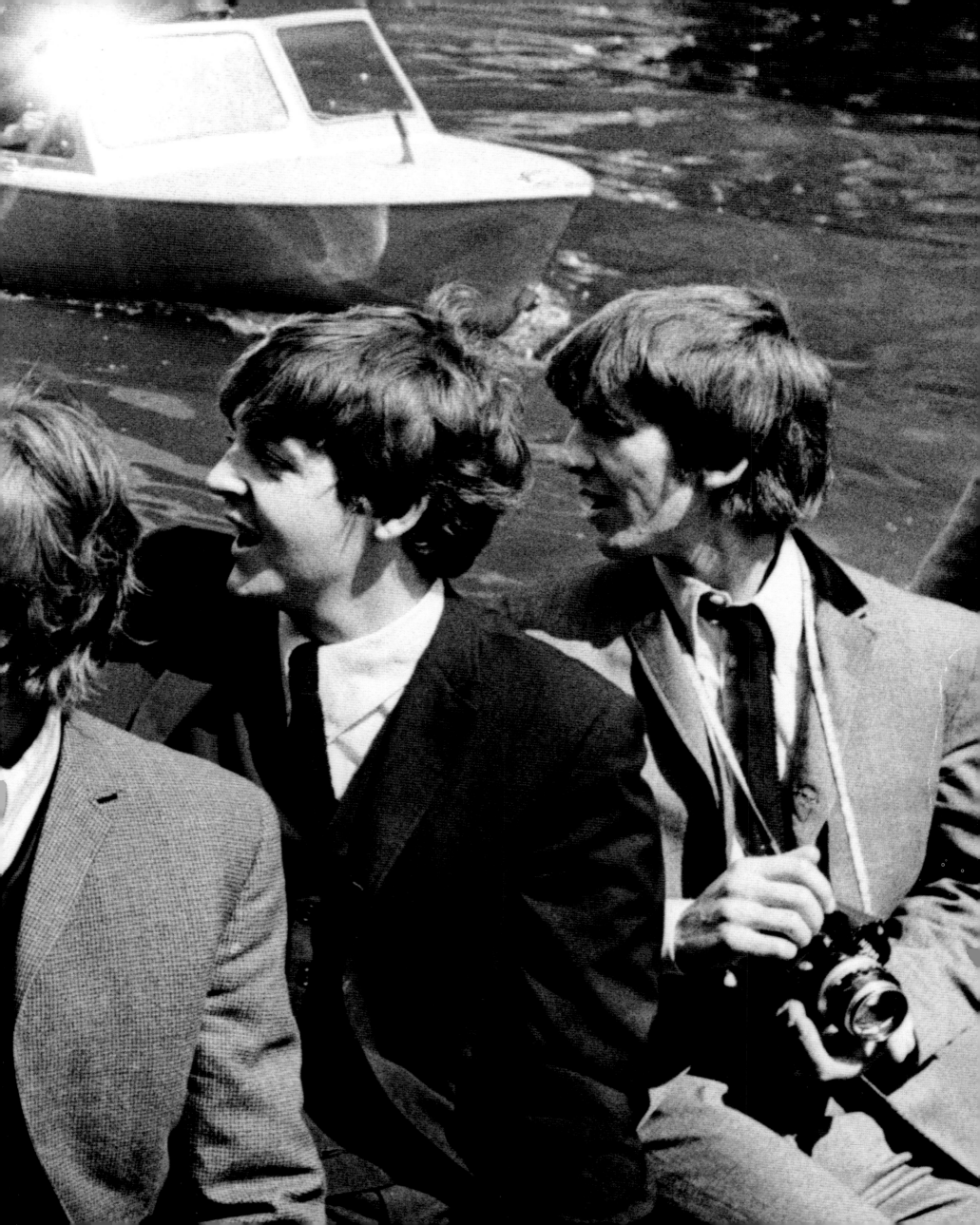

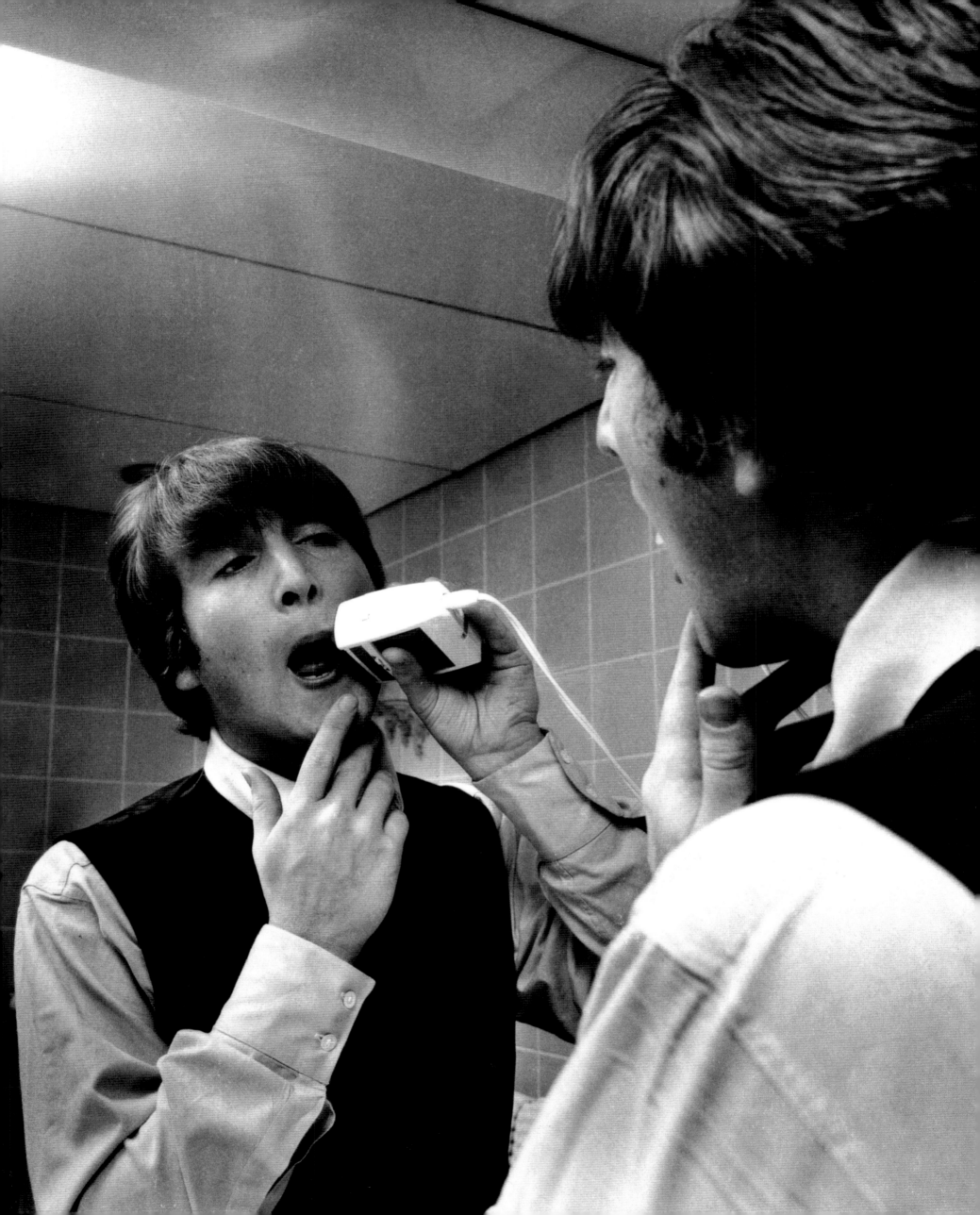

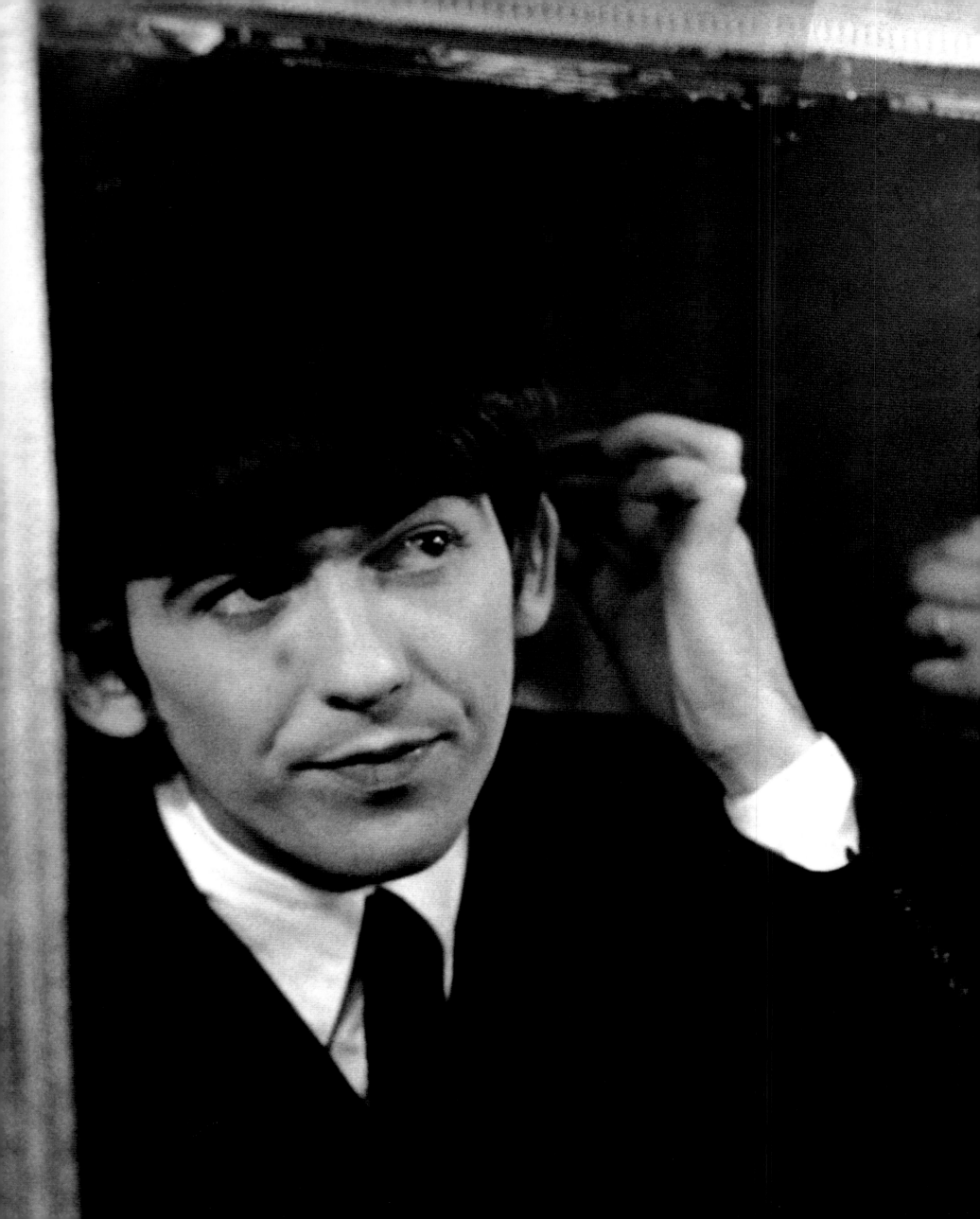

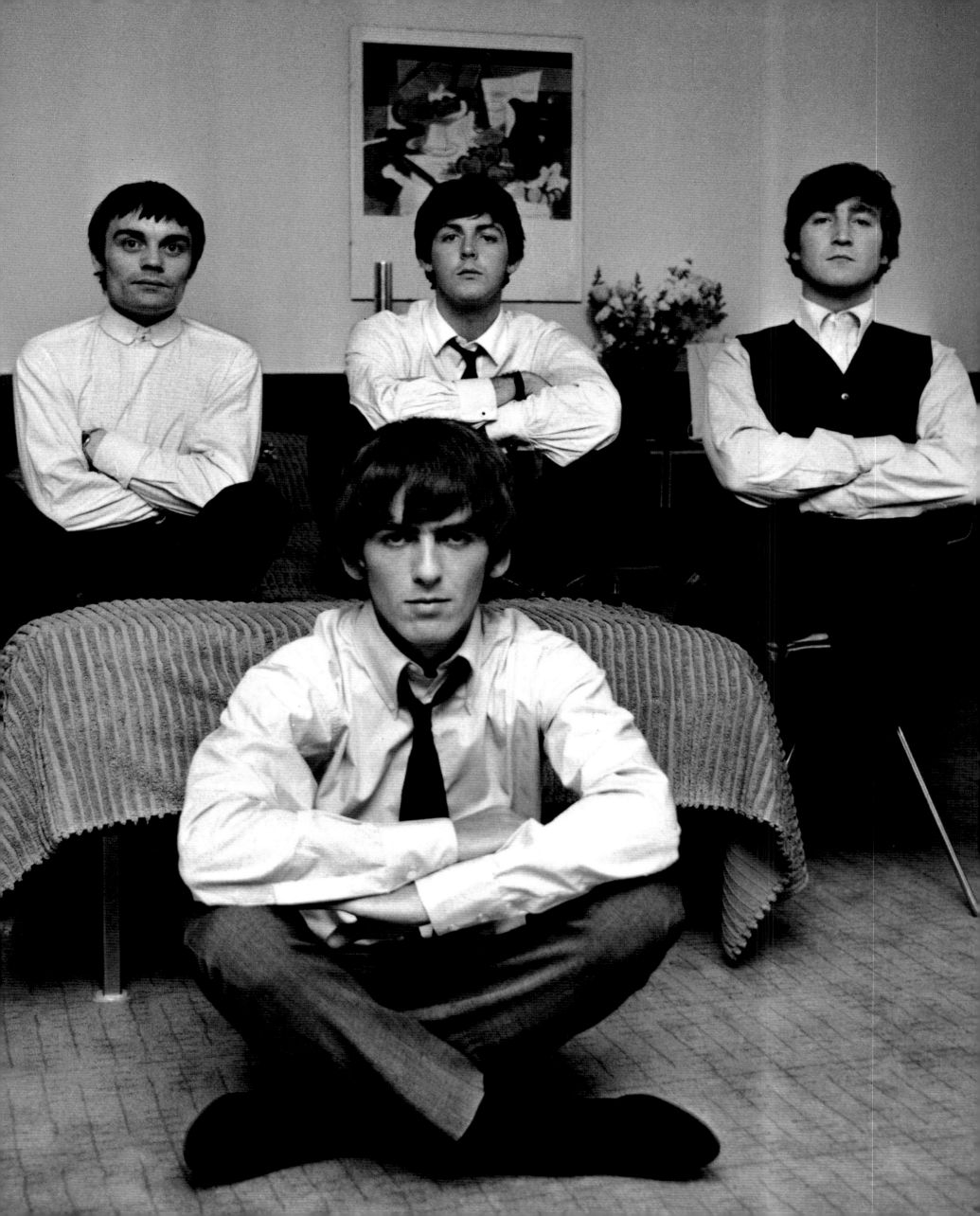

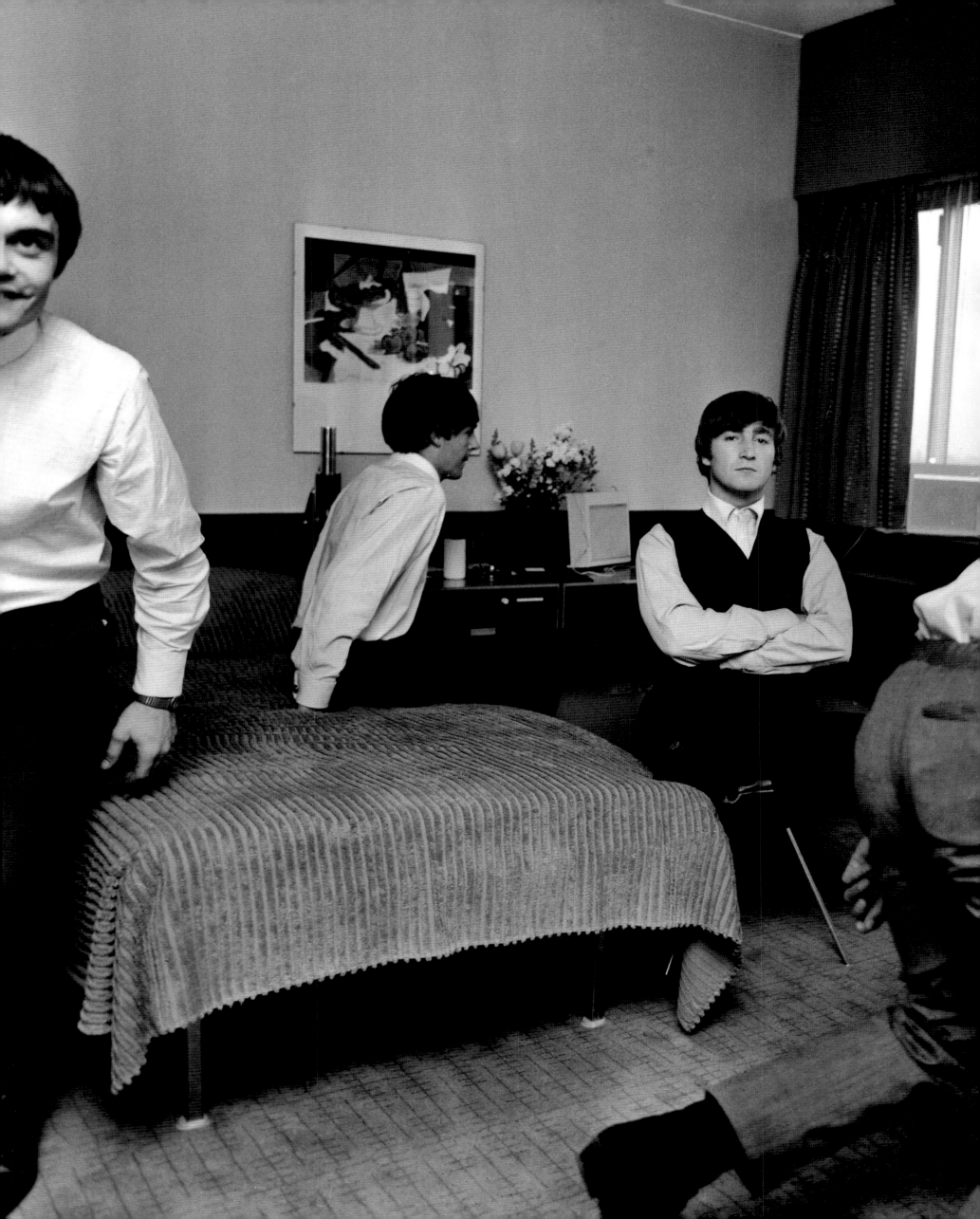

# Barbados 1966

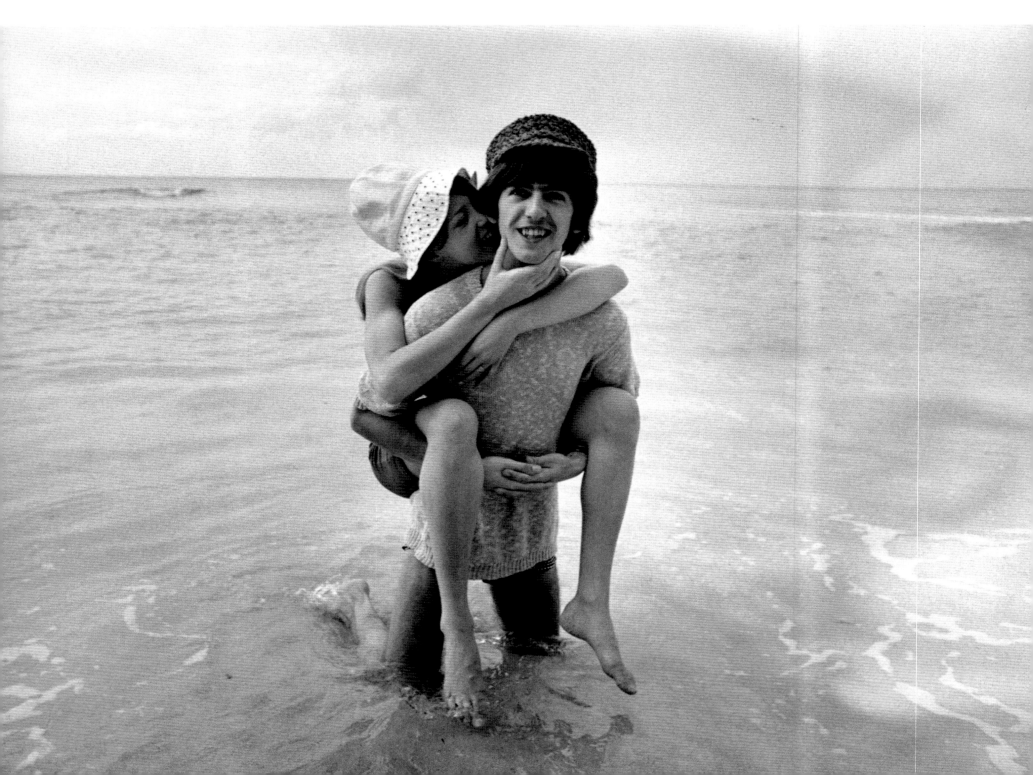

It was big news when George married Patti Boyd on January 21, 1966, in London. The press, of course, played the event as if it would break millions of girlish hearts around the world, and perhaps it did. When I was with the Beatles in Paris, I found it interesting that Ringo received the greatest volume of fan mail, followed in diminishing order by George and then John, with Paul a distant fourth. ☾ The entire world knew that George and Patti left England on their honeymoon on February 8, but their destination was kept secret. With a bit of detective work—I knew a lot of people around the Beatles—I tracked them down in Barbados. If somebody were going to give the Beatles some peace, it wouldn't be me, not as long as I was a photographer and they were public figures. I spent a day looking for them. About 4:30 that afternoon I decided to stop for a swim on a deserted cove. Who should I see walking up the beach but George and Patti. George was surprised but thought it was a coincidence. Just at the same time, another Fleet Street photographer came trudging up the beach.

When we saw them, Patti and George were having a quiet time alone together. ☾ I explained that I'd come to take a few pictures. They were fine about it. George and I had always gotten along with each other, and I felt closer to him than to the other Beatles. We had dinner that night and I left the next day, eager to get back to the mainland with the film. I didn't want to transmit from Barbados because that was a long, involved task at the time, and the quality would not have been very good. With today's electronics, it would have been another matter. ☾ Patti, leggy and waiflike, was the perfect Beatle consort. She adapted effortlessly to the role of rock-and-roll royalty. A fashion model cast as the Smith Crisps girl to promote a popular brand of English potato chips, she was nineteen when she was given a minor role in *A Hard Day's Night* (she says precisely one word: "Prisoners?"). George met her on the movie set, the same week that I was there photographing. She was his muse for some of his best songs, and when the marriage ended, she married Eric Clapton, who also composed songs in tribute to her. ☾

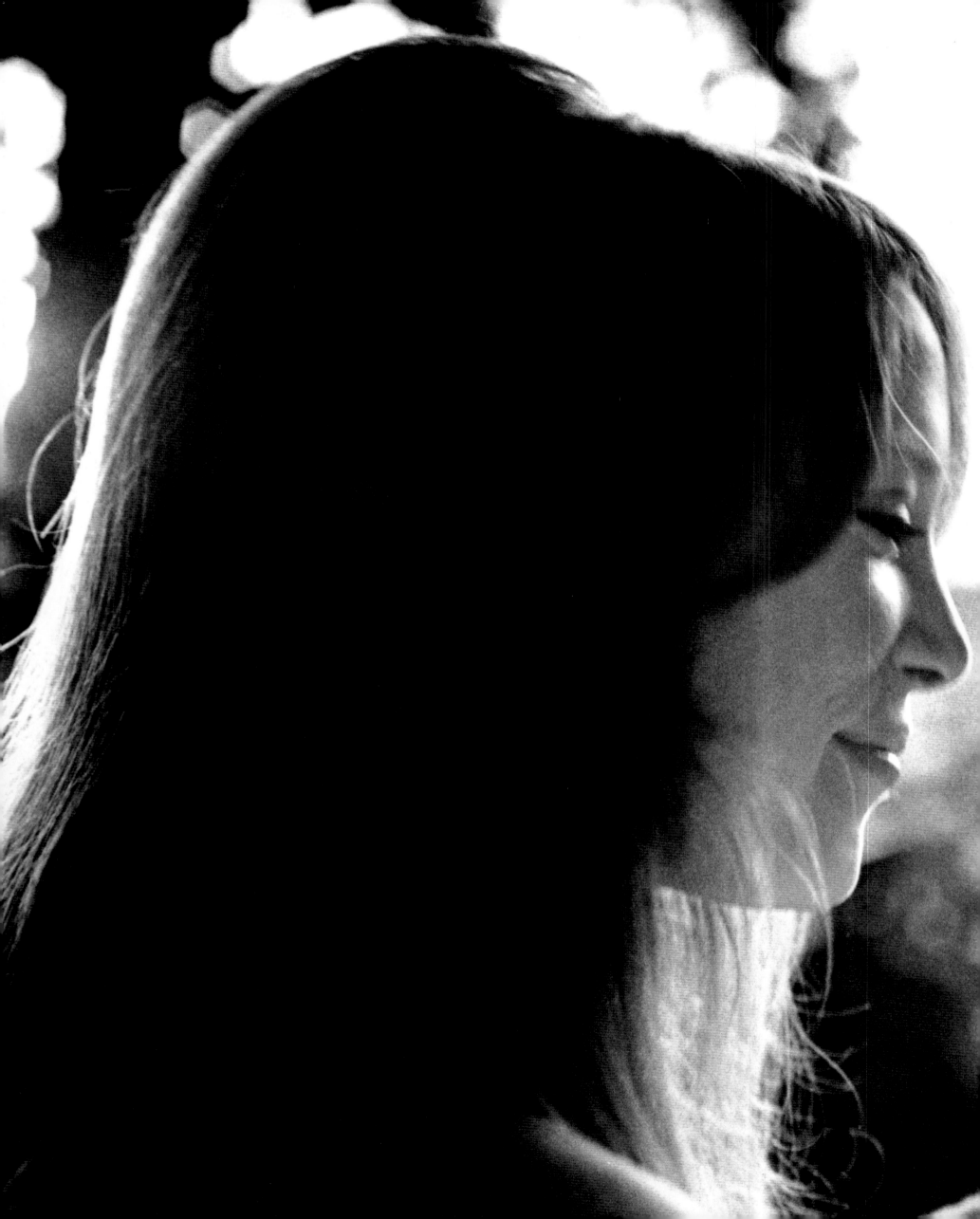

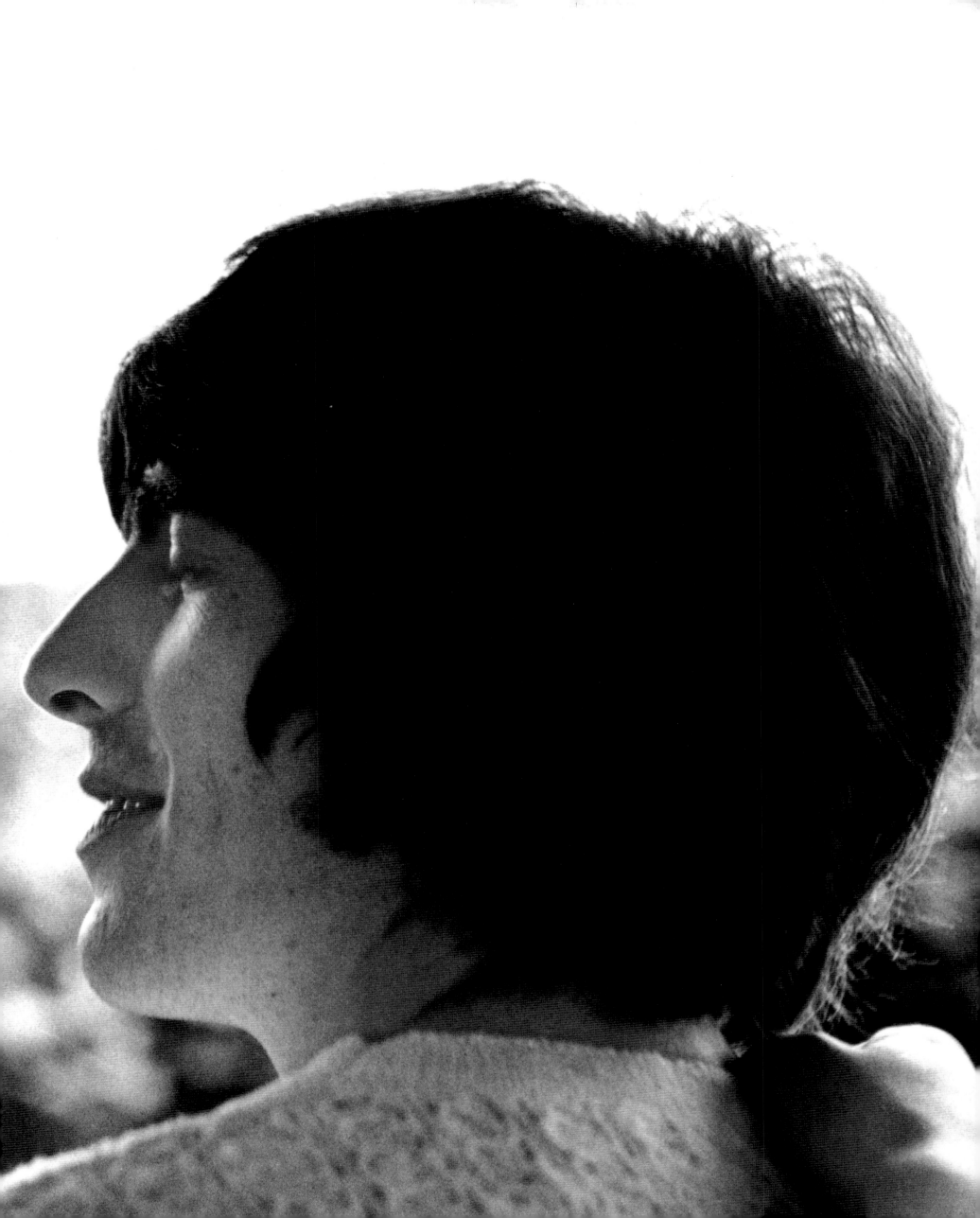

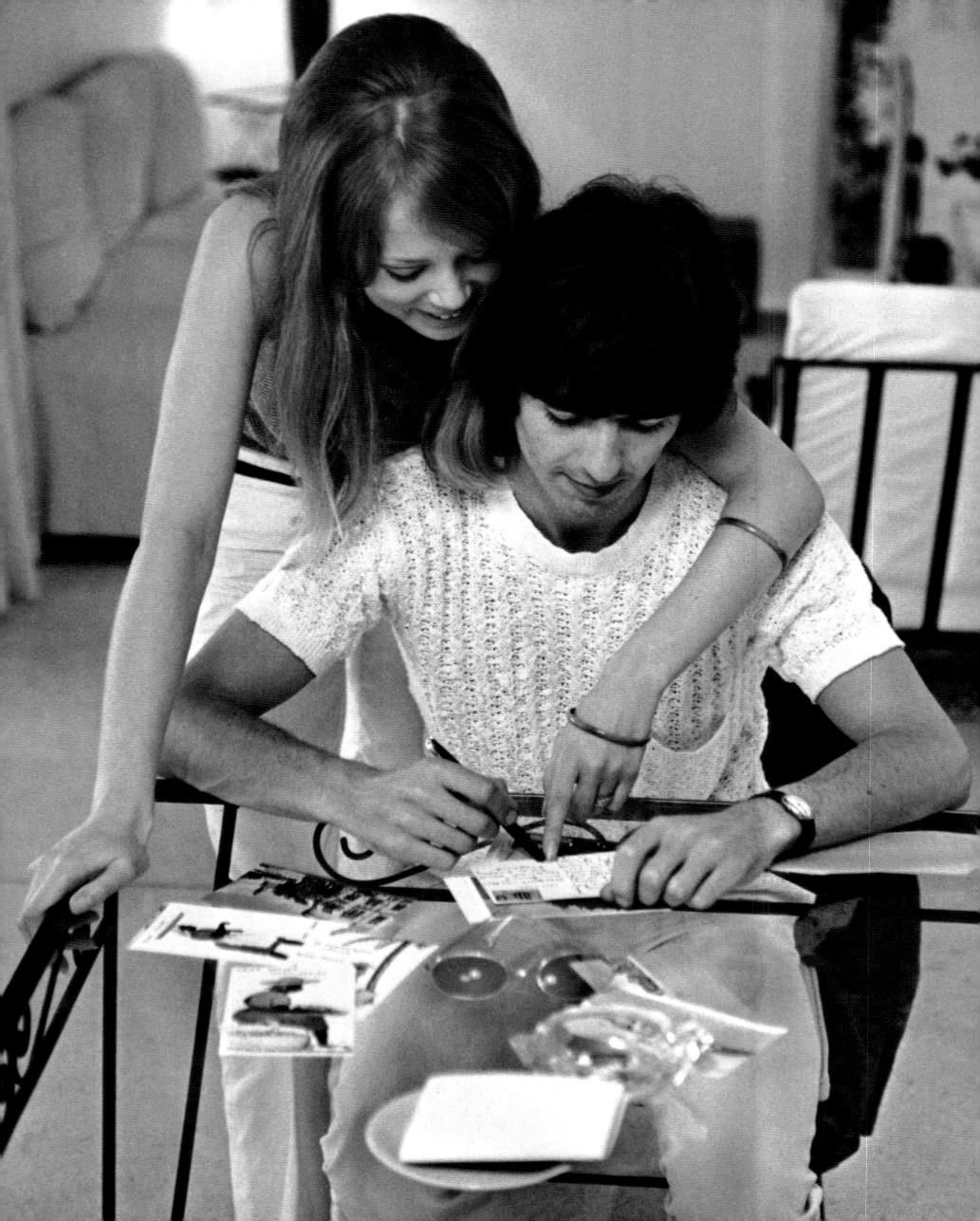

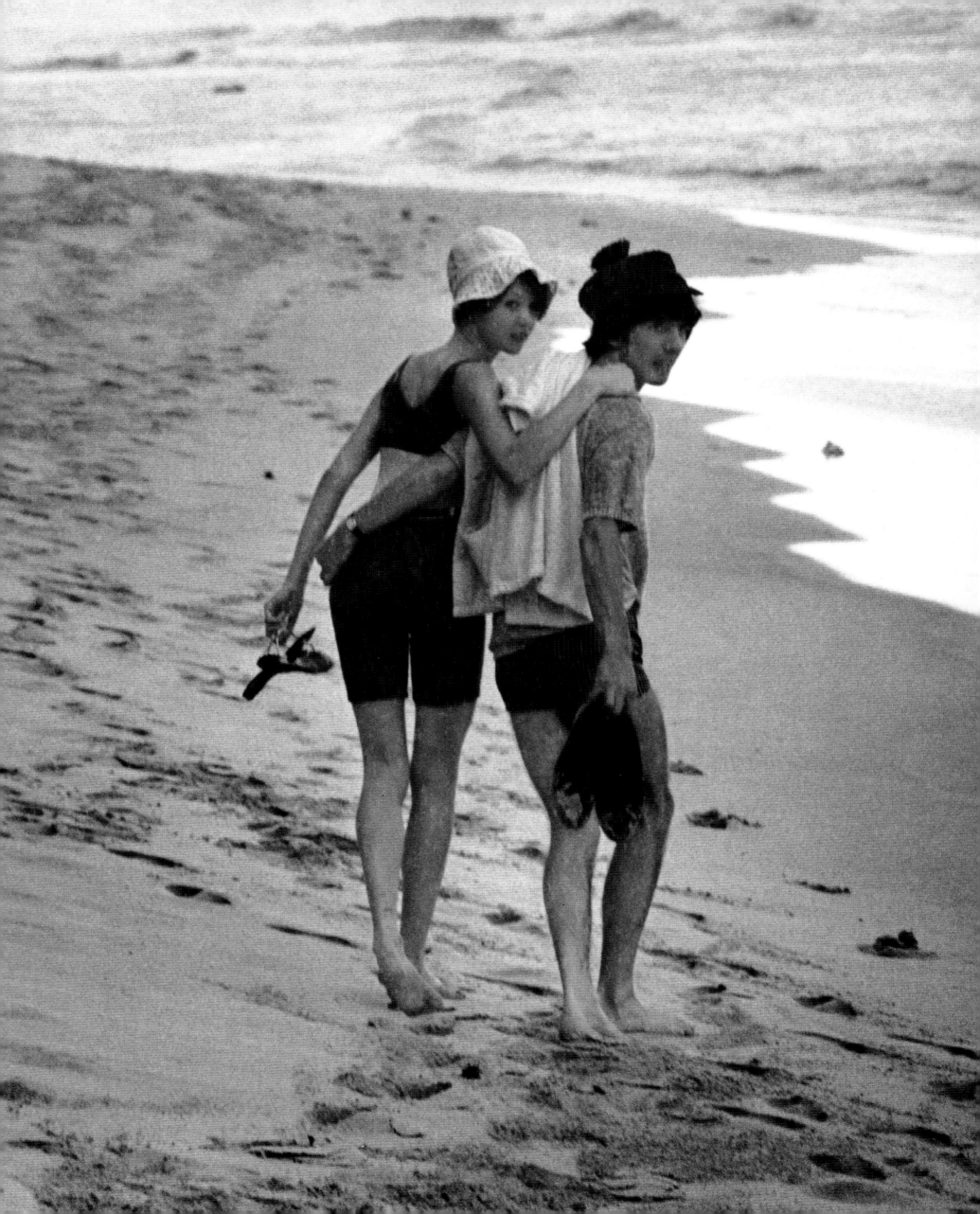

# American Tour 1966

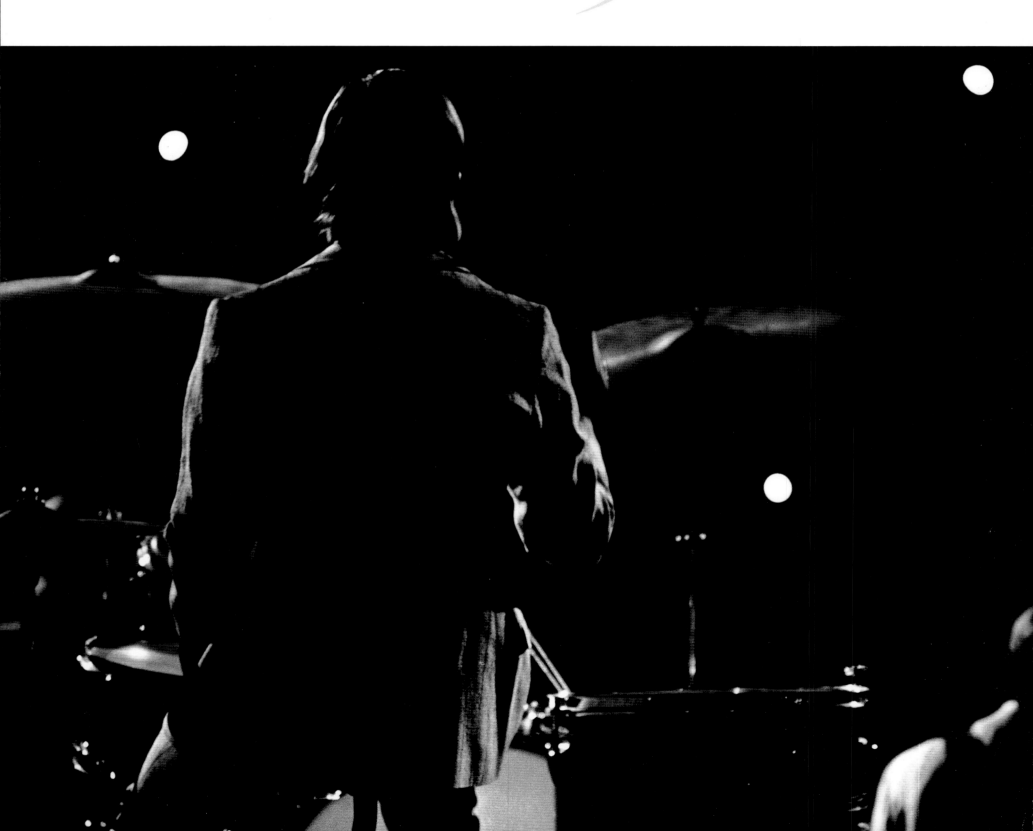

In 1966, the world seemed a more complicated place than it had been in those carefree days of January 1964 when I first met the Beatles. In late June, I found myself choking on tear gas in the little town of Canton, Mississippi, along with Martin Luther King, Jr., and others on the Meredith March. Meanwhile, halfway around the world in the Philippines, the Beatles were about to experience a frightening attack by the dictatorial Marcos regime for a perceived slight, running a gauntlet of physical abuse to get to their plane and leave the island. When we came together six weeks later, the event that precipitated it had more to do with politics than popular music. ℭ It didn't surprise me that John was in the middle of it all. On the plane coming to America for the first time, he had asked, "Do you think we will see any Freedom Riders?" One of the first things I noticed about all four of them was that they read the newspapers, and not just the music page. They were aware of social injustice, and Civil Rights were at the forefront of many conversations. They weren't four daft boys laughing and joking all the time, they were usually quite serious. And they were smart. In the beginning, their attitude was, we'll take what comes along with a shrug and a "so what." But circumstances made them rethink and resurface with a slightly different perspective. ℭ Now, on the eve of their annual American tour, John was in hot water for something he had said in an interview with Maureen Cleve published in the London *Evening Standard*: "Christianity will go. It will vanish and shrink. I needn't argue about that, I'm right and will be proved right. We're more popular than Jesus Christ now. I don't know which will go first, rock 'n' roll or Christianity. Jesus was all right, but his disciples were thick and ordinary. It's them twisting it that ruins it for me." My countrymen took John's beliefs in stride, but when the American teen magazine *Datebook* published these words on July 31, all hell broke loose. When I heard that the Beatles would be arriving in Chicago on August 11, and that John would be defending himself against a press corps whipped into a frenzy by his remarks, I got there as fast as I could. I missed his press conference, but I photographed him sitting dejectedly in the aftermath, close to tears. For the first time, and possibly the last, in his life, he had been compelled—out of loyalty to the others, who were mad at him—to apologize for something he believed in. But he was not to be silenced so easily. Five days later, in Toronto, he lent his support to American draft dodgers living in Canada rather than serving in Viet Nam. ℭ Much has been written about the tour that followed this contentious press conference. On the surface, things hadn't changed that much. They were still Brian's lads, wearing identical suits and bowing from the waist. By now, however, the roar was so deafening, the Beatles started improvising and singing anything that came into their heads. No one could hear them anyway. Meanwhile, the controversy over John's musings about Christianity lasted just long enough to sour whatever joy they might still have at playing for their fans. Scattered stores refused to sell their records, bonfires of Beatle merchandise were organized in the Bible Belt, and the media kept the story alive as long as there was a shred of news. ℭ And they were afraid. Fans who used to shower them with jellybeans in tribute now hurled a variety of objects: shoes, coins, paper cups, underwear. Paul was hit by a coin, and later by a shoe. It hurt. At the International Amphitheater in Chicago on August 12, cops cordoned off the stage, as if they were playing in a police state. The tour hit rock bottom on August 19 in Memphis, Tennessee, where I caught them giving a press conference to a group of student journalists as John stood in the back of the room looking very serious. That night, the Ku Klux Klan picketed Mid-South Coliseum and a firecracker exploded near the stage, frightening Brian, who was sure it was a rifle shot. ℭ It was probably around this time that Brian came to the realization that the Beatles had to stop performing in public. Paul would probably have gone on forever, while George loathed it. Even though the four were to receive absurdly lucrative offers to tour again, they could never agree that the time was right. They gave their last concert to a paying audience at Candlestick Park, San Francisco, on August 29, 1966. The final photograph in this book, however, was taken about a week earlier. The date: August 18, 1966. The place: Suffolk Downs Racetrack, Boston. As the Beatles step out onto the infield, a roar goes up from the stands . . . ℭ

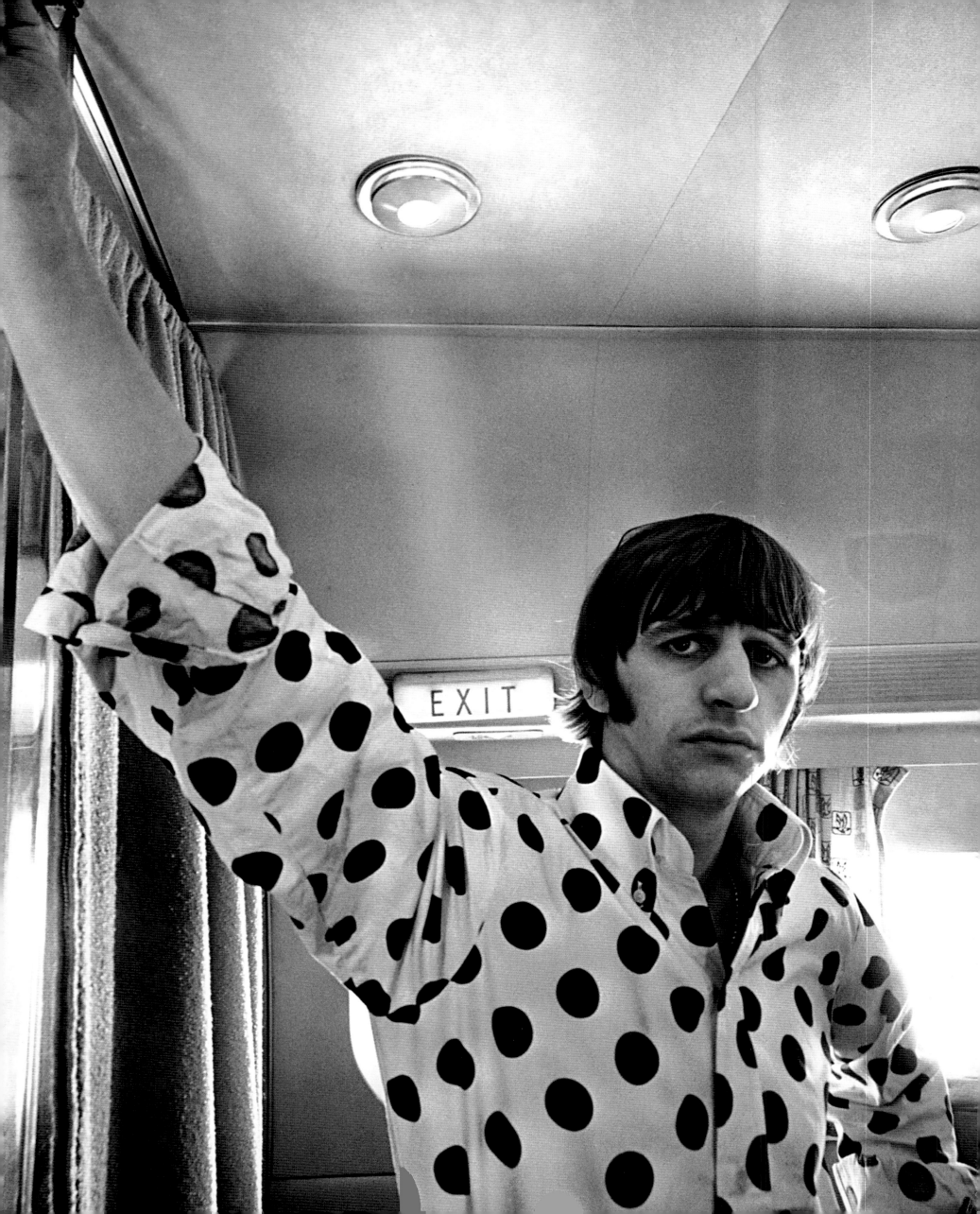

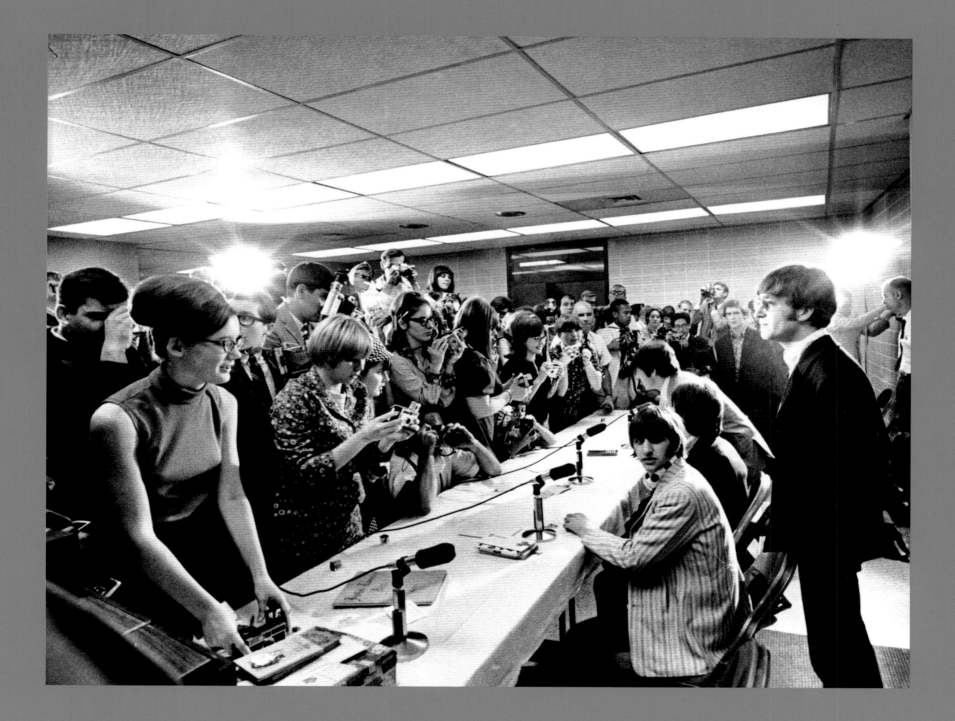

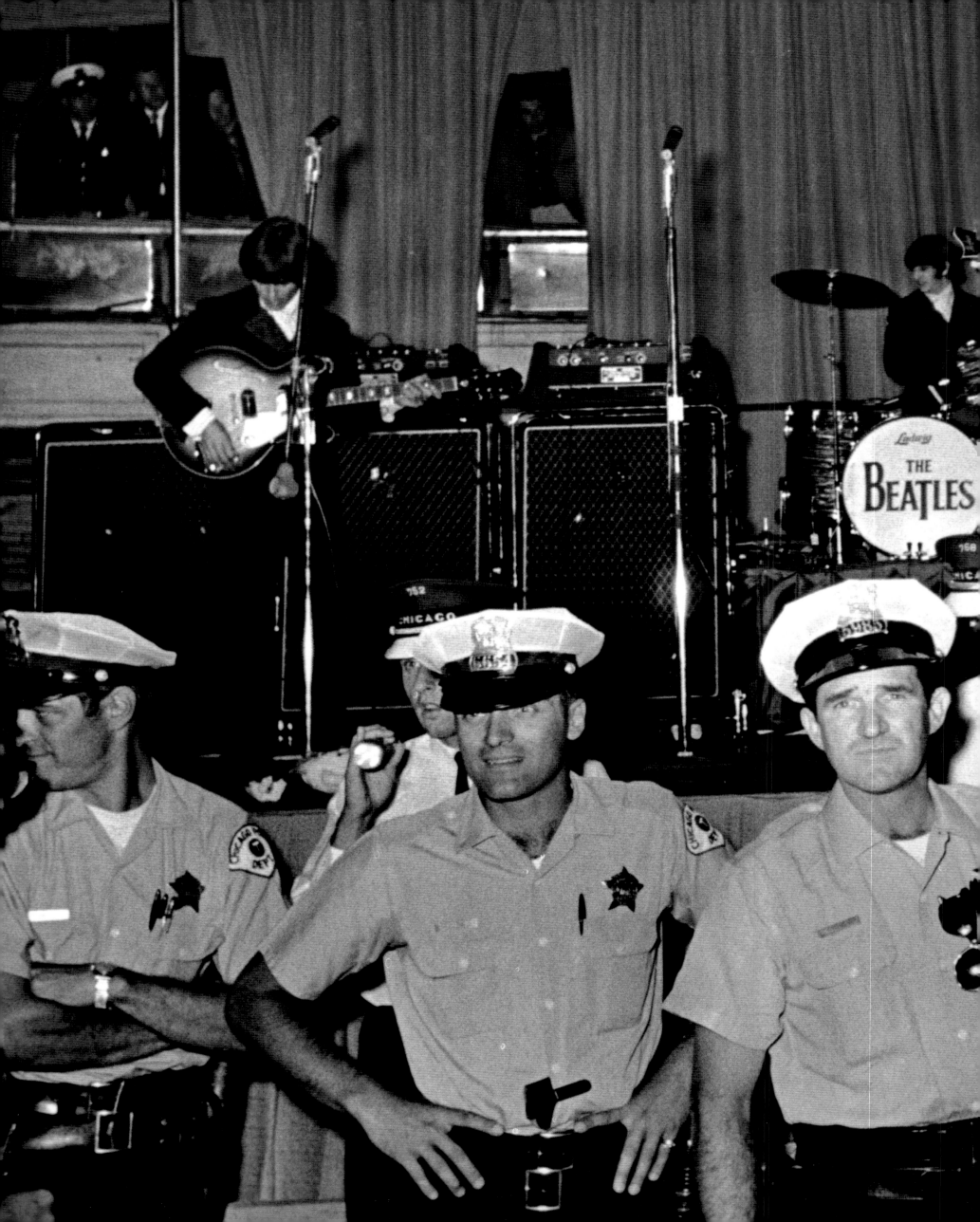

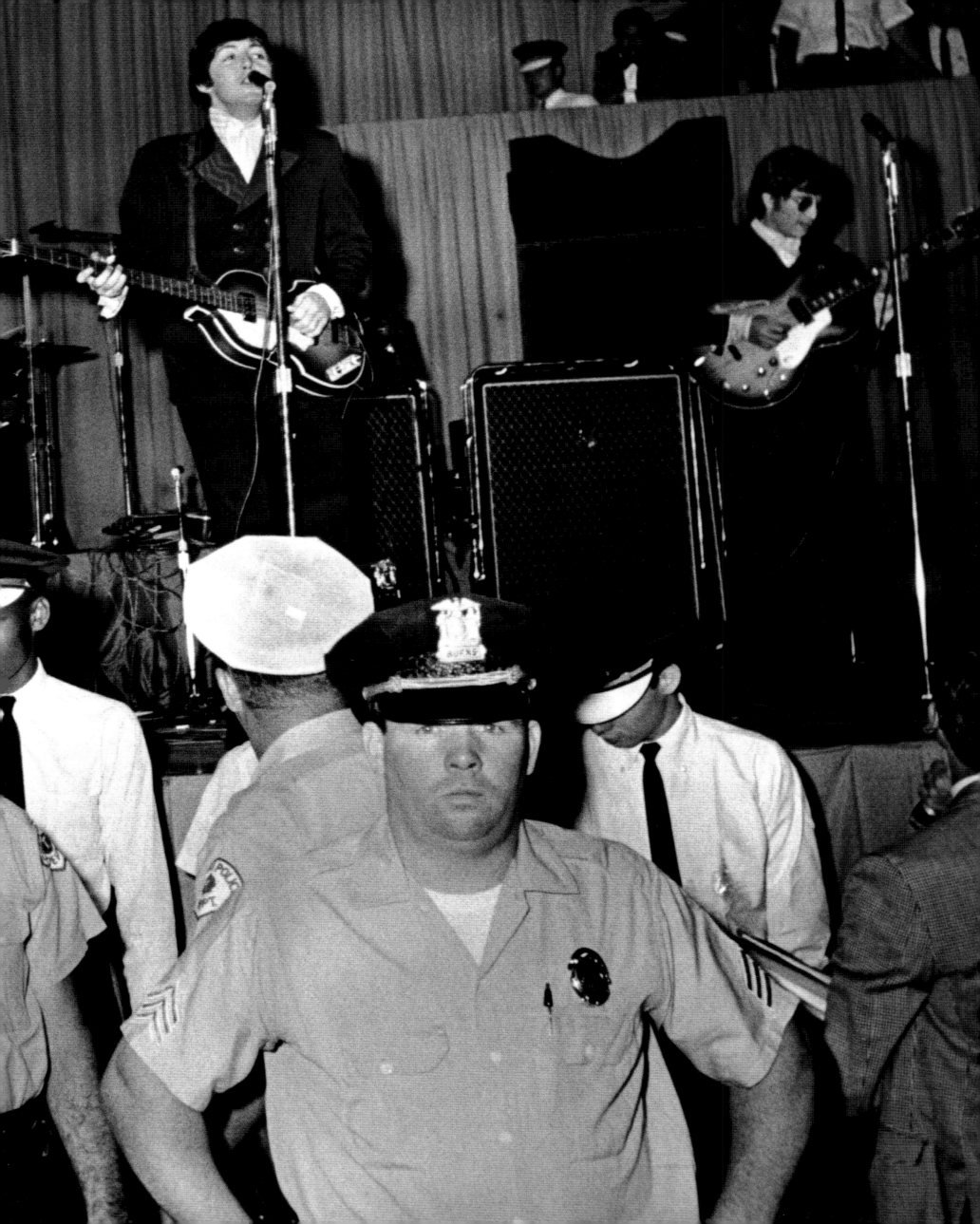

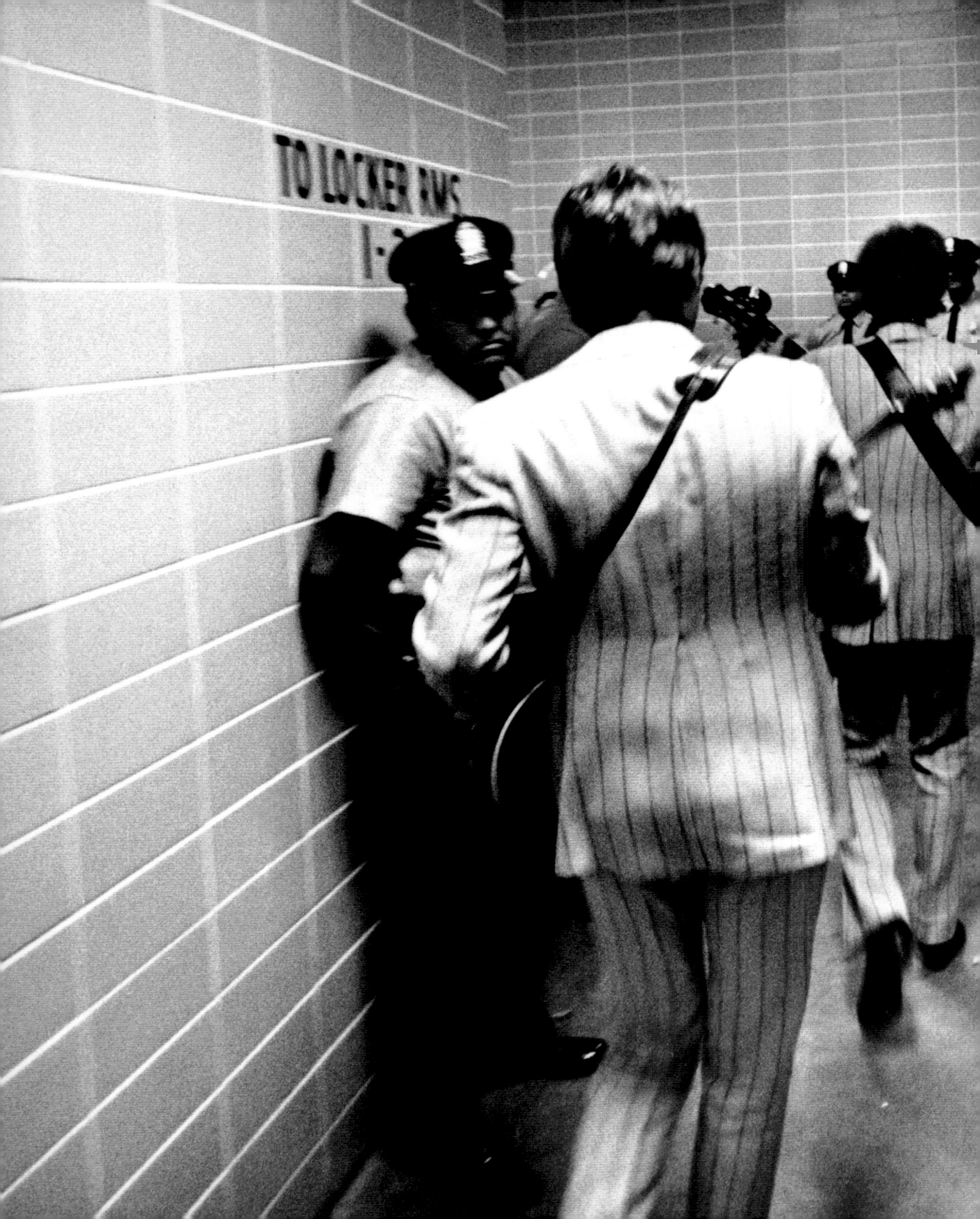

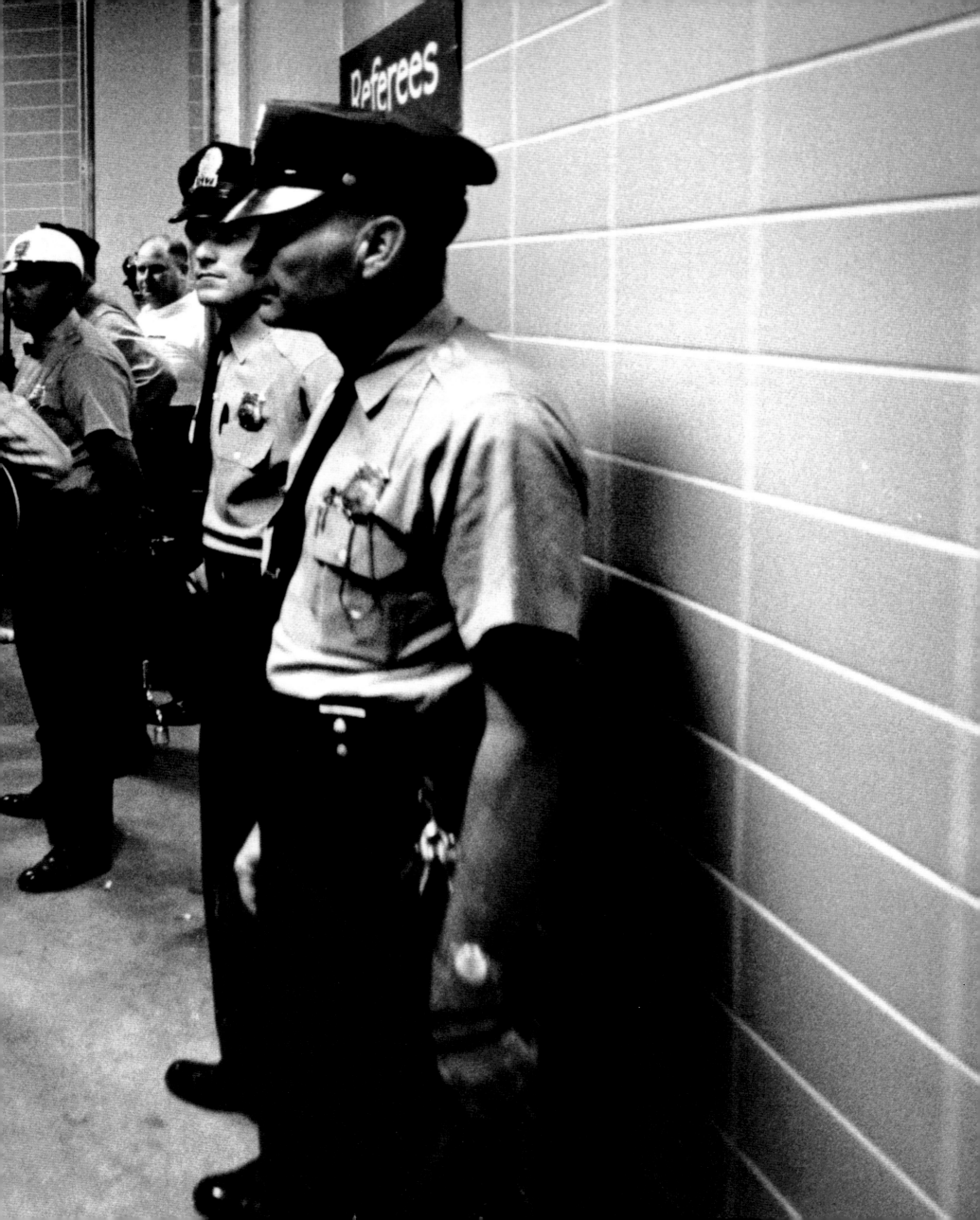

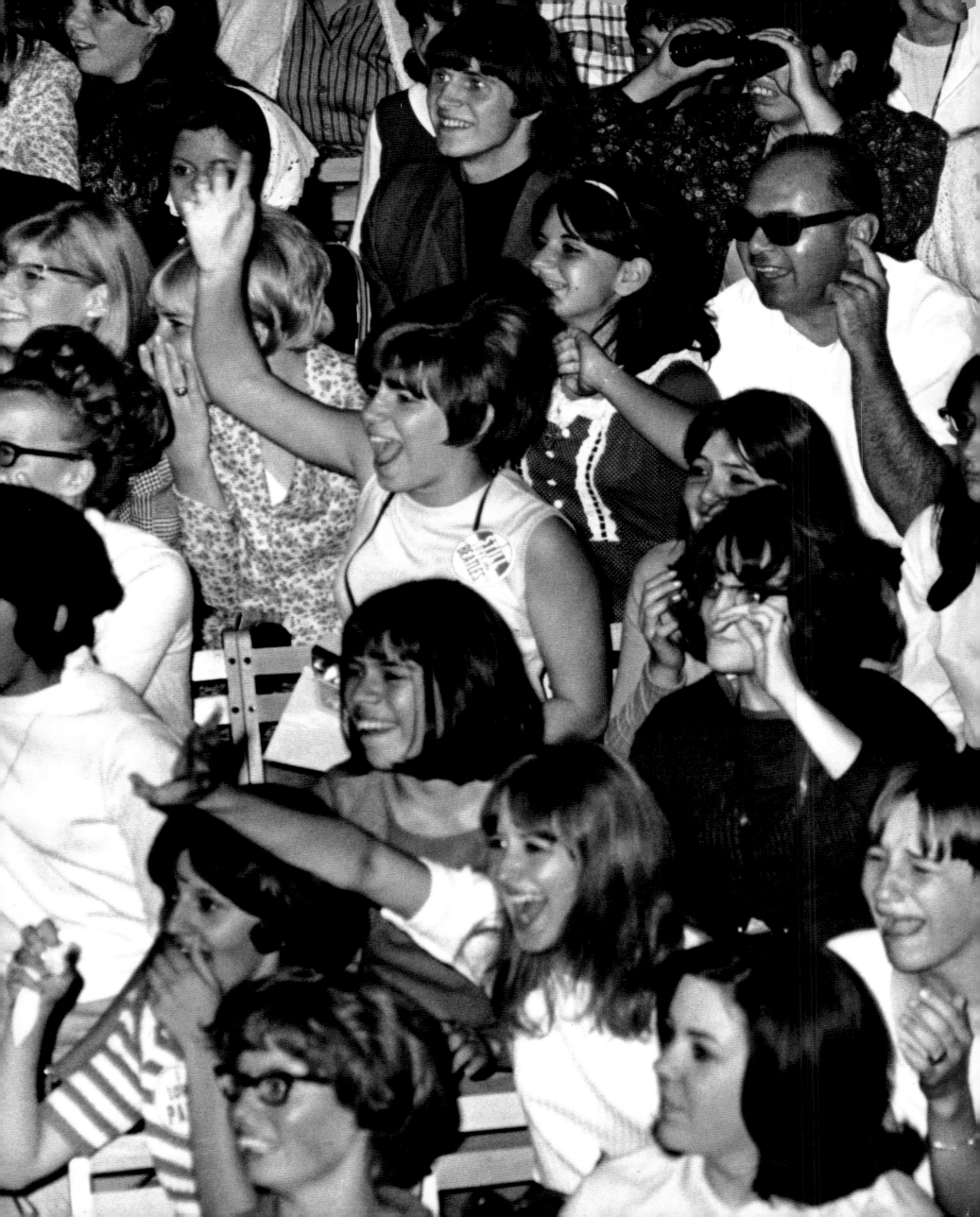

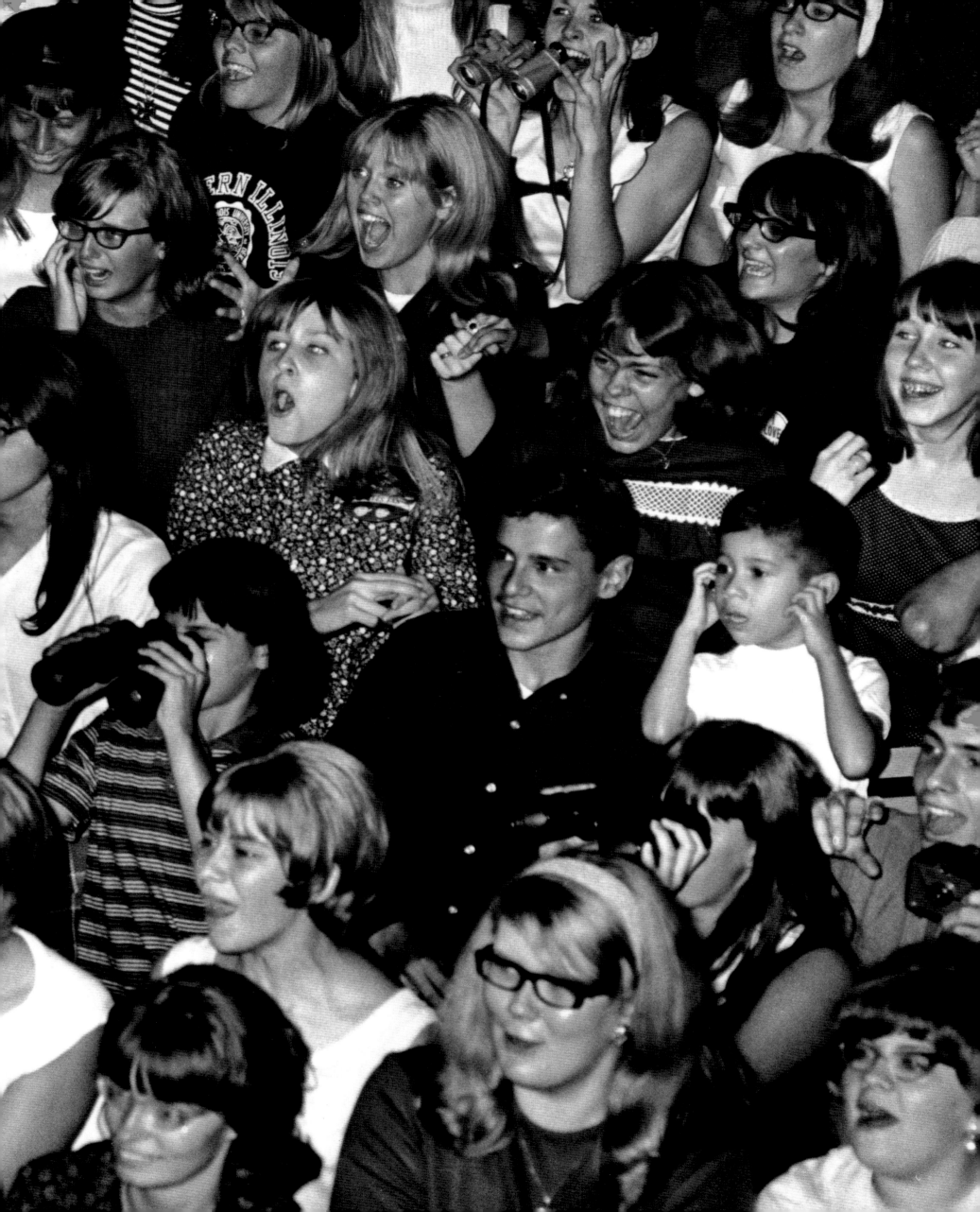

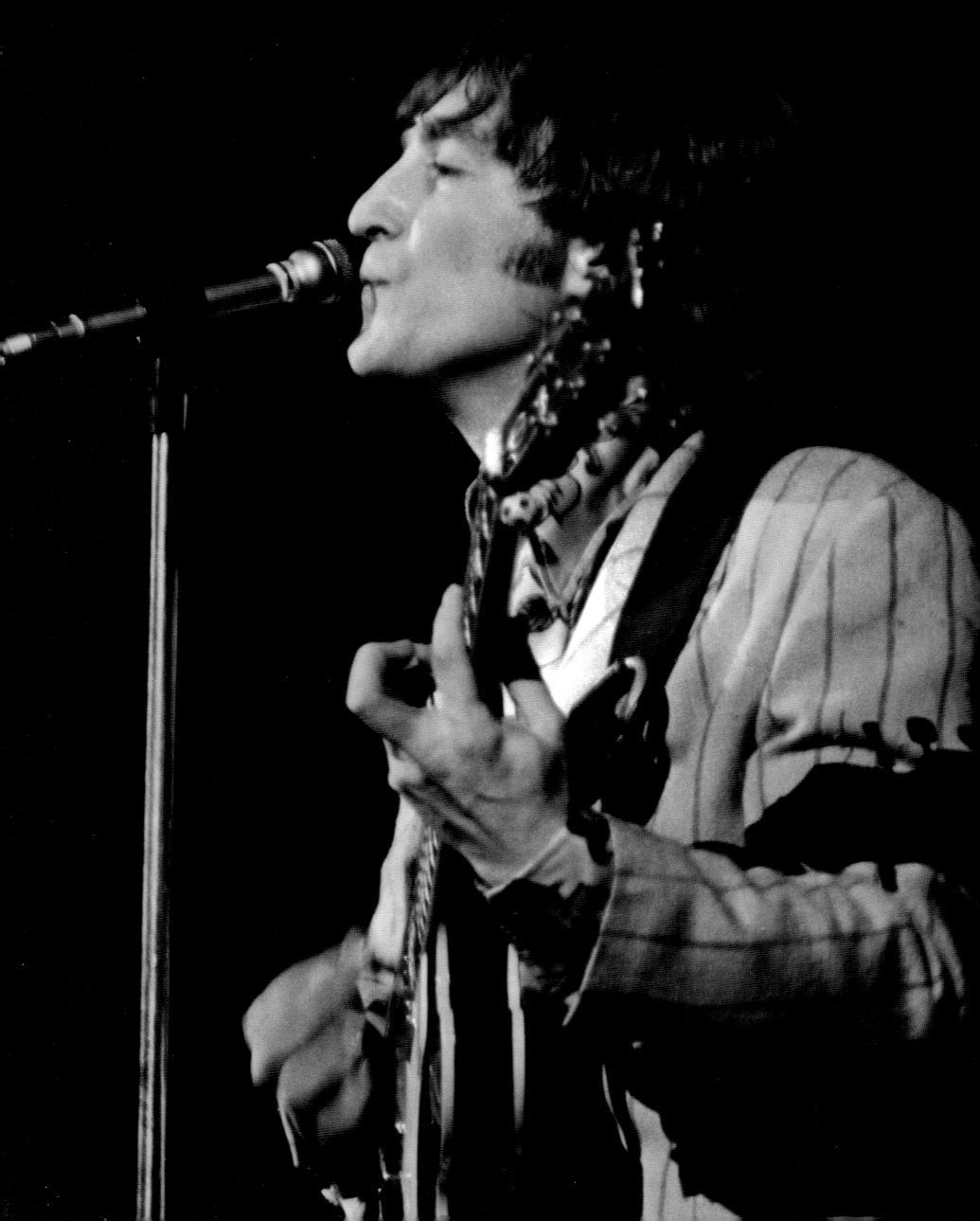

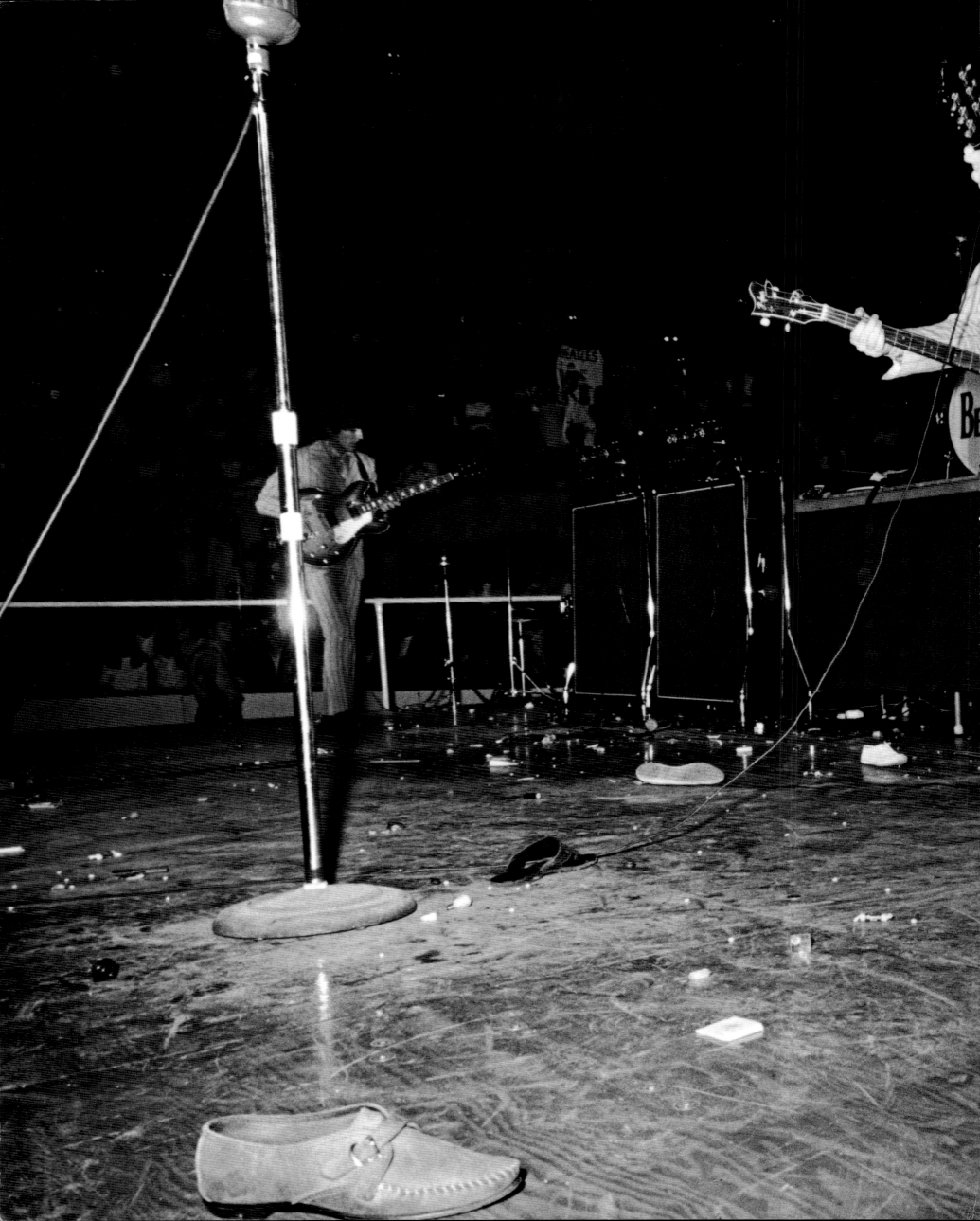

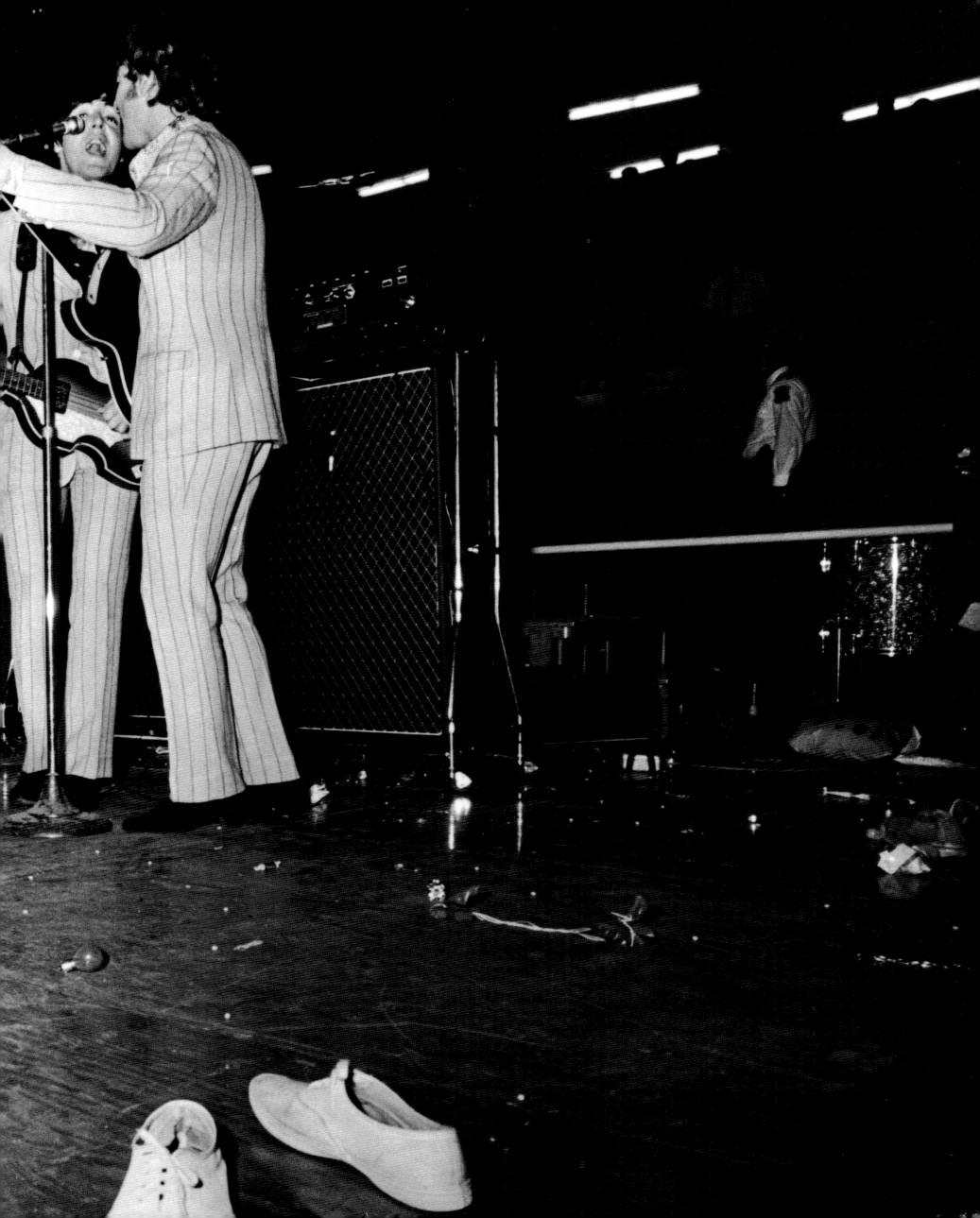

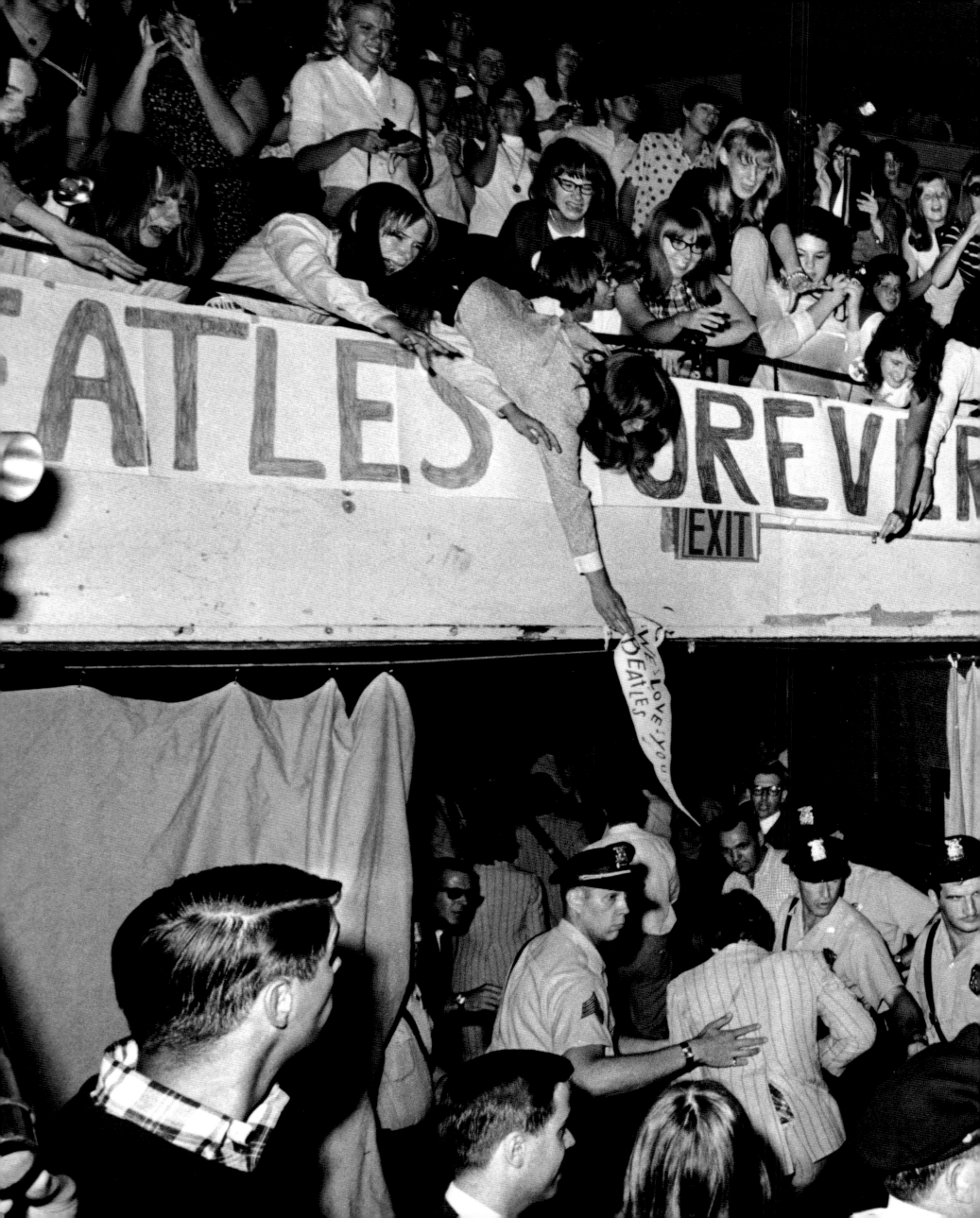

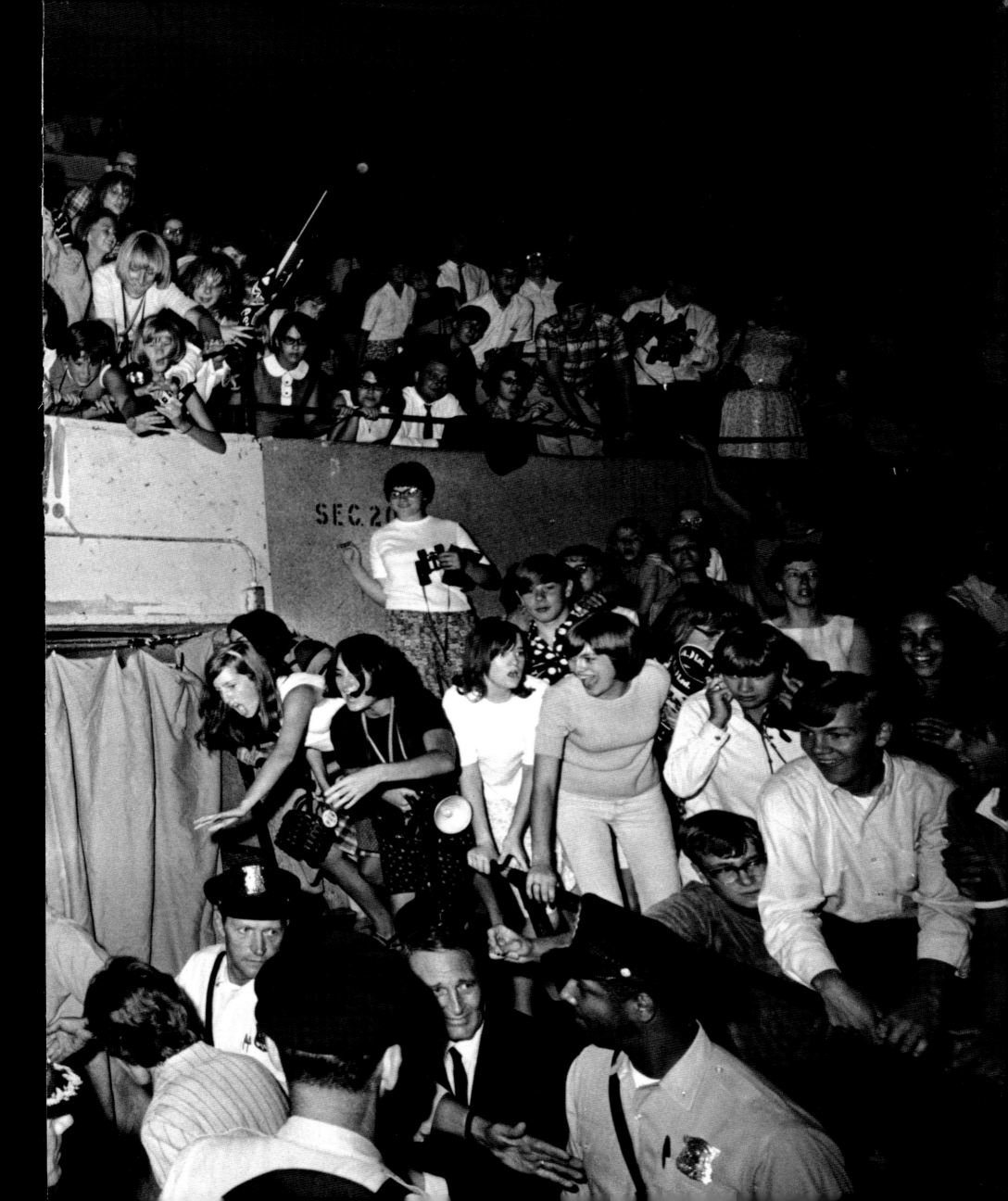

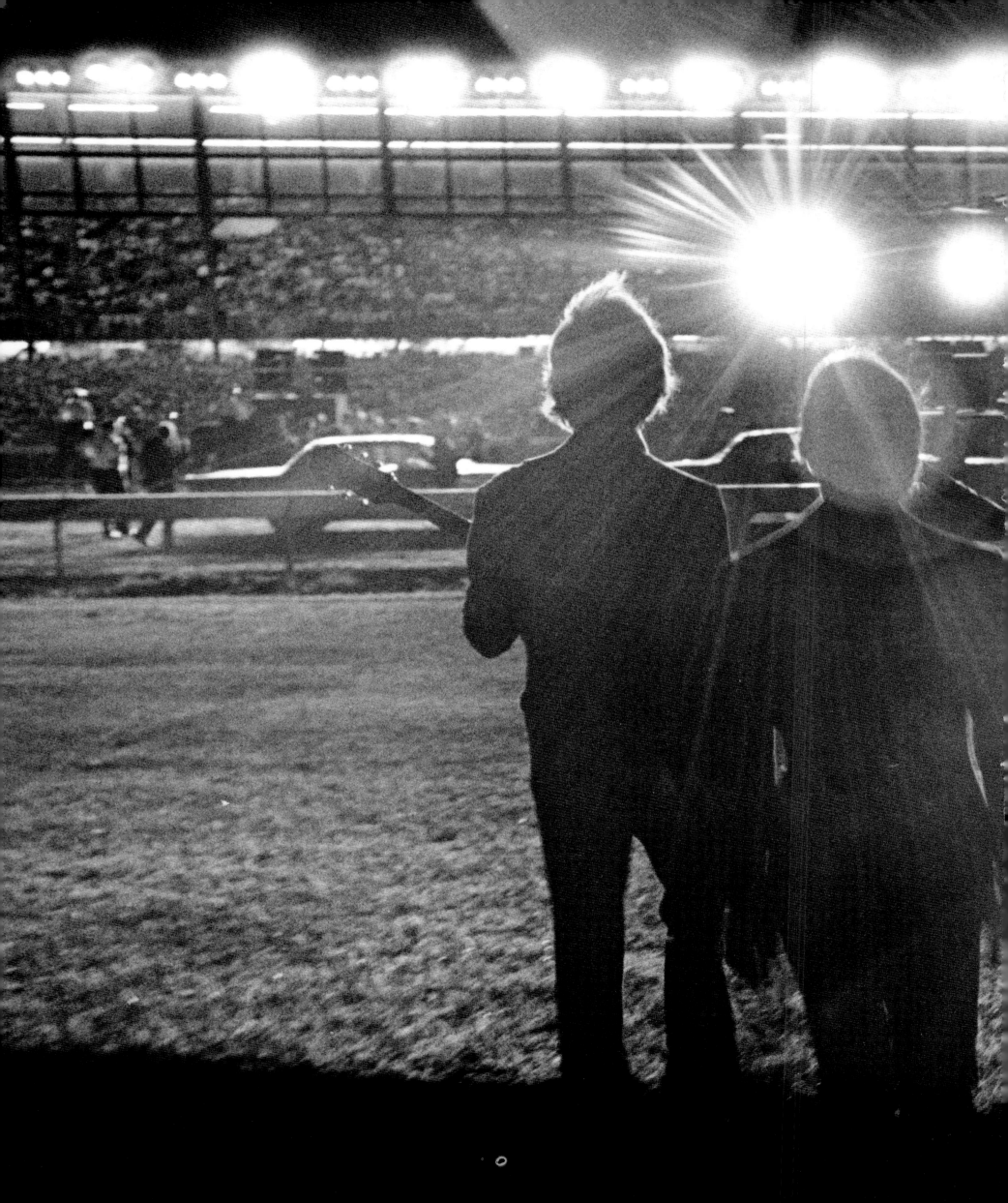

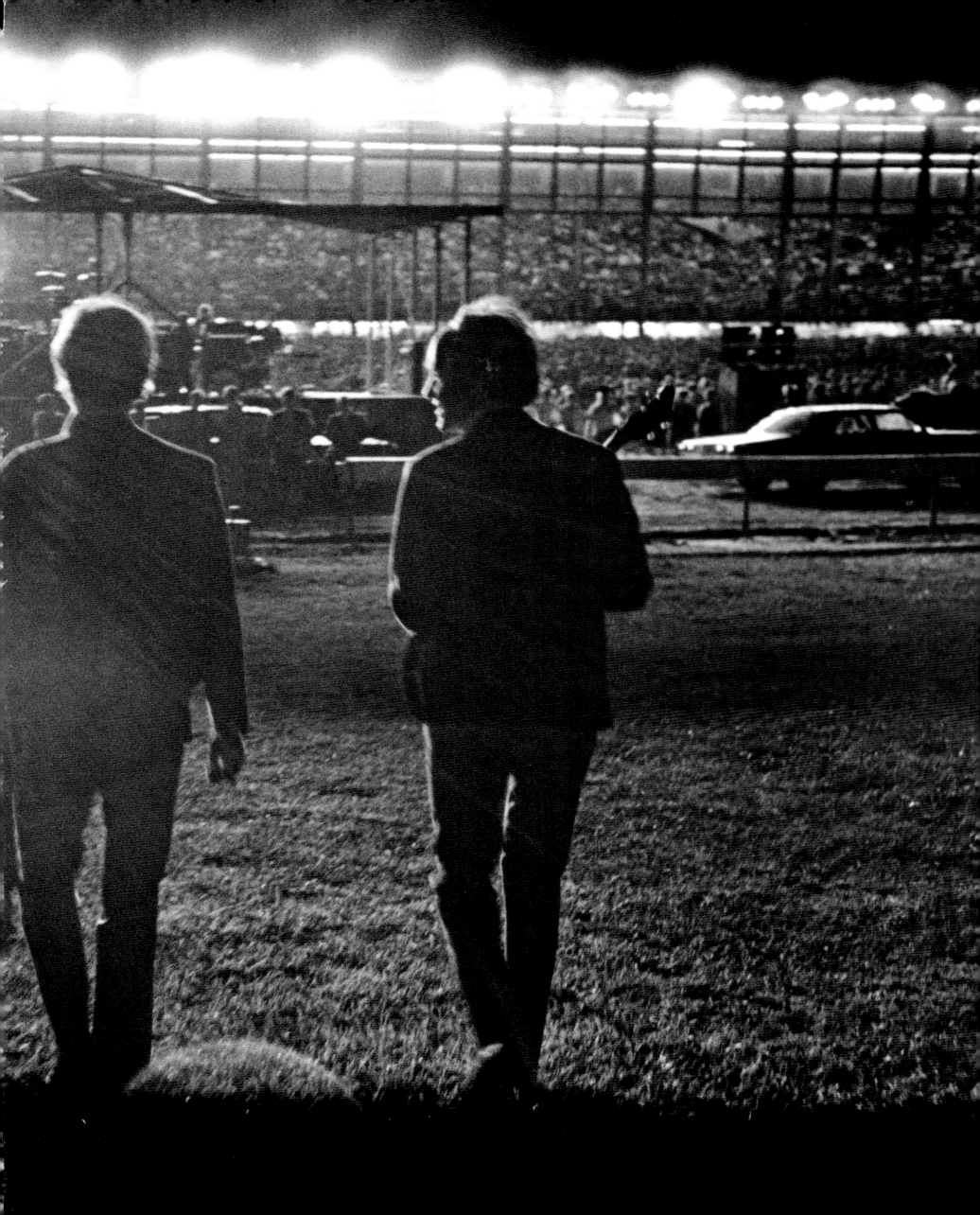